Andrew Selby

Animation
in Process

Laurence King Publishing

Contents

Published in 2009 by
Laurence King Publishing Ltd.
361–373 City Road
London EC1V 1LR
United Kingdom

Tel: +44 20 7841 6900
Fax: +44 20 7841 6910
enquiries@laurenceking.com
www.laurenceking.com

Copyright © 2009
Andrew Selby
The moral right of the author
has been asserted.

A catalogue record for this
book is available from the
British Library.

ISBN: 978 1 85669 587 9

Design: Philip O'Dwyer
Picture/footage research:
 Jemma Robinson
DVD authoring:
 Tim Grabham/cinema iloobia

Printed in China.

Cover: Still from Lovesport:
Love Paintingballing,
Grant Orchard, 2007,
©Grant Orchard
Studio aka 2008

Introduction

Cel & Drawn

Computer Generated

Stop Motion & 3D CGI

Unorthodox

Introduction

A Perspective on the Role of Animation

Entertainment. Information. Education. Animation encompasses all of these and more.

It is a magical form, able to reach into the psyche and the mindset of the audience.

The nature of this visual form can suspend disbelief and can subvert or alter meaning using a combination of visual and acoustic apparatuses. The contributors to this book have all experimented with a form that has numerous possibilities and, importantly, has arenas that have yet to be fully explored and understood. Such areas are now the focus of debate around what exactly constitutes animation.

In a pure sense, animation is a man-made artificial form, in which elements are composited together and amalgamated into a sequential piece. A number of different constituents make up its form and all of the examples in this book conform to some, if not all, of these codes. Animation may comprise vision and sound and its intention is to be displayed to an audience, but at a deeper level, the composition of visuals, linguistics and audio can be said to 'speak' to the audience.

At its core, animation seeks to narrate ideas, stories, visions and facts in often surprising and unpredictable ways, often succeeding where conventional film cannot.

With the aid of these constituent parts, this book seeks to expose the vast array of approaches and requirements used to turn ideas from imagination into reality. The case studies reveal that the creators featured in this book explore their subjects from a variety of visual and conceptual starting points. Each has a very distinct view of the work that they are creating and the audience they are communicating to. For some, this is a small-scale activity, relying on a handful of key individuals to make dreams a reality; for others, a studio of animators and producers is vital to commit the originator's vision to screen.

The question of what exactly constitutes animation appears to be evolving at a rapid rate. It seems an increasingly complicated task to categorize and specify exactly what we now identify as the true nature of the form. There are countless books being written, articles being pored over, bloggers delivering insights, panels debating at conferences and seminars, and students of animation trying to absorb all of this information. What is clear is that boundaries are changing, being redefined and challenged further by an increased interest in this area of entertainment.

In the bewildering world of 'multi-disciplinary and inter-disciplinary'[1] visual arts, this book sets out to showcase some of the most exciting animation being made today. It offers an analysis of some of the creation and production methods employed by those eager to express themselves artistically through what might be called animation. Many of the examples shown extend beyond historical definitions, but all embrace the notion that their conceptual distinctions and visual expressions are the main drivers for their work. The output may be designed to inform, educate, promote, mislead, or satisfy or promote curiosity, but above all it sets out to entertain.

For that is what we are dealing with here. Animation has rapidly become a major player in the congested field of entertainment. We continually crave entertainment; it is a major twenty-first-century passion. The proof is all around us, whether it be new digital media or the number of satellites launched to relay more and more content. Even simple statistical information, such as the number of TV sets sold per head and the frequency with which people replace them, leaves us in no doubt that our consistent demand for entertainment needs to be fuelled and teased. The rise in festivals devoted to animation and the increase in cinema ratings are now seen in a different but no less important context – that of streaming media. This is illustrated by the extraordinary growth in download figures for visual media that has occurred in the last decade.[2]

We are prompted to participate in more and more media portals, and not just from the perspective of the passive viewer. We are encouraged to share our views, our observations, our thoughts and feelings and to make these readily available to an ever-expanding audience. Media has broken down many sociological barriers. Some may argue that it has created many others. It has invaded our sitting rooms and places of work, but increasingly over the last decade, it has also encroached into our train journeys, airline trips and even into our most private spaces – say, on walks in the wilderness – with the advent of the video MP3 player.

→
One of the greatest animation festivals in the world, Annecy attracts more than 100,000 visitors each year to see the latest films.

Showcasing Animation

Animation is infectious. An audience may sit entranced by the animated worlds unfolding in front of them, but the director, scriptwriter, animators and producers know just how much work was involved in getting the film to that point. The plethora of digital packages available can alleviate some of the burdens of pre- and post-production, but there is no substitute for the hard graft of making ideas a reality.

In a world of media bombardment, the availability and affordability of technology suitable for viewing animation has broadened the potential size of the audience considerably. There is also increased pressure on the genre from other entertainment forms, all relentlessly pursuing exposure and using the same means to engage with and compete for a similar audience share.[3] This pressure will only rise in intensity.

The last decade has seen a far greater array of more affordable and user-friendly creative animation packages capable of transforming ideas into practice. Competitive pricing, coupled with incisive research into how artists interact with and subvert software, has enabled ideas to emerge that otherwise may not have seen the light of day. Once, this equipment was wholly the domain of animation production studios, whereas today individuals have a greater ability to manufacture and distribute projects of broadcast quality.

Technology has further enabled animation to be showcased in a multitude of different formats. Portable devices such as DVD players, video MP3 devices, sophisticated mobile phones and games consoles all have a capacity for storage and viewing. On a larger scale, projections and installations reliant on film are routinely shown in galleries, museums and exhibitions, both inside and out.

Animation's distinct advantages in the battle for media recognition is the rich vein of talent invested in the subject, whether through creators, critics, teachers or festival organizers. The broad range of innovative approaches is important not just in producing content, but also for exploring avenues for screening and, by default, animation's impact on the wider society. This has generated increased interest in the subject through national press, specialist publications, editorial features and collected works, and this interest has been encouraged further by conferences, film festivals, workshops and events. These activities vary in scope from rigorous academic debate and discussion through to children's animation classes, each offering an entry point into the subject dependent on experience, interests and ambition.

This interest in animation is clearly important. The exposure confirms animation's place in popular visual culture,[4] but goes further in advancing an understanding of how it has been shaped and how it progresses to affect our wider social, political and economic legacy. Keeping a subject in the media spotlight is a complicated and time-consuming process and the more the subject is debated, talked about and promoted, the more resonant and compelling it becomes.

However, although the audience can be enticed, cajoled, persuaded or preached to, one should never underestimate the power that the consumer has simply to press the 'off' switch. The opportunity to create something new, different and attention-grabbing is constant and is something articulated by many of the contributors to this book as being vital to their continued experimentation with the medium of animation.[5] It might also be one of the reasons why you have purchased this book.

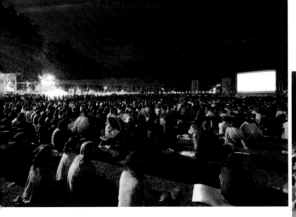

Content
& Context

Mass communication has given birth to, nurtured and educated a sophisticated audience over an extremely short timescale.

The introduction of the moving image, little more than a century ago, has accelerated through the development of movies, black and white and then colour television, commercial programming, Internet streaming and viral delivery to offer broadcasters, filmmakers, commissioners and designers the opportunity to showcase an astonishing array of visual offerings.

With this opportunity comes a responsibility to produce programming of variety and intelligence, of challenge and mastery, in the spirit that drove creators such as Winsor McCay, Walt Disney, Chuck Jones and Tex Avery to work on their original films.

Animation, like all of the visual arts, exists in a variety of contexts. These have offered freedoms to expand the form and have also shaped the direction, growth and impact of the genre over the last century. The arts are continually under threat from other subjects[6] and interests, which is perhaps ironic given that one of animation's prime drivers is its ability to engage with an audience and promote the virtues of these other subjects. To counterbalance this threat, animation has continually sought to be an apparatus for content. Although some might more readily associate animation with flippant, comical or light entertainment, there are many examples where the form has been used to promote serious content, such as political propaganda, clinical procedure and economic forecasting. Such variety shows the true diversity and functionality of the subject, ensuring that it always remains relevant.

The ability associated with the methods of thinking, producing and viewing sequentially is a human conditioned experience. We are taught to engage with this form of information-deciphering at a very young age, and this model is nurtured through life. Our ability to observe, decipher and understand content is shaped by a number of contextual parameters and importantly, our own experience. These circumstances help us question issues such as recognition, identification and acknowledgment and ultimately help us build up an overall view of the piece.

This increased exposure indicates that the animation community is not working single-handedly to promote the form. It is no surprise that due to its popularity and appeal, animation has been capitalized upon by others to reach a target market.[7] Animation has increasingly been used to advertise products and services, promote awareness, sound caution and explain complex notions with clarity and impact. This trend shows no sign of slowing down. In large part, this is due to the pliability of the form.

One moment it is used to sell delicate tissues to nurse colds and the next moment is used to explain the latest stock-market surge.

Animation may be one of the most versatile and compliant mediums available for the communications market.

Some will happily point to the craft of the form, exulting in its ability to magically transport people to domains that live-action film is unable to because of physical, emotional or budgetary constraints. By the same token, increasing numbers of visual artists are turning to the medium of animation as an exploratory form of film to expand their ideas. Some of these artists are included in this book. Man's ability to tell stories through visual form can be traced back to a time before literacy and, in a sense, very little has changed in thousands of years.

The ability to create a world, real or imagined, where stories can be played out retains a constant appeal to many. The audience always appreciates a good storyteller. From learning how to tell a sequential linear narrative, we quickly grow accustomed to the idea that stories can change structurally and that their meaning can change to become more ambiguous or to increase dramatic impact. Such devices are aided by systems of visual recognition, complexity of character and atmospheric conditions. Animation has proved that it can stand the test of time because the process relies on experimentation, whether that be through representation, structure, technology or insight.

1. Wells, P. The Fundamentals of Animation, AVA Academia, Lausanne, 2006, p7.
2. Internal Cisco estimates, published on a CD-ROM entitled Internet 101: Roadmaps for Success in the Internet Economy.
3. Motomichi Nakamura in conversation, Meet the Animators, 26 June 2007, Platform International Animation Festival, Portland, OR.
4. Wells, P. The Fundamentals of Animation, AVA Academia, Lausanne, 2006, p6.
5. Johnny Hardstaff in email conversation with the author, June 2007.
6. McCloud, S. Reinventing Comics, HarperCollins, New York, 2000, pp50–53.
7. Quoted article: 'The Third Shrek Helps Quadruple Profit at DreamWorks', The New York Times, 31 October 2007 (figures verified by Thomson Financial).

→
The Ottawa International Animation Festival offers prizes in a wide range of categories.

Structure

This book has been researched and written to appeal to readers wanting an insight into the processes of animation, who have some degree of knowledge of the basic principles of the art through reading and practice. The material will provide you with an overview of the subject, and will explain some of the visual processes and techniques involved in creating work in the major genres.

The contributors have been specially chosen to represent the major genres of animation; they represent some of the most creative and inspiring talents at work today across the breadth of the subject. The diversity of the contributors is designed to fire the ambitions of the potential creator, providing inspiration, hope and opportunity. The big studios do not feature, simply because of the raft of readily available information detailing how 'blockbuster' animated features were created.

Valuable lessons in the pitfalls and difficulties will navigate you around potential problems and prepare you for an exciting career and an opportunity to engage a whole new public. This book does not seek to provide all of the solutions you may need, but it does attempt to provide a springboard into a subject area that thrives on showcasing, developing and celebrating new talent alongside established talents.

The book is divided into four sections: cel and drawn animation; computer-generated animation; stop-motion and 3D CGI animation and unorthodox animation. Each section features a brief introduction to the area, its history, development and current placement at the beginning of the twenty-first century. The contributors showcased produce both commercial and personal work for a diverse range of audiences, and the international dimension of this book serves to highlight the breadth of interest and engagement with the subject.

From creative studio environments to major influences, from original interests through to keeping projects fresh and invigorating, the examples provide an in-depth analysis of the animators' work in both words and pictures.

Given that this is a book about the art of animation, sequential design and movement, there is also a DVD included for you to see some of the work showcased in its preferred environment – the screen.

The best artists utilize knowledge and expertise gained by accessing material from a variety of fronts. As has been illustrated by this introduction, you would be well advised to supplement your interest by subscribing to podcasts, attending film festivals, participating in conferences, making Internet searches, reading well-informed books and setting up environments for discussion with like-minded individuals. Animation needs people like you to evolve what the subject can become.

Andrew Selby, June 2008.

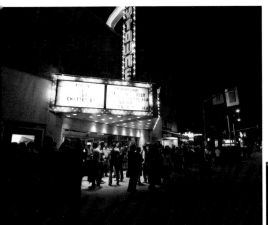

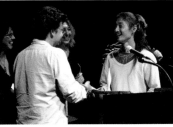

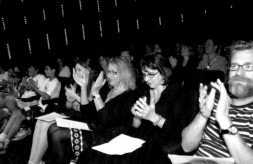

Cel & Drawn

In 1937, Disney released Snow White and the Seven Dwarfs, the first full-length, sound-synchronized animated film in glorious Technicolor – a pinnacle in animation history. The Disney model, whether aesthetic-, narrative- or technique-centred, has been an important factor in the documenting of cel and drawn animation and is one that came to define the form, creating enclaves of both ardent admirers and staunch activists. However one chooses to engage with this debate, Disney has ensured that cel and drawn animation has become the most broad and historically documented form of the subject. The techniques of both cel and drawn animation are fiercely defended by animation practitioners, historians and audiences as being one of the purest forms of the subject, arguing that these techniques have rightfully earned their place in the history of world cinema.

Walt Disney himself was a supreme storyteller, but importantly for the future of the subject he also saw that there was an opportunity to create an industry around what he loved best. Inspired by the production success of pioneering American companies such as Kellogg's and Ford, Disney's passion for getting his product in front of a mass audience is what sets him apart from the early experimentalists of the form. That is not in any way to decry the remarkable work done by Winsor McCay, Emile Cohl, Albert E. Smith and J. Stuart Blackton, who were unquestionably pioneers in their own right, but is simply a recognition that Disney represented someone who saw the power and possibility of animation as a mass-media player and who worked progressively towards this dream.

Historically important feature films such as Pinocchio (1940) and Fantasia (1941) followed, but with a strike at the Disney studio in 1941, the emergence of the altogether more mature Warner Bros. stable, comprising the likes of animation giants Chuck Jones, Tex Avery and Friz Freleng, capitalized on the unrest at Disney by offering short films based around the iconic characters of Daffy Duck and Bugs Bunny. These characters and scripts took on an altogether more surreal and challenging point of view, running parallel to other artistic movements, and distanced themselves from the safe Disney vision of the world. In Chuck Jones, the world was introduced to the idea of art within the cartoon, and, unsurprisingly, he is mentioned time and again by creators today as an inspiration for what they do.

The exploration of the art of animation was pivotal to more experimental creators such as Len Lye and Norman McLaren, the latter of whom is central to the history of the individualist works coming out of the National Film Board of Canada (NFBC). Lye and McLaren used the medium as a way of expressing their ideas through sound and image and questioning the conventions surrounding two-dimensional sequential work in the process. Lye was a prolific creator, whether through filmmaking, sculpture, photography or writing, while McLaren was an accomplished filmmaker but also hugely invested in the influence of music and sound.

Many creators produced notable works in the post-Second World War period, whether that be in the realms of entertainment, information or education. As economic prosperity grew, the popularity of television gave programmers the chance to commission more animation, most apparent in children's television through studios such as Hanna-Barbera in the 1960s. Around this time, Japanese producers saw the potential of the television market and the development of anime out of a manga tradition started in earnest, adding a further storytelling dynamic to the recent history of the form. Later creators such as Hayao Miyazaki (My Neighbour Totoro, 1988) and Katsuhiro Otomo (Akira, 1988) produced feature-length anime films that would compete with the Disney, Pixar and DreamWorks studios that had embraced the next wave of progression through digital opportunities.

While films such as The Incredibles (2004) or the Shrek series (2001–7) may seem impenetrable to those starting out, many of the key visual and scripting skills used in these multi-million-dollar features are derived from simple cel and drawn animation. The painstaking craft of the act of drawing cels has persuaded many artists to examine this form of animation further. It is also fair to say that the dedication, isolation and exacting level of concentration needed to draw 24 frames for a second's animation has driven many hopefuls away. Technology has allowed the scanning of drawings to be done economically, while programs such as Photoshop have replaced cel painting and Final Cut Pro has become the tool of choice for production. However, these are no more than tools that need to be operated and directed.

It is this myriad of possibilities that conceivably enable the act of authorship to occur. The world of cel and drawn animation is easily entered, but, as the animators in this chapter show, is difficult to resist.

Run Wrake

UK / runwrake.com

Rabbit

2005 / 00:08:26

Run Wrake's extraordinarily successful career is probably most clearly illustrated by his curriculum vitae, a twisting and cavorting visual journey through the landscape of numerous commercial commissions and critical successes. Working with the likes of U2, Stereo MC's and The Charlatans has not only given him the opportunity to get his work seen by a broad cross-section of international admirers but it has also introduced him to a number of like-minded individuals and collectives who have been instrumental in collaborating on later projects.

Rabbit is, in many senses, an adult fairytale, using the nostalgic visual treatment of vintage educational illustrations to tell a story with altogether more complex connotations. The insatiability of nature coupled with the naive images of childhood are at odds with the random violence frequently displayed through the films narrative, creating an uncomfortable and challenging viewing experience. The film is commissioned by Animate Projects, the highly successful sponsor of modern British animation that has established itself as a fervent supporter of experimentation, as writer Gareth Evans acknowledges, 'Across dozens of films, Animate has developed an identity and attitude that is the opposite of monolithic, prescriptive or pre-emptive. This hydra-headed quality is fundamental to its position in the current moving image landscape, not least because it acknowledges the huge shifts in both animation technology and production infrastructures.'

catch picture read over

swing jump under mother

cake up make children

girl shoe farm father

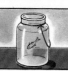
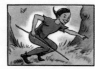

imp jar juggler

ink idol kangaroo

iron jewel

1
inspiration

jam jug kettle

↑ ↗ →
A trawl through a junk shop resulted in finding a collection of envelopes stuffed with 1950s educational sticker sheets which were in surprisingly good condition. Run waited the best part of two decades for a chance to use them in the right project.

How did you become interested in animation?
While studying Graphic Design at Chelsea School of Art, in London. Initially I saw animation as a means of combining music with the illustrative work I was making at that time. Seeing the animated video for <u>Close to the Edit</u> by The Art of Noise was instrumental for me.

How long have you been an animator, director, producer, and creator?
I have been a freelance Animation Director since leaving the Royal College of Art in 1990.

Who or what inspires or influences you?
Anything and everything.

Describe your studio environment
I have a small studio in my house in Kent, in the southeast of England.

What is your own personal definition of animation?
A collage of moving image, sound and time.

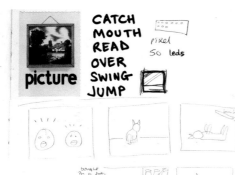

↑ ↗ →
These pages from Run's sketchbook clearly illustrate a stream of consciousness as the ideas continued to flow, sometimes best captured through drawing and in other cases, jotted down as hasty notes to himself. His ongoing reviewing and decision making process can be seen here too.

Run pitched the idea for <u>Rabbit</u> to Animate Projects using a mixture of rough storyboards and a selection of treatment sheets.

These were created from manipulated stickers found – by chance – in a junk shop while Run was searching for materials to collage with, as he explains, '<u>I had a collection of 1950s educational stickers at the bottom of a drawer for 20 years which I knew I was going to do something with one day. That day arrived, and a story was created from the finite source of images featured on the sheets.</u>' (1)

The sheets contained sets of figures and objects and a particular image of an idol on one of the sheets proved to be a significant starting point in the development of the script for <u>Rabbit</u>.

The collection consisted of several envelopes containing dozens of sheets of stickers, illustrated by Geoffrey Higham for the educational publishers Philip & Tacey Ltd., that were all in very good condition. Using a mixture of the three sticker styles, Run prepared a series of short rough animated sequences to establish movements of key characters like the little girl and the rabbit. These experiments were necessary to attempt to create a balance between the found and restrictive visual nature of the stickers and the need to try and show a degree of flowing movement through the film. After several attempts Run decided that this could be best achieved by splitting up elements like the arm of each character into different sections – the hand, lower arm and upper arm – and this principle was then applied to all of the characters where movement would be required.

While the experimentation with motion was taking place, the choice of using collaged material meant that aesthetic decisions had already become restricted by the limitations of the subject matter and the parallel physical restrictions of colour and scale. <u>Run saw these seeming limitations as an advantage and made copious sketchbook doodles and notes around the narrative theme for the film (2).</u>

2
sketchbook

A girl watches a rabbit run past

and dreams of a lovely muff for the winter

She is holding a knife, and chases the rabbit through the trees

Pulling out, through a flock of sheep, a boy is revealed, watching from a tree.

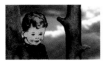

Reaching the fence that the rabbit has slipped through, her pace is hindered

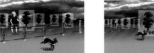 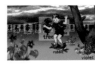

as she climbs the fence the rabbit slips away

running freely across the widening space

before entering a copse......

....and meeting its end

Triumphant, the boy turns towards the fence

where the girl dances with glee.

They walk home.

In the lounge, the rabbit is laid out on the table

flies are buzzing around the corpse

the boy tickles the dead neck as the girl raises the knife

and slices the rabbit in two.

Fascinated by the innards, the boy lifts one half for a closer look.

...dropping it in shock, as an idol in the stomach grunts, sits up and scratches himself.

The idol jumps out shouting in his strange language.

A fly buzzes past, in a flash the idol zaps it with rays from his fingers. It morphs, through abstraction

becoming two diamonds and a feather

The boy watches fascinated as another fly buzzes past

 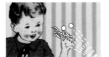

and is similarly mutated, through an alternative abstraction, into two more diamonds and another feather.

 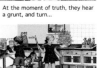

The boy and girl watch transfixed as the idol leaps off the table..

cartwheeling across the floor

transforming various objects around the room as he goes

He cartwheels into the kitchen

hopping on to a stool and on to the worktop

to a bowl of his staple diet, jam.

The boy and girl watch from the doorway

On the plums in the vegetable rack a wasp flies off towards the kitchen window

It is halted by the idol who morphs it into two more diamonds and a bottle of ink. The girl catches the jewels, as the ink bottle smashes on the tiled floor.

 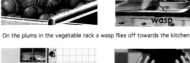

It dawns on the boy and girl that there is potential for great wealth and power.

They rush out of the kitchen, leaving the idol to his jam.

They search through various cupboards

meeting up outside the kitchen with a net and a cage.

They turn and enter the kitchen, and freeze in horror.

Next to the empty jam pot sits their cat, and no idol.

They grab it, preparing to slice it in half to retrieve the idol.

At the moment of truth, they hear a grunt, and turn...

...te place...

The boy goes for the net, as the idol zaps the cage and the cat leaps to freedom

The...

behind which he hides before jumping out to trans...

The spo...

into a large bone.

The...

The boy and girl exchange a glance before leaving the kitchen.

The jam...

while the boy takes a walk with his cricket bat.

The

...taking it to the front door, followed by the idol. They go outside.

Mea six...

As the idol enjoys his feast in the garden, the girl is pleased to see wasps gathering.

The

He is met by the girl, who hands him an axe

with carc...

hearing a distant hum, he looks up

they join the wasps to make a buzzing mass around the flesh and the idol, laying eggs

having tried to ignore the insects, the idol's patience finally snaps

ing

pot

hands

the

nd the

ep for

sheep.

s the

g meat.

Zap frenzy; An evolving soup of insects, falling diamonds and abstract shapes surround the frantic idol.

The boy and girl jump for joy as the diamonds accumulate on the ground.

In a basket fetched from the shed, the girl gathers the jewels, as the boy heads off once again.

A horse gets it.

And so it goes on until the sun sets, when the action around the jam-tub lessens, ending as darkness descends.

Inside, the boy and girl admire the day's results.

Outside, alone at last, the idol happily gorges on jam.

Night passes.

To the sound of the dawn chorus and a spoon banging on an empty tub, dawn breaks.

The idol, leaping about and hitting the tub, morphs a passing bird into a whistle into which he blows.

Hearing the racket from the garden, the girl looks outside to see whats going on.

She fills another tub with jam, and takes it out to the hungry idol.

The insects return, and a montage of shots follows as the cycle of day to night to day repeats, the idol's days taken up by transfiguration, his nights spent

eating jam, the fly's larvae turn flesh to bone, the boxes of jewels, feathers and ink multiply, the jam cupboard empties.....until there is just one jar left.

The last of the jam is put on a dish by the girl, and used as bait to tempt the idol back into the house. Meanwhile the boy loads their van with boxes of ink and feathers. When this is done, they lock the happily eating idol in, and drive off.

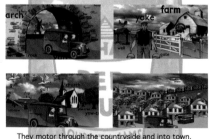

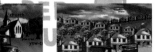

They motor through the countryside and into town.

Back at the house, the idol has become restless after eating all of the jam, and is transforming various objects around the room.

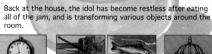

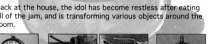

A clock becomes a gun and a fish becomes a crown

As the ideas started to flow, he was eager to commit them to a storyboard and to try and emulate the pace he was thinking at. Run used Photoshop to scan and compose images directly on screen. This also proved to save valuable time as the images were already in a format that he would later be able to use when constructing the film.

The storyboard amounted to some fifteen sheets, using a mixture of captioned full colour stills and supporting script to explain the story to the funding body (3).

← ↓

The storyboard presented to Animate was created in Photoshop as a way of showcasing both the narrative and the treatment, supported by a parallel text description, but also meant that these images only needed to be tweaked slightly for them to be used as final film frames.

3
storyboard

Outside, a rabbit appears and nibbles at the grass below the bones. The idol sees it through the window, and becomes excited, scampering over to the vegetable rack. He proceeds to throw carrots out of the window, luring the rabbit closer.

In town the boy and girl find a shop. Inside, they negotiate with the man who runs it, the exchange of their feathers and ink for a vanful of jam. The man, seeing the potential market for quills, and thus, ink, agrees. Once loaded up they set off, waving to the shopkeeper, and head for home.

Back at the house, the rabbit has eaten the carrots outside, and finally leaps through the broken window to get at those left inside. The idol leaps about excitedly, before blowing on his fingers, and aiming them at the rabbit. He fires, and the metamorphosis begins. Unlike previously however, the abstract stage of the mutation goes on and on, providing a colourful, evolving selection of shapes upon which the idol flies around, whooping for joy.

Finally they reform, into a tiger.

The boy and girl walk through the door as the tiger picks up the smiling idol with his teeth, and with a flick of his head, tosses it into his open mouth. The boy grabs the gun, but as the tiger crunches his jaws together, the idol dies and all of his transformations unravel.

The gun turns into a clock once more, the tiger a rabbit. A dying fish flaps about on the floor as the boy and girl focus on the rabbit. Before they have a chance to act however, the boxes marked 'jewels' burst, spewing forth a carpet of wingless flies and ants which swarm across the floor, up the legs of the boy and girl, until they are enclosed, flailing around, in a crawling shroud

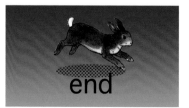

In the shop, the man looks bewildered at his apparently empty 'pen set' packs, not noticing the pair of insect wings in each one.

The rabbit takes a last look at the struggling figures, before jumping out of the window, and away into the open fields.

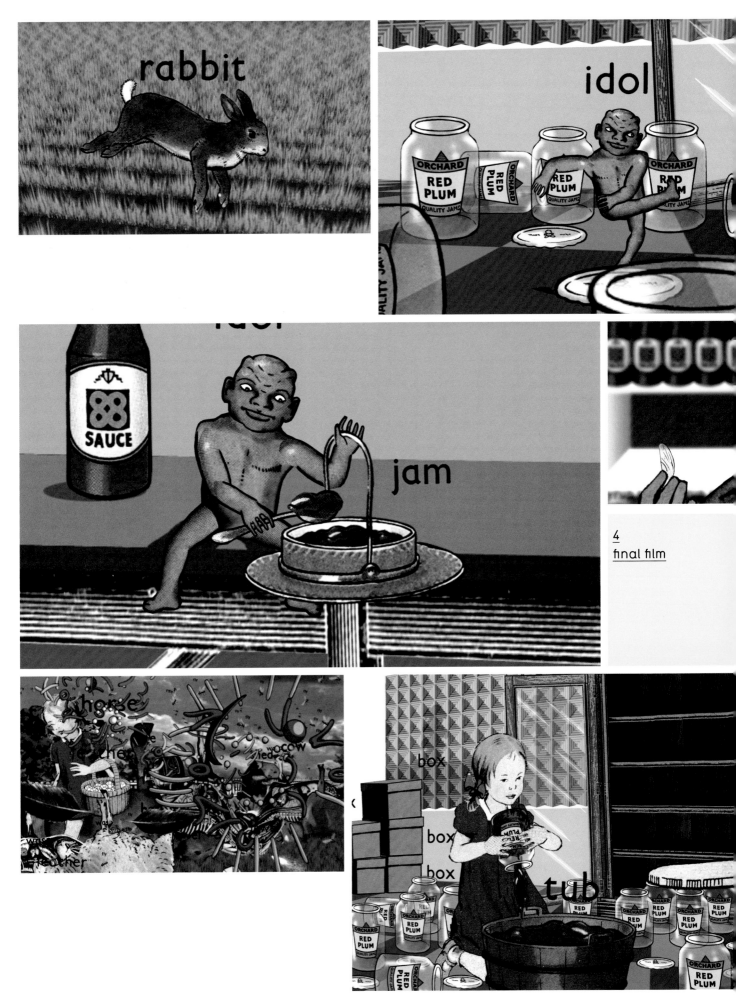

Gary Thomas, co-director of Animate Projects explains the thinking behind supporting Rabbit as a viable project, 'We'd previously commissioned Run to make Jukebox and he was very successful commercially. But his approach to his own work remained very much from the perspective of a visual artist – and that's the practice model that Animate supports. Even when we've commissioned animators coming from an industry context, what we've offered is a protected space, away from commercial pressures, and we've worked with them as individual, independent artists. We don't commission the studio or the producer.'

Animate began as a collaboration between the Arts Council of Great Britain (now Arts Council England) and Channel 4 television in 1990. It was one of several broadcast co-commissioning schemes that the Arts Council ran in the 1990s for arts documentaries, dance films, and artists' film, which is what Animate came under. For the Arts Council, there were three key benefits: leverage of additional funding for artists to make work; the opportunity to influence broadcaster's agenda; access to a relatively huge audience for artists' work. That's the context in which Rabbit was commissioned: through an open submission scheme, with selection criteria that, along with originality, strength of previous work, and having a viable budget, included 'appropriateness for television'. For both the Arts Council and Channel 4 that meant 'Does it rise to the challenge?' and 'Will it excite and intrigue the audience?'

Run explains that he was eager to get on with making Rabbit, 'I spent about six months getting to a nearly complete storyboard, but I found I really wanted to get on with the making of the film.

While each of the frames were prepared in Photoshop, I still wanted to maintain a hand-drawn presence so I created the drawn backgrounds using pen and ink.' The skies were filmed very early in the morning from Run's house in London, which faced east, 'Getting up at sunrise in the autumn was the perfect way to ensure the best quality results. The ability to capture something immediate just by sticking a camera out of the studio window was very appealing.'

Rabbit was an all-consuming piece of work and Run spent a full 12 months animating the scanned stickers in After Effects in various layers and then importing other layers such as backgrounds, texts and the atmospheric skies in to the final stills. He was the writer, director and producer, and did the bulk of the animation, although he was helped out by a couple of interns to get the film complete for release in the final three months of production.

Music was added to the film after the final production was agreed. The soundtrack was put together by Craig Butters and Run used long-time collaborators Howie B and Craig Richards to create the right atmosphere for the film. Run explains that this production process was significant for him, 'Putting a soundtrack to the film after the animation was completed was obviously easier in relation to timing but there is still the pressure of making the sound relate to the images – when you've collaborated a long time with these guys they know what you are thinking and that definitely helps.'

The film has gone on to receive a good deal of critical acclaim since its first screening on terrestrial television in the UK and Run is already engaged in creating his next project. The prickly undercurrent of violence makes for some disturbing viewing sitting as it does against a relatively traditional narrative structure and the simple visual technique, but that hasn't stopped Rabbit (4) being a heated topic of debate around animation film festivals and online forums, proving once again that content stirs emotion and the pacing of that content is well worth the months of preparation.

↖

Final film stills from Rabbit illustrate a collection of processes and techniques combined to achieve the final look, including scanned stickers, hand drawn elements and live action shots of the sky, composited together in Photoshop and After Effects to reveal a creeping undercurrent of violence in the seemingly innocent world of nostalgic children's book illustration.

The Blackheart Gang

South Africa / theblackheartgang.com

The Tale Of How

◎ featured on DVD / 2006 / 00:04:30

The sheer imagination and beauty of the South African film The Tale of How is the result of the shared creative passions of The Blackheart Gang, comprised of Ree Treweek, Jannes Hendrikz and Markus Smit. Collectives are common in animation, and this film benefits hugely from the synergy of the constituent parts of the group, whether they be artists, musicians or producers. That this film is a personal piece, created by the group as a labour of love sandwiched between commercial projects, says much about the vibrancy, tenacity and sheer ambition of three individuals working closely together for a common good.

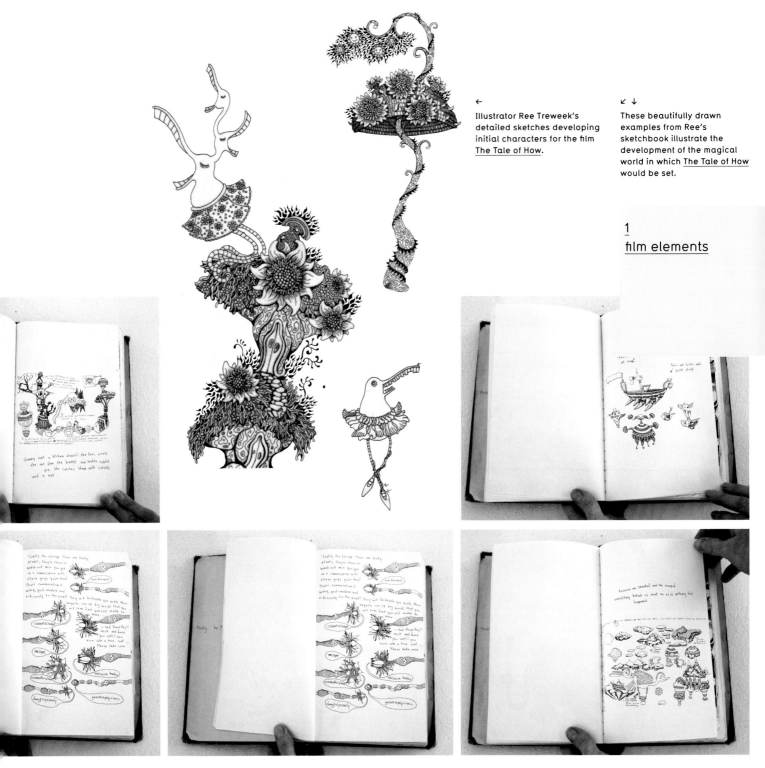

←
Illustrator Ree Treweek's detailed sketches developing initial characters for the film The Tale of How.

↙ ↓
These beautifully drawn examples from Ree's sketchbook illustrate the development of the magical world in which The Tale of How would be set.

1
film elements

How did you all become interested in animation?

Well, there are many connections. Jannes and Markus are cousins. Ree and Markus met while doing a shadow-puppet project with a group of friends. Markus then introduced Ree to Jannes. We wanted to do something, make something. A type of creative chemistry just developed among us. At the time, none of us had any real experience; we just threw ourselves into it and the result was a film titled Ringo. This started as a weekend project, but we ended up working on it for another nine months. We didn't plan. Things just developed. I think that this is the basis of our working dynamic. We learned as we went along.

How long have you been animators, directors, producers and creators?

Markus began making music when he was sixteen. Jannes began making movies at twenty-one and Ree began drawing as long ago as she can remember. Ree is the illustrator and character developer for The Blackheart Gang. She works as a freelance director and illustrator with Jannes, who is director and compositor. Markus is the musician and writer for the group, working out of his studio SayThankYou.

Who or what inspires or influences you all?

Sincere storytelling. Authenticity. Beauty. Visually, we are informed by ancient art from many countries and cultures, including Indonesian, African, Mayan and Egyptian, and by objects such as old etchings and maps. We like myths and legends combined with stories of the new world, the work of illustrators like Mark Ryden and Patrick Woodroffe and movies like The Dark Crystal.

Describe your studio environment.

At the time that we made The Tale of How, Ree was freelancing from an office in The Old Castle Breweries in Cape Town; Jannes was working at Blackginger Visual Effects and Markus from his studio. Jannes and Ree recently started a company called Shy The Sun. They co-direct commercials from their studio, also in Cape Town. We are a collective, so we collaborate openly with each other. Each person has their own skills that they bring to the gang and we all rely on each other to add to our projects. That means trusting the other members and being aware of our roles in the bigger picture. At the time of production, Ree would join Jannes after work at Blackginger to work on the movie until late into the night. It mostly involved drinking loads of espressos, listening to good music, telling stories, hanging out and working hard. We work on a kind of hand-me-down process. Usually at the beginning of the process, Ree and Markus would get the concept down, after which the whole gang would spend time together. Markus would then work on the audio, while Ree and Jannes led the production process, and finally the whole gang came together again at the end of production.

The Tale of How was a part-time project, made over a period of one and a half years working in the evenings and at weekends, including nine months' production time, all with no budget. The idea was to create something original, inspirational, beautiful and sincere. The story is the second instalment of a three-part story, developed by Ree and Markus, called the Dodo Trilogy.

Ree grew up on a small town just outside of Kokstad with the incredible stories of a songoma called Khotsa circling about her. It was believed that Khotsa had a number of giant snakes under his control. Ree imagined that one of these giant snakes lay beneath her bath and would drink up all the soapy water once she had pulled out the plug.

Markus began writing a script based around this childhood story, while Ree drew all the elements for the world (1) and developed the characters (2).

Jannes composited, styled and directed the whole animation process and Justin Baker was head 3D animator and modeller.

Markus and Ree brainstormed this concept and came up with the idea of the household with all its various planets, libraries and histories.

2
characters

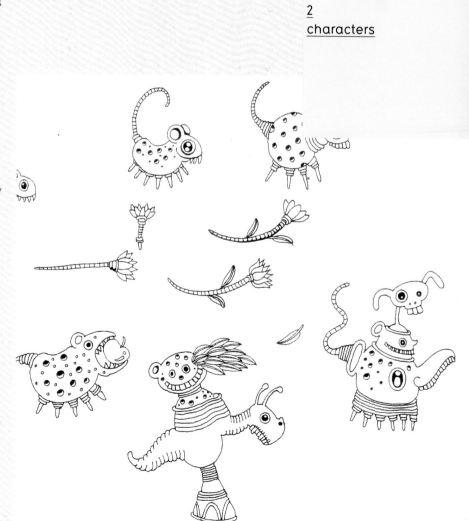

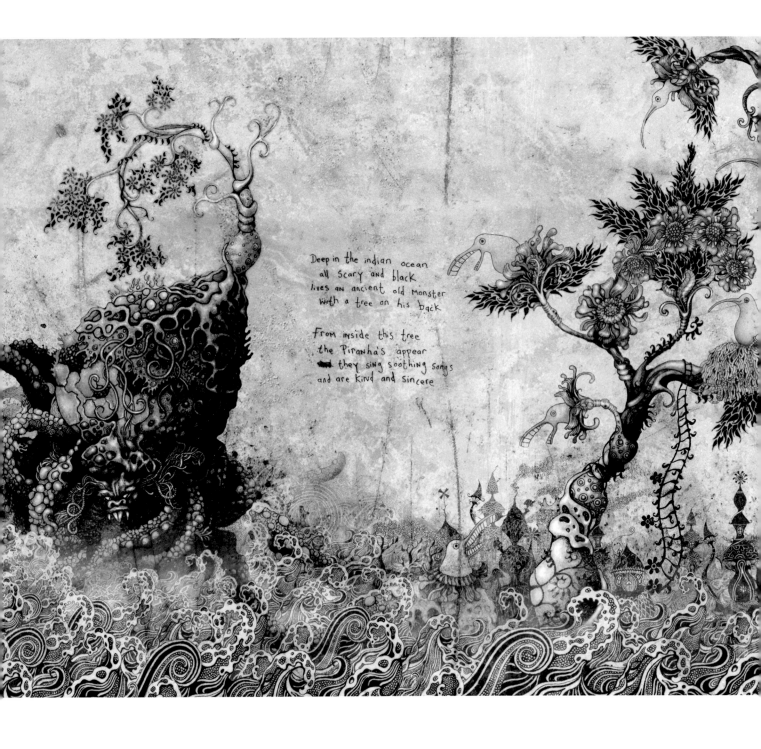

Deep in the indian ocean
all scary and black
lives an ancient old Monster
with a tree on his back

From inside this tree
the Piranha's appear
they sing soothing songs
and are kind and sincere

One day Markus bought a scruffy stuffed dodo that a friend had given him to Ree's house and suggested she make some drawings of the bird. Inspired by the present, <u>Ree came up with pages and pages of shape-changing birds that would later be called piranhas and would set the basis for the story of The Tale of How (3)</u>.

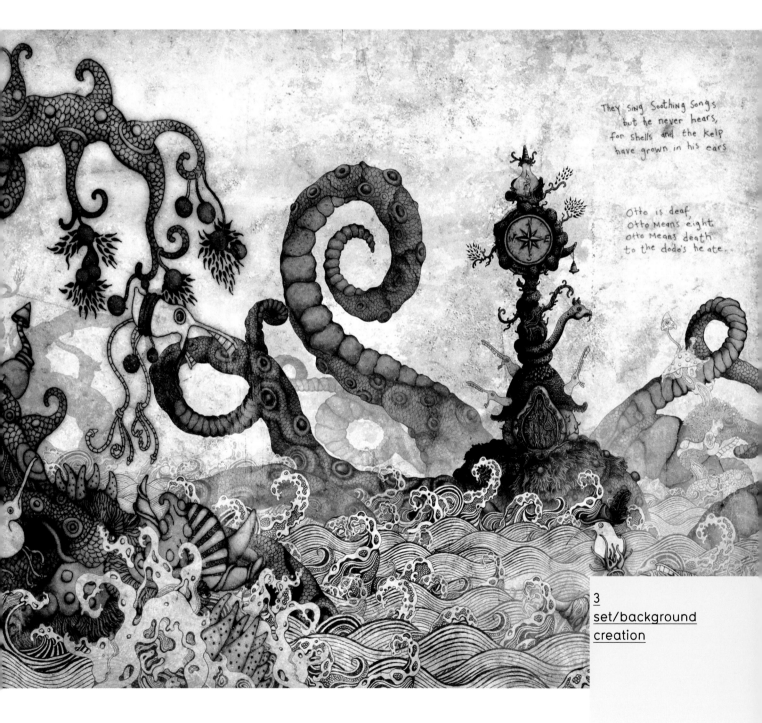

They sing soothing songs but he never hears, for shells and the kelp have grown in his ears

Otto is deaf, Otto means eight otto means death to the dodo's he ate.

<u>3</u>
set/background creation

While visiting Kokstad, Markus wrote the poem and Ree began to develop the world of the piranhas further. Jannes describes the film as a 'history of a household – a visual journey through a library far away where various types of creatures came to live.'

The script developed while the gang brainstormed the household. Markus developed an initial audiobed to work to. Ree drew all the elements with pen on paper, scanned them and coloured them in with Photoshop. Jannes then built the scenes with her elements in Photoshop, added textures and prepared the layers for After Effects. He would then build 3D environments in After Effects, add live-action video elements and animate all of the two-dimensional elements. A lot of time was spent blending the two-dimensional elements and live action to create a seemingly living world complete with depth and dynamics. Environmental elements such as caustics and volume light helped to achieve this feel.

The next step was to give the 3D animators a background plate to animate on. Jannes explains, 'Blackginger Visual Effects and Animation let us use their machines and a group of young 3D animators working there at the time helped with the birds, in their own time. It was great working with them and there was a fantastic atmosphere with all working on the project.'

Justin, who did all the 3D work, modelled the birds (4) and developed shaders to look like Ree's drawings. Jannes would then composite the renders into his scene, treat them and do the final camera animation (5).

This was important for the whole gang, as Jannes points out: 'We wanted to maintain an authentic feel, so it was important for the 3D birds to look as two-dimensional as possible.' With the final visuals completed, Markus then laid down his completed audio track on the final rendered animation.

The film has been an international sensation, something that delights the animators greatly; 'We never really knew about the short film animation market, even after completion of the project. We just knew that we had to put it out there. The good response was a bonus. We needed that reciprocation after working our lives away on the project. It definitely inspires us to do more and better. Ree has a very specific drawing style, and I suppose that won't change that radically.

Our style will change and adapt with each new project because we never want things to look the same.

Hopefully, our next project will look completely different. We will use animatics this time round and spend more time on pacing. We don't want to give away more than that.'

This film is further evidence of a new creative wave coming out of South Africa. Cape Town's relative isolation from other creative hotspots appears not to deter artists, designers, writers and filmmakers, who thrive on the strong local buzz of challenge and creativity, coupled with a progressive outlook fuelled by industrial and social development. While many would argue that this growth is in its infancy, the inspirational spirit exploding out of The Tale of How is sure to tempt other creatively minded people towards a career in animation. As the gang concludes, 'We really hope to inspire people. This project was about beauty, sincerity and passion. We want to share that. And hopefully, for just a moment, pull people out of the chaos they have grown so accustomed to.'

→ ↘
Stills from the film illustrate the evocative beauty and compelling mystery of the story through seemingly masses of layers of imagery.

↓ ↘
Following on from the drawings of the stuffed dodo, this series of mysterious sculptures was made for inclusion in The Tale of How, as well as providing ample opportunity for Ree to draw inspiration for her characters.

4
3d models

5
final film

Koji Yamamura

Japan / yamamura-animation.jp

A Child's Metaphysics

◎ featured on DVD / 2007 / 00:05:08

The world of Koji Yamamura is often a magical one, where his surreal imagination concocts situations that are comical, bizarre, unnerving and sometimes weird. It is truly a world of individual expression. A Child's Metaphysics attempts to explore the ecology and philosophy of children with a melancholic humour that entertains but ultimately questions the audience's perception of the seemingly happy childhood world, using meticulously crafted drawings.

In this film, Koji creates such visual delights as a child whose head is constructed from numerals, and a child who winds up his own face and carries it under his arm. This sequence is quickly followed by a child whose eyes are depicted by fish and a child who lies down on the floor, head-butting his own identity. These images express Koji's penchant for exploring the manipulation of emotions, and the tension that is created between subjects on the screen and the audience in the cinema. This is perhaps most tellingly brought to a head with the image of a child who cannot say anything because of the zipper across his mouth, which when undone simply reveals another zipper.

↓ ↘

These images show a tiny proportion of Koji's developmental drawings for the key characters in the film. Although he was inspired to create the film to illustrate the plight of children in Japanese society, he was clear that he didn't want to use overly representational forms.

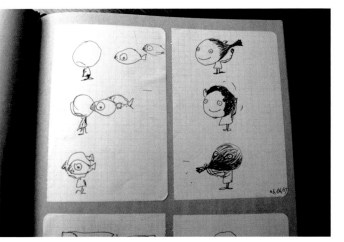

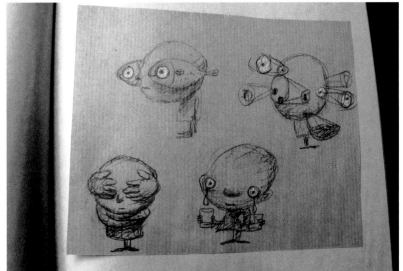

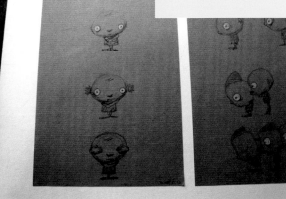

1
characters

How did you become interested in animation?
Watching short animated films produced by animators from the National Film Board of Canada and the Soviet Republic was a real inspiration to me when I was in my twenties.

How long have you been an animator, director, producer or creator?
For almost 20 years.

Who or what inspires or influences you?
The animated films of Ishu Patel, Yuri Norstein and Priit Pärn particularly inspire me.

Describe your studio environment.
I run my own studio where I'm both the producer and director.

What is your own personal definition of animation?
Something that is created by a frame-by-frame technique.

↓
Koji studied reference material for background props to give his characters a sense of place and scale. However, these retain a very personalized feel due to the nature of the line and its economical use.

↘
A series of images taken during the film's post-production in the recording studio, as both the soundtrack and narrative sequences were added. Koji is shown here with his daughter, Kiri, and a friend's children, who all undertook narrative parts.

A Child's Metaphysics was inspired by the conditions in which Japanese children appear to be trapped nowadays. Stories of juvenile crime and problems with children's education are constantly being reported. These are subjects that Koji finds particularly troubling, so he wanted to create a film to share both his observations and his concerns. During a screening, he wanted the audience to laugh along with the film, but afterwards he wanted them to think deeply about the content to find their own interpretations of the story.

Koji used the motif of Leonardo da Vinci's Vitruvian Man, which represents a supposedly idealized form of a human being. During the film, this motif reappears and every time the form changes, a child makes an effort to cram his body into this motif. Koji was clear that he didn't want to make visual representations of the children too life-like, but did want the voices to sit harmoniously with the frames, as he recalls: 'The images of the children were created from my recognition of Japanese children who seem trapped in present-day society. It is their voices that lead them into a little bit of liberation and a small revolution.'

The film began with Koji sketching ideas around a narrative theme. Since the film was made from many episodes, he didn't feel the need to make an all-involving storyboard, deciding instead to concentrate on short sections of narrative that could be pieced together into a final edit. In this way, ideas could be produced continuously while the process of animating went on simultaneously. Koji was then able to fit these visual experiments into a musical score, continuing this organic process of creating. 'I tentatively used Prokofiev's piano pieces when I did some offline editing. They fit this film exactly, so I decided to use arranged versions of them, with the help of Hitomi Shimizu. It turned out pretty nice. Those miracles happen sometimes in making animation.'

The assumed roles of producer, animator and director helped Koji maintain and promote a level of control in the making of A Child's Metaphysics.

From the initial drawings made in sketchbooks and on rough pieces of paper, Koji began developing characters and situations for those characters to exist in (1). These drawings enabled Koji to develop a feel for and an empathy with his characters before committing his drawings to animation cels.

Using a mixture of drawing tools, Koji's strengths as a draughtsman are apparent in the economy and weight of individual drawn lines to bring his subjects to life. The relatively small scale of the drawings made their subjects resonate a particular kind of voice and enabled a certain empathy to exist between the creator, his subject and his audience.

The film took two months to complete. In this time, the cels were drawn one after the other on coloured paper, using a peg bar to keep each cel registered in the same position (2), and thus eliminating the image appearing to shake on screen.

Once the cels were complete, Koji began to scan the images one by one into the Mac, using RETAS!Pro (a piece of Japanese software for creating animation), Photoshop and, ultimately, Final Cut Pro (3).

↓ ↘

Each cel is drawn by hand on pre-punched paper that allows the registration of each sheet to be exact, maintaining a consistent flow when the sheets are scanned. The lightbox enables sheets to be placed over one another. Koji then draws the top cel slightly differently so that, when seen in sequence, the drawings appear to move.

2
drawing cels

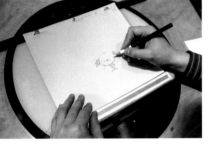

3
scanning cels

→

Each cel requires scanning and colour balancing to achieve a degree of parity. Any slight change in conditions will be amplified when the film is shown in sequence and will distract the audience's attention.

Koji explains, 'I don't use any digital technology during the process before shooting. All of my film material is handmade (4).

But the post-production process is done digitally. My attitude towards digital broadcasting, such as streaming, is sceptical, because I want the audience to watch my films with the best graphic and sound quality.'

Koji tried to avoid montage-like effects in the final edit, instead preferring to composite the pictures deftly so that each cut stood up independently.

His ability to manipulate the visual sensitivity of this film runs in parallel to the lengths to which he was prepared to go to ensure that the soundtrack and voices co-exist to transport the audience into his surreal world. Koji is clear about where this drive comes from: 'Imagination. To enrich imagination, you need to refine your own sensibility through observations of reality.'

Working traditionally is clearly liberating for Koji, although he remains honest about some of the shortcomings involved in creating a film in this way; 'It costs a great deal of money to make film prints and it would have been nearly impossible to distribute A Child's Metaphysics without financial help from the Japan Arts Fund.' The film succeeds in a manner familiar to audiences who respect and admire Koji's work, far removed from other dominant genres of animation emerging from Japan, to tell a simple story in a sensitive, thought-provoking way.

4
final film

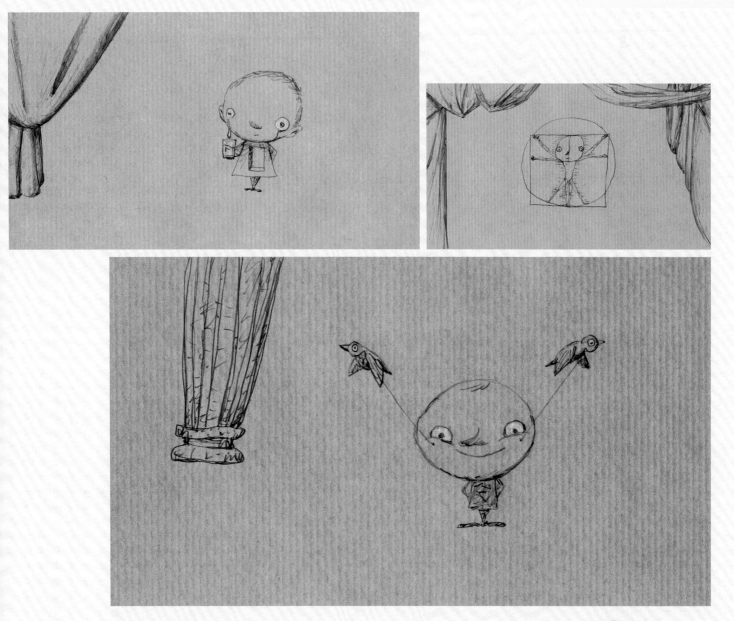

Michael Dudok de Wit

Netherlands / dudokdewit.co.uk

The Aroma of Tea

◎ featured on DVD / 2006 / 00:03:15

Immediately recognizable by their gentle and poetic illustrative feeling, Michael Dudok de Wit's films display a level of sophistication whether they are commercially commissioned or, as here with The Aroma of Tea, his personal work. The work celebrates the joy of creation using brush and ink, a fascination with Chinese and Japanese calligraphy and brush painting, together with a passion for a particular performance of Corelli's Concerti Grossi and the desire to tell a simple story about a journey.

Funded by the Dutch Film Fund and the Franco-German TV network Arte, the film follows the path of a small shape travelling purposefully and rhythmically towards its final destination. While the choice of animation process is entirely in keeping with his other films, Michael's choice of materials is anything but, with each mark created by a brush that has been dipped in tea. For this project, he acted as writer, designer, animator and director – and he also chose the music.

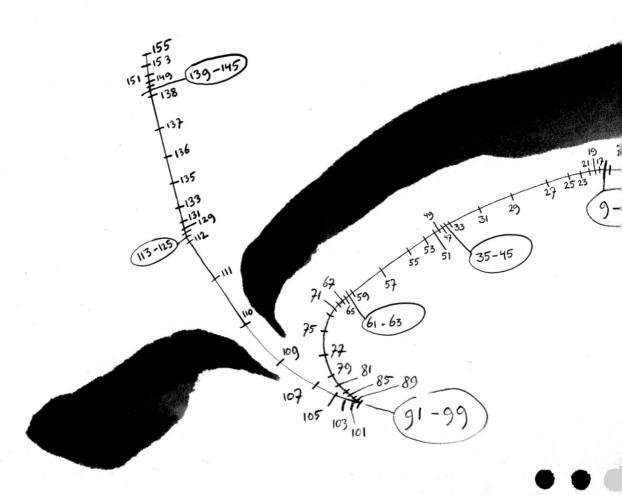

How did you become interested in animation?

As a child I drew a lot and I read a lot of comics, especially from French, Belgian, Dutch and Italian artists. In the 1960s I saw a handful of short animated films from Central and Eastern Europe, and the power and originality of those films made a lasting impression on me; they were totally unlike commercial animation from the United States. I went to an art college in Geneva not knowing which art form would be the right one for me and within a few months I realized I wanted to combine drawings, narrative and music. I changed to another art college (in Farnham, UK) that had a specialized animation course.

How long have you been an animator and director?

I've been an animator since completing my studies in 1978, and also a director since the early 1980s.

Who or what inspires or influences you?

I'd say nature, in particular animal and human behaviour, music and films, whether they be fictional or documentaries. Stories in general, really. I'm also fascinated by the interaction between light and shadow. My parents and siblings were creative in their own ways and living with them has inevitably shaped my own taste and creative urges.

Some of the well-known artists who have stayed with me since my childhood are Rembrandt, Hergé, Sempé, Charlie Chaplin and Carl Barks, and later George Herriman, Moebius, Hokusai, Kurosawa, Antonioni, Yuri Norstein, Frédéric Back, Fabienne Verdier, Isao Takahata and Hayao Miyazaki.

Describe your studio environment.

I made The Aroma of Tea in my studio, a small house in the back of my garden in London. It is just one room with a stimulating atmosphere and everything I need. Because the film was intended to have a meditative quality, I chose to work by myself, communicating with my producer, technical director and other professionals mostly by phone, mail and email.

What is your own personal definition of animation?

It used to be films that have been made frame by frame, but now I can't think of an accurate definition.

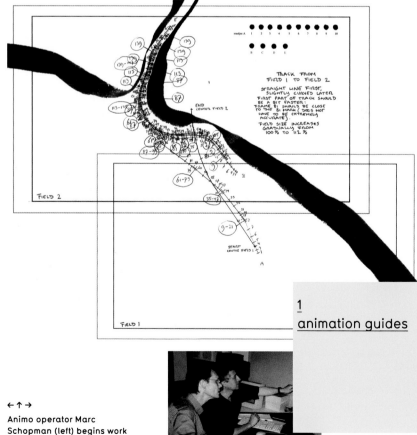

1
animation guides

rondjes 1 - 12

6 7 8 9 10 11 12

←↑→
Animo operator Marc Schopman (left) begins work on plotting the dots onto the backgrounds of the film in his studio in Antwerp, Belgium.

The idea for The Aroma of Tea came to Michael while he was walking along a street, but he waited a couple of years before allowing himself time to play with the concept, originally with ink on paper.

Only when he had completed a storyboard was he truly convinced of the strength of the project (2); up to that point he had been worried about the relative absence of entertainment value and humour.

Michael explains: 'The plan was to synchronize the animation to a recording of Corelli's Concerti Grossi by Ensemble 415. This beautiful performance was deeply inspiring and I listened to the music over and over again. I then showed the storyboard to my producer, Willem Thijssen, who calculated the budget, searched for funding and started securing the music rights to make the project happen.'

With approval for the film being negotiated, Michael began the next stage by painting the backgrounds on watercolour board. He painted lots of simple lines with a brush, randomly at first and later working towards a more detailed vision. Instead of using China ink, he decided to use tea in a highly concentrated form. 'I just loved the idea and the dye turned out to have a wonderful colour and texture. The colour also proved to be stable when exposed to light. The only drawback was that the liquid would rapidly turn mouldy in the container.

About 400 tea bags in water were boiled down into about a pint of thick, dark liquid.' From this successful experimentation, Michael drew many hundreds of background designs (3) before editing and selecting the right ones, scanning them and adjusting the various contrasts and hues in Photoshop.

He found the visual exploration involved in painting the backgrounds to be one of the most enjoyable parts of the six-month-long production. It was around this time that Michael heard coincidentally about the release of a Japanese feature film called The Taste of Tea. He wondered if he should change the title of the film to Voyage, but later relented and reverted back to the original title.

Michael analyzed the musical score using the computer and proceeded to draw a visual representation of the music track to mark all the important sync points (4).

The animation consists of dots moving through rhythmical and seemingly topographical landscapes.

Michael had to plot the paths of the dots so that they could be smoothly animated: 'For each moving dot I would draw its path, test it on the line tester (Take 2 on an Amiga), fine-tune and

2
storyboard

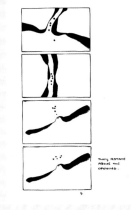

↑ →
The idea for the film comes to life through a simple storyboard.

3
preparing tea and background painting

↑ ↗
Michael creates the dye to draw each frame.

↑
Michael creates the titles and backgrounds for The Aroma of Tea using European and Japanese brushes, watercolour board and tea.

4
music analysis

translate the final result into an accurate path (1) for the Animo operator, Marc Schopman, to position the individual dots.

Each dot consisted of about ten separate dots that cross-dissolved into one another to create a subtle "live" effect.' Michael spent a couple of days with Marc in Antwerp, overseeing the completion of the film in Animo. He then went to Amsterdam to supervise the transfer onto 35mm film stock. The input of the film's sound editor, Nic Gill, was essential to the quality of the soundtrack.

The Aroma of Tea appears to be a relatively simple film, but Michael explains that visual simplicity often comes at a price: 'The backgrounds and movements look simple and easy, but because of the purity of the film, I could not hide any weaknesses behind a busy story, funny gags, fast timing or rich visuals. I discovered I had to spend more time than I predicted on the backgrounds and the animation to get them as close to perfection as possible. That was difficult, yet often also quite exhilarating.'

Michael is enthusiastic about the outcome of the film (5), and although he has had some mixed reviews from friends and family, he is driven to create more: 'The creative process was very inspiring. In the future I'll probably do what I have done so far: take plenty of time preparing a project, just daydream about it and do my research.

I expected mixed reactions and that's what the film has attracted so far. Not everybody likes experimental or semi-abstract films.'

Michael is clear about the benefits of working within a digital domain, even though the hand-crafted nature of his films are strongly apparent, as he concedes: 'The film would have been much cruder and probably unacceptable to me if I had not had access to digital technology. The finished product is available in digital format as well as on 35mm film. Both formats are excellent, but digital is definitely more versatile.'

Michael's advice to potential animators is clear: 'If the potential animator has never attended an animation festival before, I would say: go as soon as you can. The big ones, such as Annecy, Ottawa and Hiroshima, are good, but the smaller ones can be very good too. See amazing films, see flawed films, go to talks or workshops, and meet people. Many experienced animators are very approachable. If you wish to study animation, do some good research about animation courses first, because they can differ a lot. And if you have just graduated and you want to be a professional, please don't be too proud. If you can't find the perfect animation job, get a less than perfect one for a while, because even if you are extremely talented, there is a lot to learn. Finally, if you want to be creative in animation but circumstances don't yet allow you to be, try to be creative in related ways in the meantime, whether in drawing, writing, storyboarding, comics or poetry.'

Michael's advice about the skills and attributes necessary to be successful as an animator or director is equally thoughtful: 'An animator will mainly need to develop the following: curiosity, sensitivity to timing, drawing or modelmaking skills, and sensitivity to choreography, acting and drama. A director will need the same skills; however, being good at drawing or modelmaking is not always essential. A director will have to understand film language and he or she will need leadership skills. Most independent filmmakers will need the skills mentioned above and, apart from being creative, they will have to be technical to some degree. They will need the talent for conveying something special and in most cases a talent for storytelling. I would suggest that the following two qualities are of immense value to all creative people in the animation industry. They are obvious, but I believe they are too often taken for granted: the capacity for judging work critically – knowing within yourself when something is good or not good enough – and the capacity for asking for and listening to feedback from others.'

5
final film

↑ ↗
The film leads the viewer on a mesmerizing journey through an abstracted landscape of rhythmic topographical undulations and gentle peaks to the sound of Corelli's Concerti Grossi.

Mischa Kamp

Netherlands / submarine.nl

Bloot (Naked)

2006 / 00:00:36

In this series of six short films, animator and director Mischa Kamp gently and humorously documents the change in adolescent bodies of some Dutch teenagers who are going through stages of puberty. Using the technique of rotoscoping, each film sensitively portrays some often naive but frank observations while subtly distancing the audience from the true visual identities of the subjects and allowing their stories to be told without prejudice.

The source material for Bloot (Naked) comes direct from stories shot on digital video, playfully directed to enable the teenagers to feel safe confiding to the camera some of their most intimate fears and observations of a time in life full of unpredictable events and occurrences. The films have been widely praised for their openness and honesty, cleverly handled by Mischa's lightness of touch through the scripting and editing of each film that exposes an important empathy with her subjects.

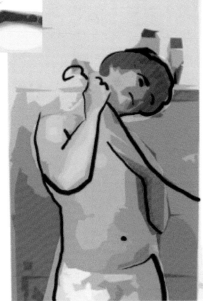

1
sketches

↑ →
Early treatment sketches for one of the film's main characters.

How did you become interested in animation?
I was working for a television programme called Waskracht. While working for the programme, we made short documentaries as well as collaborating with animators on bumpers and leaders. Later, Submarine Productions introduced me to the technique of rotoscoping and asked me to develop a children's series. That's how I came up with Naked. Seeing the technique of rotoscoping in the film Waking Life and other short films like the Figures of Speech series (itvs.org) also inspired me.

How long have you been an animator and director?
I graduated from film school in Amsterdam in 1996. I've been working as a director since then and Naked is my first animation series.

Who or what inspires or influences you?
Through animation I'm most inspired by the possibility of visualizing a vivid and personal story. For example, it is entirely feasible to create unique characters, many of them clearly recognizable and some of them 'bigger than life'.

Describe your studio environment.
I work as a freelance director and for Naked I divided my time between my own studio and Submarine.

What is your own personal definition of animation?
Animation is a perfect way to reflect the animator's world by using drawing and modelling techniques leading to a moving image. The creative process should result in images of the animator's fantasy world or their perceived reality.

Naked is actually a series of six mini documentaries, collected into a series that were originally aired on Dutch television channel VPRO Broadcasting. The series contains the titles: Breasts, Sweat, Hair, Sex, Menstruation and Heavy. Each film is six minutes in length.

For this project, it was essential to seek out interviewees who would be natural and comfortable in front of a camera and Mischa had to earn the trust of the teenagers she was interviewing, as she points out, 'I started the research out of my own office and made visits to various schools to meet and interview teenagers.' From these initial meetings, Mischa tried to let each of the individual subjects get to know her and feel confident that they had a story to tell and to make the process of collecting visual and audio material as discreet as possible through subsequent encounters. Her directing ability was able to make each of the participants feel suitably relaxed for her to coax and channel thoughts and observations on the subject into a substantial body of research material.

Having gathered material from these pre-arranged site visits, the process of editing and animation part took place at Submarine Production Company in Amsterdam as Mischa explains, 'Most of the animators were designing at the studios of Submarine although some of them were working from home.

Between research and shooting, I worked with the various animators to discuss what processes of animation was most suitable to illustrate the stories the teenagers wanted to tell." (1)

The process of rotoscoping was chosen to create the Naked series largely because the original digital footage could be easily appropriated as the basis for creating the work. From a production and economic perspective this decision made much sense, but importantly, the process allowed for a separate visual identity, which would not only tie the series together as a set, but also importantly preserve the privacy and the dignity of the films participants. This consultation process was an important factor in the creation of the film, but also in the subsequent success of the series in allowing other children to gain the confidence to speak more honestly about their own experiences without fear of persecution.

↑
Mischa's simplified line drawings, reminiscent of 1950s style line illustrations, make humorous observations of unexpected and embarrassing social situations that give an indication of the playful nature that the series Naked is shot.

↑
Early storyboard sketches and supporting notes reveal the basic story and suggest simple character movements and linked camera moves.

The rotoscoping process enabled the team of animators to trace Mischa's live action footage frame by frame. A rotoscope is actually a piece of projection equipment and traditionally, the technique has been used for animated cartoons where pre-recorded live film images were then projected onto a matte windowpane and redrawn by an animator. But with the advent and accumulation of more powerful computer platforms, rotoscoping on this project took on a whole new mantle although it is still a process that requires several pairs of hands and takes many hours to create a few minutes worth of film. From the live action footage, the animators at Submarine could trace the individual images to new digital film and the process brought a sense of visual authorship to the work in the form of a suitably teenage identity.

As software has developed, the technique of interpolating has become possible, where the space between the animated frames is 'smoothed' to eliminate any visual disturbance that might be encountered as the computer renders the material, particularly over a longer time frame where the density of material can be problematic without a large memory store. Clearly, this approach, while being digital in nature, owes more in spirit to the artist than to techniques familiar in more CG-orientated works. The ability to be able to draw, using a Wacom tablet and pen rather than a mouse, gives the skilled artist similar experiences to using traditional media and ensures a greater parity between traditional and electronic techniques of expression and delivery, especially important for this series. Flash was used as the software of choice to generate the images and the editing process was undertaken in Final Cut Pro.

The backgrounds and environments allowed for more creative freedom and playful expression, and as the images show, Mischa and her team made strident attempts to emphasize the emotive quality of the information that the teenagers were disclosing through the most appropriate and sensitive choices of colours, textures and surfaces (2).

The films have won awards in several children's film festivals and have been acknowledged for their directness and their ability to communicate effectively to an audience not wholly confident about being able to explain these emotions to their peers. Naked documents these changes for them sympathetically and, for a wider audience, the series importantly chronicles some of the social and emotional conflicts present in teenage lives in the Western world today.

↓ ↘
Character studies of Ilham, another of the films central characters. From the digital recording, a line drawing is made by tracing around the image and the face is painted in simplified tones following colour tests. Further experiments start to explore potential background and prop treatments on screen.

Julian Grey

Canada / headgearanimation.com

Forgetfulness

⊚ featured on DVD / 2005 / 00:01:45

As part of his advice to potential animators, Julian Grey believes that being able to work with other people, as well as being prepared to manage different parts of a job simultaneously, is a core skill that hopefuls should all have in abundance. It is a skill that seems clear-cut, yet many find it hard to put into practice. In an age when audiences perhaps expect increasing complexity, Julian believes that having this core skill enables animators to concentrate on communicating a simple story effectively. Forgetfulness is a good example of this, even though its outward appearance may at first seem rich and complex, visually and metaphorically layered carefully for the audience to unravel. This film is a sensitive and thoughtful portrayal of a curious and odd subject.

Made in collaboration with popular American Poet Laureate Billy Collins, Julian's film explores the effects of fading memory and middle age, told in a whimsical and evocative way. An example of a happy creative partnership born out of a commission from the Sundance Channel, handled through agency J. Walter Thompson in New York, Forgetfulness is an excellent example of using animation to evoke both conscious and subconscious feelings through the marriage of sound and image.

Long ago you kissed the nine Muses goodbye
and watched the quadratic equation pack its bag,
and even now as you memorize the order of the planets,

↑ →
The storyboard images demonstrate just how organic the process of creating the film was, with elements roughly collaged using photographs, paper cut-outs, paint-outs and coloured markers.

1
storyboard

something else is slipping away, a state flower perhaps,
the address of an uncle, the capital of Paraguay.

as if, one by one, the memories you used to h
decided to retire to the southern hemisphere
to a little fishing village where there are no p

↑
A detail from the treatment sheet explaining the overall visual feel of the film, together with additional handwritten notes by Julian.

How did you become interested in animation?
As a child I watched things like Norman McLaren's Neighbours, plus Looney Tunes, of course, and later more experimental stuff like Jan Svankmajer. The early days of MTV, particularly their groundbreaking Liquid Television, was also influential, and Peewee's Playhouse was a watershed for many animation techniques.

How long have you been an animator, director, producer, creator?
15 years.

Who or what inspires or influences you?
Travelling, French and Italian films, Agnes Varda, Rauschenberg, Picasso, the Dadaists, the great cartoonists, Saul Steinberg, Ricky Gervais and Stephen Merchant, and of course a glass of wine with my better half.

Describe your studio environment.
Head Gear Animation is based in Toronto, Canada. It is very much an art studio. It also happens to have a bunch of computers and cameras. It is an open concept allowing easy communication and sharing of ideas and music – music is always playing and is integral to the creative process; all genres, no crap.

What is your own personal definition of animation?
Observe what's around you and apply those observations to the creation of moving images.

Is your film funded?
No.

Explain how you came up with the idea of creating your film.
I am a director and partner at Head Gear Animation and I was available at the time to take this project on. I decided to choose three poems by Billy Collins from a big list provided by the agency. Each poem suggested different animation styles and approaches: Super 8 scratchy film as a metaphor for memory in Forgetfulness, erasing or painting out images, using little figurines for Some Days, and anthropomorphizing a hand and pen moving through the apparent jungle of a writer's desk for Budapest.

There was a token budget, but essentially this was a pro bono project.

A decision was made early on not to shoot actual film for cost reasons, so digital video was the alternative. A pencil storyboard was developed, based on the lines of the poem Forgetfulness (1).

An animatic was created of the drawings in Adobe After Effects, cut to Collins reading the poem. Julian worked quickly: 'The animatic is the most important phase as it determines how much source material you need for certain parts of the poem. I set out with a DV video camera and began to compile shots, like the seagulls at the marina.

I worked with a creative director at J. Walter Thompson, who signed off on the basic storyboard. However, it was very much a freeform entity at this point, and what I shot would determine how and why I would use certain images.' As the film took shape, Julian began making creative decisions, selecting certain shots then rotoscoping or cutting out frame by frame so they could be composited and combined with other images. Additionally, scratchy leader film from old Super 8 was composited on top of the images throughout.

Julian designed, shot, animated and did most of the compositing for the film. The process was, however, very organic and he went continually back and forth between locations, shooting more footage and watching it back in the studio, before roughly compositing the scenes in After Effects. Gradually, the film started to take on the spirit and evocativeness of Collins's words. Julian built and collected props, including the planets, flowers and books.

At this stage, certain elements such as the small paper boats were chosen to be individually rotoscoped. After this, the final compositing started and with it the opportunity to fine-tune masks, edging, positioning and the movement of subjects through the frame. From here, Julian collaborated with the composer to create a soundbed that could process Collins's voice to resonate with the faded grandeur of the imagery, as he explains: 'We wanted the sound to be scratchy, like it was being received through an old telephone handset, to suggest the anecdotal, distant nature of the poem.'

Following final approval from the agency, Julian tweaked the film in relation to colour balance and timing and then <u>Forgetfulness</u> was ready for colour-correcting at Technicolor Labs. Amazingly, the process of animation took only five weeks, from origination to pre-production, and Julian is quick to praise the team at Head Gear for their contribution: 'There are always people around to lend a hand or bash an idea around with. For example, I would go out with a couple of other people to shoot stuff, so I could have some feet in the shot or have someone hold a bounce card. I also had people helping with props, like the clock on the wall and the suitcase. Naturally, I used the acting talents of people working at the studio at the time, as well as the lovely Susan Armstrong, who appears as the person struggling to remember.'

<u>Julian is effusive about the experience of creating Forgetfulness (2),</u> saying, 'I would love to do more stuff like this. I have already pitched on a number of commercial spots that wanted to use this look and technique. They all fell through though, which is okay because none was a real fit. Again, the best application would be another poem or story.'

Julian insists there has never been a better time to be exposed to incredible things from all over the world, 'whether through travel, the Internet, festivals or books, it's all out there waiting to be absorbed. There is always the risk of overload, but that only happens when you yourself are not busy creating anew. You have to wring out the sponge pretty regularly...'

↗ →
These stills from the film exude the same spirit and evocativeness as Billy Collins's poetic soundtrack.

Computer Generated

Although they have evolved from more traditional methods, digital animation and computer-generated imagery have distinct characteristics that set them apart as an important and recognizable branch of the subject. The most obvious is that, unlike cel, drawn and stop-motion, the codes and conventions of creation and manipulation differ greatly. For example, the physical presences of gravity in cel and model variants have no natural place in digital animation, although of course an extra dimension in this hyper-reality can be constructed for them to be situated. The digital domain conceivably has no dominant physical form(s) and can exist in a further metaphysical environment, free from the constraints of using more conventional methods. In the right hands this gives true validity to the notion of groundbreaking work.

History has been kind to the computer. Starting off life as a mass of instrumentation occupying floors of buildings, it has physically shrunk and yet metaphorically ballooned into a device that pervades our day-to-day existence. From controlling the tedium of everyday operative situations, the computer is used in a far greater range of activities today, including the development of animation in a variety of forms through the lifespan of a project.

Interestingly, the birthplace in US military circles of the technology that we now know as the Internet was also the origin of digital and CGI animation. This is no coincidence. The use of such technology has, in the true pioneering sense of the animated tradition, been recognized, deconstructed, repackaged and appropriated to enable new ideas and stories to be told. We might think this technology has been around only recently, but actually it has a longer history.

From John Whitney and Motion Graphics Inc. and later Information International Inc (John Whitney Jr.), through creators such as John Stehura, Larry Cuba and Ed Emshwiller, early CG experiments leading to film were conducted through the 1960s and 70s. A true watershed in the method was conceived by George Lucas's teams. They would later form Industrial Light and Magic, and in turn would become the chrysalis for Pixar, through which mainstream audiences today are most familiar with this form of animation. The timeline from Stehura's Cibernetic 5.3 (1960–65) to John Lasseter's The Incredibles (2004) spans only four decades, yet the technical advances on the part of the creators and the parallel cognitive and perceptive demands on the audience cannot be underestimated.

For individual animators and filmmakers, through to large studios, the availability and accessibility of CGI tools has developed hand in hand with the creation of broadcast platforms, enabling the process of origination, development, production and distribution to become a possibility, if not a reality, for many. Software giants such as Adobe and Apple have increasingly sought the opinions of the creative industries in their quest to develop products that enable artists, writers and musicians to express themselves, but at the same time have cultured a level of opportunity and expectation with new tools capable of making other ideas a reality. Far from creating an aesthetic regime, the ability to listen to artists and empathize with their requirements has been pivotal to the intelligent development of software packages, through conferences, free trials, support in kind and creative partnerships.

The result is that an infinity of possibilities lies at the fingertips of potential creators. Whether it is an animated music video created in Flash for web distribution by a band, short animated sequences for smallscreen devices, or feature-length animated film, the possibilities of 2D CGI are being continually tested and exposed. While there is little doubt that in a commercial context the development of certain program functions to 'in-between' and cel paint have reduced the amount of physical labour in the pre-production arena, many critics argue that films created with this approach feel synthetic and lack conviction. This view suggests that CGI tries to ape the 'reality' of the photographic image, when in fact much of the more distinctive and memorable work tries hard to distance itself from that particular aesthetic.

Provided that creators have the basic tools, a myriad of creative possibilities await. Of course, technology provides only the support mechanism; there is no substituting creative flair and imagination in the role of content. Originality of thought is paramount in the creation of memorable work, as the filmmakers in this section convincingly illustrate.

Motomichi Nakamura

Japan / motomichi.com

We Share Our Mother's Health

2006 / 00:03:30

The Knife, a Swedish band formed by Olof Dreijer and Karin Dreijer Andersson, commissioned Motomichi Nakamura to create a video for their 'very hysterical and mainly panicked kind of song' We Share Our Mother's Health, released in June 2006. Their work has been described as 'burbling electro groove' (Craig McLean, January 2006) and they maintain a distance from mainstream bands by releasing material through selected publishers such as Rabid Records in their native Sweden, Mute (USA) and Brille (UK). They have performed live on only a handful of occasions, most notably at London's ICA and in Manchester. Their decision to commission animation rather than release videos of performance comes from the complex decision-making process surrounding how to best capture electronic form visually.

Motomichi's work is in the graphic idiom. Whether creating paintings such as his 'Monster' series, or designs for giant inflatable ambient advertising pieces for Need For Speed, his work is characterized by the dynamic use of graphic symbols juxtaposed against a limited and direct colour palette. In We Share Our Mother's Health, this direct, often raw, approach works hand in hand with The Knife's shrill lyrics and claustrophobic synthesized sound to create a cacophony of abrasive tension.

How did you become interested in animation?
I studied Illustration at Parson's School of Design in New York, after leaving Tokyo. To be honest, I simply wanted to see how my illustrations and characters looked when they were animated, so I started animating.

How long have you been an animator, director, producer, creator?
I started animating when I was in school, so I have been doing animation for about 11 years.

Who or what inspires or influences you?
I love Michel Gondry's music videos. I'm also inspired by raw art.

Describe your studio environment.
I have a studio located in Tribeca in New York City. I work with two interns who help me out with various tasks such as errands, promotion and some production work.

What is your own personal definition of animation?
It's one more way for visual artists to communicate ideas.

Please provide a synopsis of your film.
The animation starts with a girl waking up from a long sleep when an apple hits her. She then starts a journey where her nightmare and her reality becomes one. During her journey she is constantly watched by birds and by an unknown character who's locked in a building somewhere and who is in pain. He is trying to communicate with her. At the end of her journey she gets to keep the apple.

Is your film funded?
Yes, the band commissioned the film.

Motomichi discussed the themes and issues behind the song with the band, while they listened to the track together. 'When the band first sent me We Share Our Mother's Health, they told me that the song is about things that go on in your family that you can never escape. Sort of like a disease that locks you up and remains deep inside you. They were looking for something visually extreme and conceptually dark that would reflect this idea.'

The track conveyed feelings of anger and pain for Motomichi, so he decided to use those emotions to develop a concept for the animation. The intention from the outset was to create something very aggressive but that was communicated in a rather suggestive way, much like what we experience in nightmares.

Motomichi describes this recollection: 'when you have a nightmare, the location where you are is often vague but at the same time it can feel very real. To achieve that atmosphere, I decided that I needed to use a lot of close-up shots so that you could see clearly what's going on visually, but you can't really tell where it is happening or how each scene relates to the main story. I also decided to leave a lot to the imagination by leaving the "action" out and instead showing what happens either before or after the action took place.'

For this project, Motomichi took on the roles of character designer (1), animator and director, following his enthusiasm to be involved with different stages and roles of the process.

His interest in the project invaded nearly every part of his daily life: 'I started off by listening to the music track over and over, while in the subway, even in the bed before I went to sleep.'

1
character design

The origination process began by simply imagining key frames (2), such as the very first visual, which became realized as a giant bird flying over a city.

Drawing directly onto the screen in Illustrator, he then developed a masked character who is locked in a small room in a building, and from that developed the girl as the lead character.

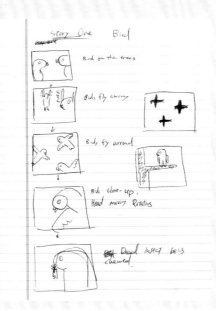

↙
Further felt-marker drawings of trees, which are stripped back to their bare essentials to create the powerful graphic statements that are so intrinsic to Motomichi's work.

The band then suggested using images of medical instruments (3). Somewhat fortuitously, Motomichi happened to be undergoing nasal and septal surgery while working on the storyboard phase, so was inspired to include medical instruments as part of the animation. Their cold, clinical presence and the nonchalant way in which they appear to be handled help set the visual mood of the piece.

Motomichi wanted the audience to be able to follow the story when watching the video, but he didn't want the story to be too literal and linear. Instead, he decided to come up with a completely different story for each character, then mix and shuffle these separate stories into one storyboard.

For example, the original story for the giant birds has them just flying by but after mixing this with the girls' stories, the birds fly by and then pick up the girls' heads, thus mixing two different component narratives into one. This direct process also enabled Motomichi to control the balance between sound and image.

3
medical instruments

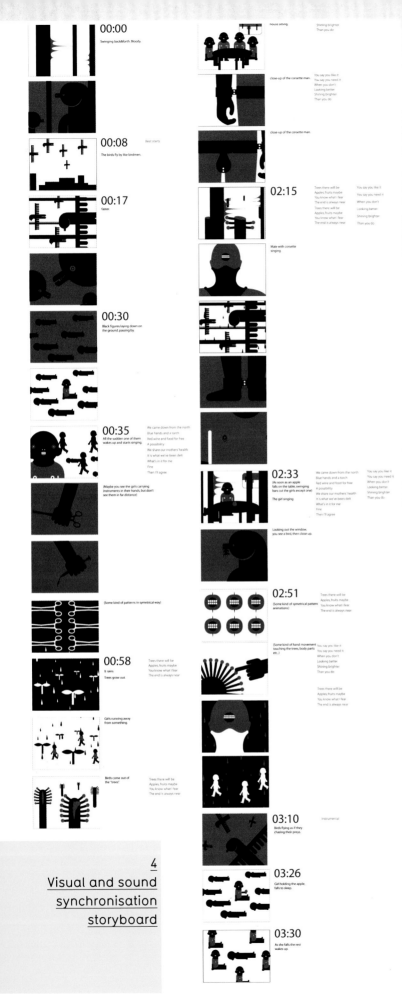

4
Visual and sound
synchronisation
storyboard

In order to make sure that the visuals were in synchronization with the sound as much as possible, he imported specific sound clips into the timeline in Flash (4) from the very beginning and animated along with it, magnifying the timeline view of the sound so that he could visually tell the movement of the sound.

The animation was fully created in Flash 8, but once it was completed it was exported as a QuickTime file without sound. The movie and the music were then imported into After Effects and colour-corrected for broadcast. Indeed, every part of the process has Motomichi's fingerprints all over it, with the exception of transferring the files to Beta tape, which was undertaken by a post-production house. In all, the film took just two months to complete.

The experience has been productive and inspiring for Motomichi. Since completing We Share Our Mother's Health (5), he has created other animated shorts such as Journey of Puro and 101 Video Ringtones, as well as a whole host of character-related projects. This entrepreneurial approach is set to continue.

'I have some ideas for new animations in which I'm planning to use a similar storytelling technique, but I would like to further develop each character and to enhance the interactions between the characters. I think people are more and more exposed to animation and films because of online portals such as YouTube. I find that very inspiring because, for the first time, people can choose what they really want to see anytime they want. One thing I love about online content is that some of the work can be very personal and chosen by viewers for very particular reasons. Since my work is based on very personal feelings, I find that current trend very inspiring.'

Motomichi is rightly unapologetic about the role he believes technology plays in his work, largely because it helps his work retain a very personalized feel. 'I think without technology, it would be very difficult for me to create something like this just by myself, because of the huge amount of production involved. It's also very important for me to be able to have total control over each step of the production, since I use many personal elements in my work and the ability to utilize and unleash technology allows me to do that. I wanted the audience to feel very uncomfortable when they saw this film.'

Paul Bush

UK / paulbushfilms.com

While Darwin Sleeps

◎ featured on DVD / 2004 / 00:05:00

Describing himself as a filmmaker rather than an animator, Paul Bush admires artists who work with honesty, intelligence and humour. <u>While Darwin Sleeps</u> echoes these sentiments perfectly. More than 3,000 insects appear in this film, each for a single frame. As the colours glow and change across their bodies and wings, it is as if the genetic program of millions of years is taking place in a few minutes. It is a rampant creation that seems to defy the explanations of evolutionists and fundamentalists. It is like a mescalin dream of Charles Darwin's.

The film is inspired by the insect collection of Walter Linsenmaier in the Natur-Museum of Luzern in Switzerland. As each insect follows the other, frame by frame, they appear to unfurl their antennae, scuttle along, or flap their wings as if trying to escape the pinions that attach them forever in their display cases. Just for a fleeting moment, the eye is tricked into believing that these dead creatures still live.

↓ ↘
The Natur-Museum in Luzern, Switzerland, provided Paul with some fascinating source material to trigger the creation of <u>While Darwin Sleeps</u>.

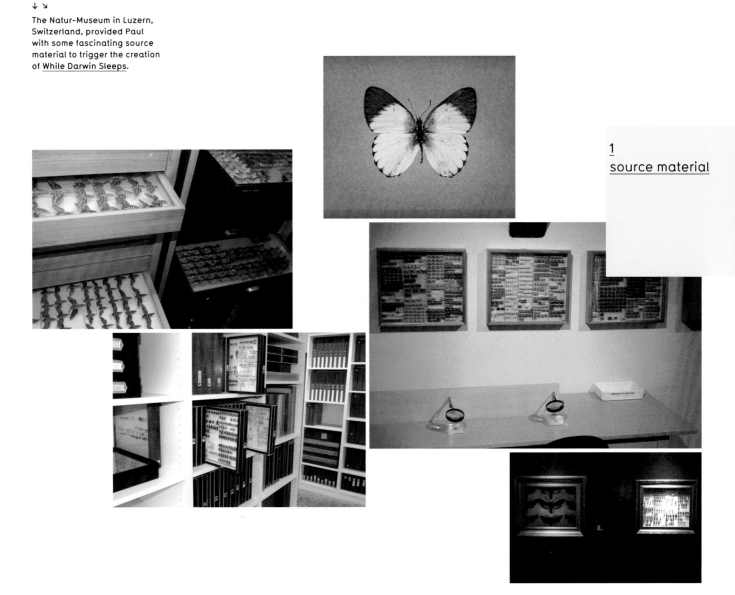

1
<u>source material</u>

How did you become interested in animation?
By chance I had an idea in 1992 for a graphic technique in which I scratched frame by frame on top of images of wood engravings, and I was commissioned by the Arts Council Channel 4 Animate! scheme to make my first animation, His Comedy.

How long have you been an animator, director, producer, creator?
I left art school in 1978 and have worked since then as an artist/filmmaker.

Describe your studio environment.
I work in a studio at home in London, but in this case most of the work was done on a laptop while I was teaching in Switzerland and travelling between there and my home.

Is your film funded?
It was not funded but at the time I made While Darwin Sleeps I had a fellowship from Nesta (National Endowment for Science, Technology and the Arts), which meant I had the time to work on this film without being paid.

Explain how you came up with the idea of creating your film.
The project came about when I was teaching a film course in Switzerland at the art school in Luzern. I set a project for students to bring in a favourite collection of theirs, to film these objects and then make a short film where they tried to communicate to the audience the pleasure they got from them. They made really interesting films and I thought I should have a go myself, particularly as I was stuck a long way from home with nothing much to do!

I'd heard there was an amazing insect collection in the Natur-Museum and I asked permission to film it, which the museum granted (1).

Paul worked with the museum's curator, Marie-Christine Kamke, spending two days photographing as many insects as he could with a digital movie camera. As he had to film them in the display cases, it was vital to input the images into the 2D animation program Mirage and remove the backgrounds digitally. Paul ordered the insects in sequences in which they appeared to move and change smoothly and placed the sequences on artificial backgrounds, with each insect appearing for just one frame. This process created the majority of the image material. While the shooting of the material happened quite quickly, the cataloguing took far longer, as Paul tried to edit images together that were as similar as possible. This process needed careful selection as any single frames that were disproportionate, whether in size or colour, would create a jarring effect.

The process took a year, alongside other projects, and large parts of it were conducted working on a laptop on trains and waiting in airports. It could have been made conventionally on film in a number of ways, but this would have been slower and more cumbersome and Paul would not have been able to do it while travelling. However, this process enabled Paul to think about how the material could be edited. 'After I had the bulk of the film, I had some other ideas and went back to the insect collection to film some more images for the beginning and the end of the piece. My sound designer, Andy Cowton, had made some recordings in a museum including a rather dull talk by a tour guide, so I decided that the film should begin a little like an educational film. We should hear humans talking about insects and see them as we normally look at them in museums, in their cases.'

As the soundtrack continued, the intention was to move closer into the insects and begin to 'see' and 'hear' the insect world. The film succeeds in creating an altered state, where the audience move between documented and imaginary worlds, transported by the mesmerizing, fluctuating imagery and the abstracted drone of the soundtrack. The end of the film coincides with the audience being returned back to the human world as if nothing has happened, no time has passed, supported by the seeming continuity in the narration.

Paul wrote the sequence and recorded a retired head teacher for the voiceover. Although the film was shot on mini-DV, it was transferred to 35mm deliberately in order to get wider distribution; around 20 prints are currently in circulation.

While Darwin Sleeps is of course shown on all the new broadcast platforms too, but it's not dependent on them. Paul found the process liberating (2).

'I find that making a piece of work always inspires me to do more, as other ideas come out of the process. When you don't work, or have difficulty, then it just gets harder and harder, which is a situation parallel to writer's block.'

Paul is, however, less than convinced of the current state of animation in his home country. 'The financial climate is terrible and this lowers the morale of all people working in the animation industry, but particularly the independent section. The UK was probably the world leader in innovative animation up until a few years ago, but animation departments at Channel 4, S4C and BBC all closed within a few years. Government money was consolidated into one organization, the Film Council, which has shown little interest in animation, and the effects are already noticeable in the quantity and quality of animation being created.'

Frank Flöthmann

Germany / 2-f.de

PingPong

◎ featured on DVD / 2006 / 00:02:22

Berlin-based illustrator and animator Frank Flöthmann's series PingPong originally began life as a static comic, with various off-shoot enterprises including posters, but with the advent of MP3 as a format for music and image, quickly developed a digital presence. The development of video capabilities using this kind of technology enabled Frank to not only design, but also publish and distribute PingPong widely and the series has been an instant hit around the world ever since.

This particular episode of PingPong, A Walk in the Park, creatively utilizes the advantages as well as the limitations of the platform, using scripting techniques similar to silent films of the past and limited colour to communicate the simple ideas, using a mixture of programs like FreeHand MX and Snapz Pro. However, this isn't really about technology, it is about a creator who is first and foremost a very good storyteller. If you're reading this and someone is listening to their iPod sniggering away to themselves, chances are they are watching PingPong.

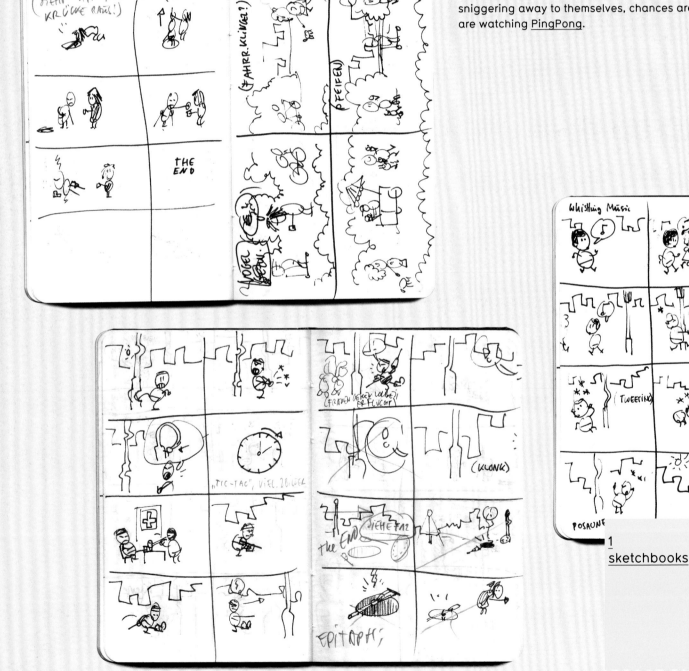

sketchbooks

How did you become interested in animation?
I've just always loved animation since I was a child. When I studied graphic design we had animation classes and went to animation festivals. That's where we made our first stop motion films.

How long have you been an animator?
I've been a professional illustrator since 1994. I started making animatics and animations in 2005.

Who or what inspires or influences you?
My main artistic influences are probably the great new ligne claire comic artists and illustrators, like Ever Meulen and Joost Swarte. My Inspiration comes from 'quality' television, the city that I live in and talking rubbish with my best friends – not necessarily in that order!

Describe your studio environment.
Some friends and I share an old apartment as a workspace. We have separate rooms so they can close their doors when I start fingerpicking my guitar while restarting my Mac.

What is your own personal definition of animation?
Provoking the illusion of as much motion as necessary with as few means as possible.

Frank describes the motivation for making PingPong as, 'trying to tell an internationally understandable story.' Most of the films in the series involve very personalized observations that he believes will strike a chord of familiarity with viewers, irrespective of their cultural or social background.

These observations became starting points for Frank, and the ideas that he had were drawn quickly in various notebooks back in his studio (1). The sketches were never detailed because the important elements were always going to be described using graphically simple shapes and symbols. It was the spirit of the storytelling that Frank tried to capture as he doodled frame by frame (2).

The sketchbook format allowed Frank to play with the drawing compositions and the narrative style and pacing of his short films without needing to commit anything to screen. This playful air helped retain a freshness and vibrancy to his storytelling and gave each episode a charming sense of immediacy with its audience.

↙ ↓
Double-page spreads from Frank Flöthmann's pocket-sized sketchbooks showing the initial drawn ideas for the PingPong series, capturing the essence of the ideas as keyframed sketches.

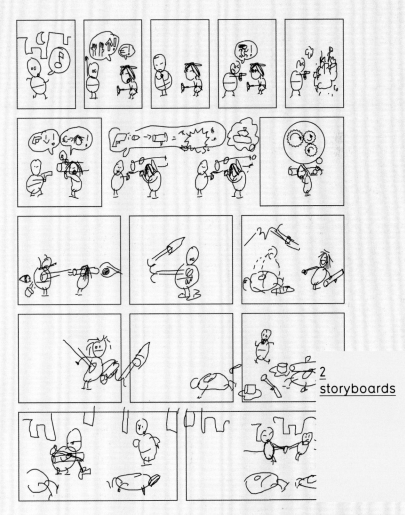

2 storyboards

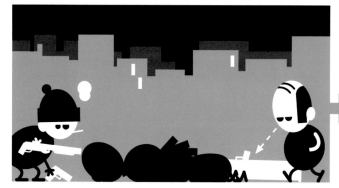
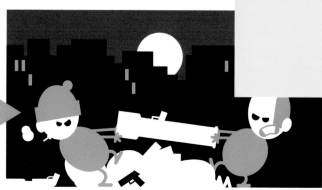

←

Having created the story, Frank's visual language is multiplicitous – in this case, a poster for the film.

↓

The 'common currency' of the film is highlighted in the exuberant use of familiar graphic symbols and facial expressions to elicit the correct response from the audience.

Each frame of the animatic was then drawn in FreeHand MX, in exactly the same way that Frank creates his illustrations.

Essentially his work for PingPong is like piecing many of his illustrations back to back as a stream of moving stills (3).

Frank made the entire soundtrack for his films too, using Apple's GarageBand and looping material together. Since there is no narration, the soundscape that he created needed to retain the simplicity of the images but also create emotional tags to which the audience can respond.

To produce the film, Frank simply imported the visuals and the sounds in QuickTime Pro. Equally easy was the publishing of the material in iTunes Music Store using clickwheel.net. It is perhaps not surprising that Frank is pretty attuned to the possibilities of technology although he knows it has its place,

'99.9% of PingPong is made digitally, and without the technology the series possibly wouldn't be so easy to craft, but for me it is the drawing skills, an extraordinary feel for timing and motion, an aptitude for storytelling and the urge to create something original that are necessary to work successfully in this field.' (4)

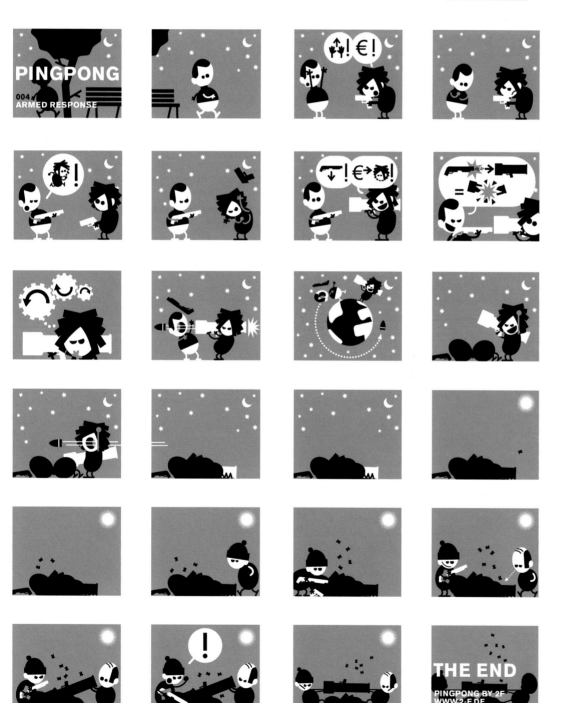

4
final film

59 / Frank Flöthmann

Jerôme Dernoncourt
Corentin Laplatte
& Samuel Deroubaix

France

Once Upon a Time

featured on DVD / 2006 / 00:05:37

An animated triumph of some meticulous planning with regard to pacing, Once Upon a Time is home to a bizarre and somewhat surprising adventure playground of steam-powered vehicles, a cameo appearance by Henry Fonda, some very rickety structures and an unlikely hero in the shape of Saut Bande who all conspire to prove that experimental animation can sometimes have little or no logic. Indeed, in this graduate film, created by Supinfocom-educated animators Jerôme Dernoncourt, Samuel Deroubaix and Corentin Laplatte, the celebration of all things improbable seems to last longer than the five and a half minutes of the film's duration.

As we thunder across the wild west in an ever-increasing gluttony of transportation devices to gain the affections of an unlikely treasure in the guise of Shirley Temple, the film mixes modern 3D CGI with some primitive cut paper animation skilfully as a way of whisking the audience through an enchanted world of possibility, evoking the sense of discovery and a pioneering spirit not dissimilar to the world of the Western, where this film derives many sources of inspiration. Here, animator and director Jerôme Dernoncourt provides an insight into the film's origins and two-year development.

1
character and
prop design

How did you become interested in animation?

I would say that animation was a form of enlightenment for me. I am quite accurate, curious and imaginative. I loved drawing as a way of capturing these thoughts. The more I was studying the more animation became a serious proposition for me as it could, and still does, allow me the freedom to develop my own universe. It gives me that freedom to transcribe my emotions. Certain people paint, write books or are comedians. My way is through animated films.

How long have you been an animator?

I've been involved in creative projects for seven years but I have dedicated only three of those years to animation, as a director and animator. Before directing my first film, I studied graphic design and have been in charge of the scenography on different projects. I would say it is a classic way. We start creating stills and then we want to see them move...

Who or what inspires or influences you?

People I meet randomly in the street usually inspire me. I am very observant and I often imagine situations when I see something or someone. It is like dreaming awake. I am also very influenced by all kinds of cultural expressions, whether that is cinema, comics, painting and contemporary art with artist such as James Turrell. I do think it is very important to keep an eye open on everything relative to the picture, technically as well as visually. That's why having a strong knowledge of history of art helps. Images that we create must be a reference for everyone, and then we can put our two cents in.

Describe your studio environment.

In Supinfocom, you can't do anything but work. You are in the middle of nowhere and to reach the deadline you have to work usually between 9am and 11pm everyday, including the weekend. The class is composed of 48 people divided in two different groups: the first will be taught a specific 3D software, such as 3D Studio Max; the second one will be taught another software package like Maya. This is the only difference between those two groups. Otherwise, the course is the same for everybody. We have one machine per person and an Avid station for the edit. Usually everybody is friendly! Supinfocom is in partnership with Supinfogame, a school dedicated to video games and the ISD, while a third school is devoted to industrial design. That makes things interesting. We can share our skills and experiences. Even if the furniture is not new-fangled, what makes the university interesting is the people.

What is your own personal definition of animation?

For me, animation like every other form of art must convey emotions. Animation is no different to live-action movies in many respects, although we have far more creative license! We can create universes that can be either singular or complex with fewer means.

In order to understand the creation of Once Upon a Time, it is necessary to appreciate the curriculum and the resulting timeline at Supinfocom. As part of a two-year programme, students spend the first year working on the pre-production and learning using industry standard tools such as Maya and 3D Studio Max, that eventually will be applied to their graduation film. As this technical teaching is conducted, students in their first year are also required to develop scripts, and encouraged to explore the visual substance of their films, enabling a basic 2D animatic to be created, that will then allow creation and production of the film in their final year.

Corentin came up first with the idea of Once Upon a Time as a way of encouraging experimental animation processes by mixing elements of live-action and 3D CGI in an original way.

He came across some significant reference pictures of surreal handmade machines created by a street art company, the Royal Deluxe Company that both Jerôme and Samuel liked, and the three decided to work as a team buoyed by this combined interest. Part of the Supinfocom curriculum dictates that all students will have a chance to direct their own film, so each student was required to present a synopsis at the beginning of the first year, that was then subjected to an internal jury, as Jerôme continues, 'So we teamed up to develop the script, with each of us bringing a part of his "universe" and we tried to do something that was reflective of our own personal interests but that was also collective. Our common goal was this eagerness for mixing techniques, and to that end we used cut paper animation, live footage and CGI. We were influenced by short films like Copy Shop by Virgil Widrich and commercials by Antoine Bardout-Jacquet for Honda, where we assist in a chain reaction made from car pieces.'

This idea of linked and kinetic processes appealed to Jerôme, Corentin and Samuel as it gave the opportunity of working outside a conventional narrative structure, creating instead something that could exist through an ambiguous turn of events, as Jerôme explains:

'there was a chance to do something absurd but poetic, not unlike that found in Javier Fesser's films, where the actions are coming in rapid succession without any real link. Our characters are swept along by the action more than they create it.' (1)

The look of the film was something that came about after much discussion between the three animators, 'Visually, we wanted a "do-it-yourself" look, mixing everything we could to create a world by extracting elements from their context, like Shirley Temple and other live footage, but also designing backgrounds by combining multiple layers of footage from different films.

As most of our references were <u>old pictures and films (3)</u>, it became apparent that our film could work successfully in black and white.

As part of a later decision, we kept a touch of colour specifically to structure the image and direct the audiences' attention to particular elements or components that might aid meaning. We also applied this concept for the soundtrack by extracting sound from movies and piecing them together, before modifying them to achieve the final score.'

The three spent the following weeks developing the script, <u>trying to bring new ideas and coherence to what they were doing (2)</u>.

The initial look of the film was drastically different from what it is now, feeling distinctly like more of a time trial. Corentin, Jerôme and Samuel decided that they needed to chose a live-action genre that was going to ignite and sustain their interest, but also allow their original ideas to develop, as Jerôme explains, 'When we mentioned Western we had a lot of ideas for our 3D characters.

We watched as many films as we could lay our hands on, paying particular attention both to the soundtrack and to the shots, where we could use backgrounds from that footage to create our own landscapes. So we rented every film starring Shirley Temple and painstakingly analyzed every single shot, one by one, to get the perfect facial expression and camera angle. We knew this step was very important for us and would make our integration with later CGI elements easier.'

↓
An inventive approach to creating a synopsis – here a series of visuals does a handy job of explaining the outlandish nature of <u>Once Upon a Time</u>.

2
developing
script/synopsis

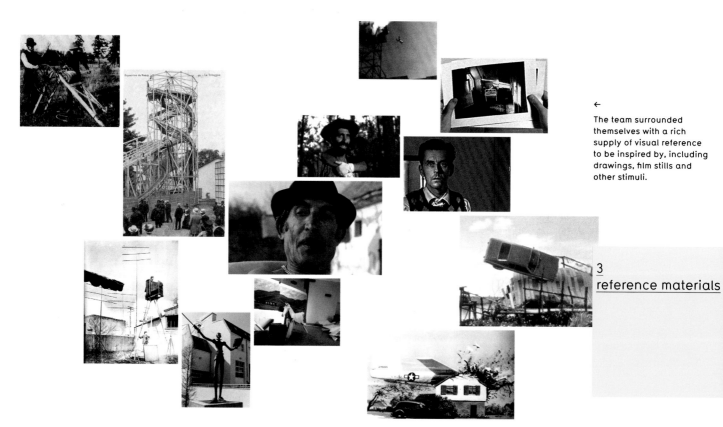

←
The team surrounded themselves with a rich supply of visual reference to be inspired by, including drawings, film stills and other stimuli.

3
reference materials

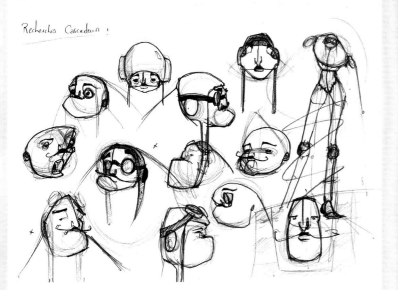

Recherches Cascadeur :

In parallel, the three designed their environment for the film to be set with Jerôme taking responsibility for the characters (4), while Corentin and Samuel designed vehicles and other essential props.

This 'hands on' process allowed them to test different techniques of construction that they wanted to use in the film, such as cut paper animation, and in doing so they had great fun manipulating the properties of the materials, as Jerôme states, 'We tried to explode paper with firecrackers – it worked very well – almost too well! The blending and mixing of animation techniques was certainly one of our interests while doing this film.'

4
character design

↑ →
A selection from a larger series of images depicting the gradual development of the stuntman's stature, facial characteristics and intricacies.

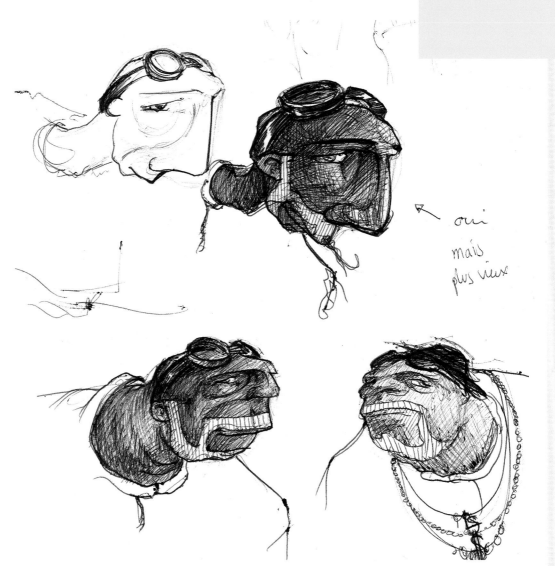

oui
mais
plus vieux

↓
From the drawings, the character of the stuntman was developed through a clay model that allowed the character to come to life in three dimensions.

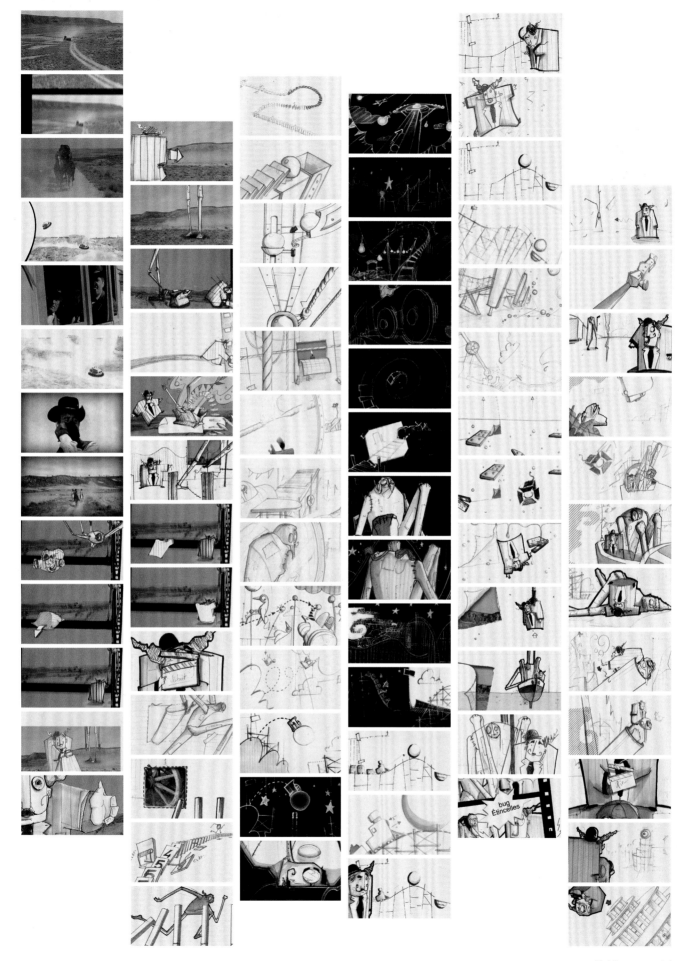

The tests eventually manifested themselves as first one storyboard, then another (5), until there were a series that needed refining, with help from tutorial advice and other students creative input.

After achieving a final storyboard that each was happy with, Samuel, Jerôme and Corentin added a soundtrack and animated the stills to create a 2D animatic so they could work on the timing and check that everything was coherent. The animatic revealed the pacing was out and the three were advised to directly work on a 3D animatic, as it would be easier to work with the roughly animated elements, the montaged backgrounds and the CGI components all in one.

5 storyboards

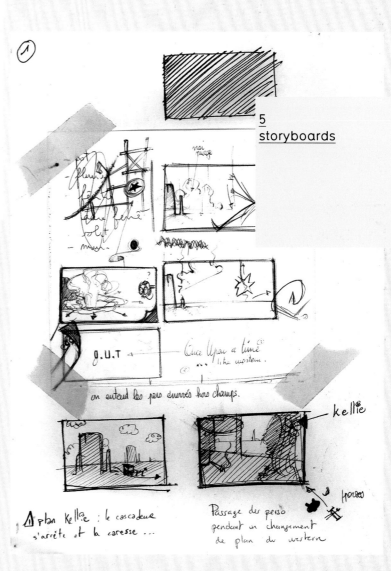

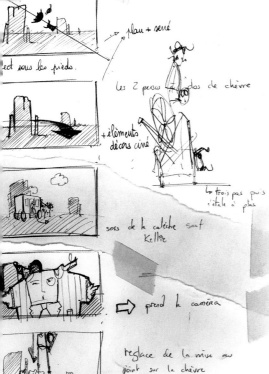

It also meant that once the animatic had been properly timed, finished sections could be dropped over the rough structure without any loss of structure, flow or, crucially, pacing. During this phase, the three decided to cut nearly 80% of the films original ideas planned out in the original storyboards with the result that the subsequent edit makes the film more dynamic and striking.

In particular, the characters could be positioned along with the camera in order to match the camera moves taken from the live footage, creating a tangible sense of ownership between the materials (6). By November 2005 the rough 3D animatic was finished, and the proper production stage could begin in earnest.

The relief of completing the animatic was tangible and the three could then begin to finalize the characters. Over the next two months, the modelling, rigging and skinning for the character of the stuntman was undertaken by Jerôme using Maya, while Samuel and Corentin treated the director in the same way. All of the team worked on the background elements.

This process was not without its complications, largely as a result of a shortage of technical knowledge, as Jerôme concedes, 'Actually we needed a lot of help. Although we were quite sure of what we wanted to do artistically, we needed help to realize our ideas. Despite having been taught a good deal of 3D software, most of us barely knew what a polygon was, yet we had to deliver a 3D film only a few months later! So help came from every student in our class. When someone had an issue, another student had usually had the same problem before and had normally found a solution. This is how Supinfocom works. Some people worked with us on the sound while someone else did the final title because we were very late.

We also took a lot of objects from the other films with the lovely benediction of their directors and friends, for example, the final sequence when the background explodes and objects are falling from the sky. We didn't have the time to model most of the objects so we borrowed them (7). Besides, it was part of our concept to mix and recycle things.'

6
character positioning
and lighting

7
borrowed 3d objects

With two working on the animation, the third member of the team was responsible for rendering the film as material was finished, and the production process was completed in June 2006. This part of the process required close collaboration to allow the shots to come together and certain key decisions were taken, including animating the shots and rendering them in multiple layers in order to have more control in the post-production stage. Jerôme and Samuel had kept in mind the soundtrack that Corentin finalized at the end of the project, but the three had a precise idea of what it should be from early on in the process. In the last step, smoke effects and live footage were added and the three worked on the film grading, as Jerôme explains,

'When we had a shot ready we replaced it in the animatic to be assured everything was right. <u>And little by little the animatic became the finished film (8).</u>'

Jerôme is full of praise for the education he received through Supinfocom, from both his tutors and fellow students, although he warns it is not an easy ride, 'the internal jury gives you advice all along the course and helps you to keep a fresh eye on your project. It is the same with your close friends, who can do something totally opposite in an animated sense, but they will always give you interesting comments on your work. When you work 16 hours a day, seven days a week on a film you may lose both yourself and your objectivity. So it is important to get help either to do stuff or just to have an opinion.'

8
final film

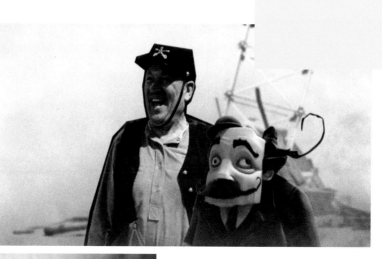

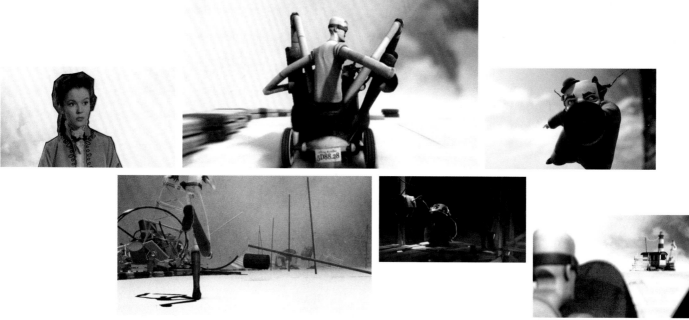

Lycette Brothers

Australia / lycettebros.com

dConstruct
◎ featured on DVD / 2006 / 00:00:21

I Ride Over Alphabet Town
◎ featured on DVD / 2004 / 00:01:10

Cinebugs
◎ featured on DVD / 2005 / 00:00:43

Birdcage
◎ featured on DVD / 2004 / 00:01:10

John and Mark Lycette, from Victoria, Australia, cite references as broad as Mickey Mouse, King Kong, a naked woman, Adolf Hitler, an old cassette tape, a skull, the roof of a mosque or temple, a snowman, a film projector, an ET-like alien, a man in a top hat, a car, Ned Kelly, a modernist sculpture not dissimilar to a Brancusi, a cartoon head and a Star Wars stormtrooper in their making of the film dConstruct. This eclectic approach embodies their work and is continually referred to by the brothers, especially in their projects created for mobile devices.

Cogs, mechanisms and nature are recurring features of Lycette Brothers' animations. The fascination with mechanisms is partly due to their appreciation of machines and the aesthetics of mechanical motion, but also to the nature of working efficiently within Flash, where the reuse and repetition of elements and the reduction in keyframe animation is desirable. The works reveal a desire to combine the natural and digital worlds, enabling audiences to see that even though they use technology to make images, they still talk about and reference the central things in life that we are about, namely nature and the world we live in.

Here also showcased are the films Birdcage, I Ride Over Alphabet Town and Cinebugs.

1
dConstruct

How did you become interested in animation?
Through studying graphic design, which led to learning about designing on computer, animation became accessible and more easily achievable.

How long have you been animators?
Professionally about ten years, but we grew up together working on creative projects; endless street scenes drawn on reams of computer paper, tree-house construction, go-carts and murals.

Who or what inspires or influences you both?
Many things. Nature and the environment are consistent influences, as are machine devices and antique objects. Artists and designers who inspire us include Patrick Woodroffe, Escher, Abram Games, Malcolm Garrett, Neville Brody, Vaughan Oliver, Edward Wadsworth and the Russian Constructivists. We are also inspired by comic artists like Daniel Torre, Hergé, Mobius and we like anime and manga created by Hayao Miyazaki.

Describe your studio environment.
Our studio is usually pretty messy. There are many books, magazines, objects, stickers, folders, postcards, computers and paraphernalia, drawings, etc. We surround ourselves with as many creative references as we can.

How do you expect the audience to react to your films?
We probably expect audiences to react the same as we do to our work. We get a buzz when we feel that a work has that extra element that we did not expect or identify in the beginning because it carries a subconscious message or intent that stimulates an emotional reaction. While not always present, it is a common goal and if you strive for detail and quality you usually do achieve it, we find. Audiences are hard to please, but we like to think that if we ourselves are the hardest audience to satisfy then most people out there will feel the same. The projects themselves have different goals in terms of audience reaction.

John and Mark emphasize the importance of allowing ideas and the development of the visuals to intersect.

For dConstruct, an important challenge was to experiment with ways to make 'efficient' computer-made animation, specifically using Flash software, as there was scope to explore the creative opportunity that limitations offer. John states that, 'making content for mobile phones is perfect for us – we have a long history of making creative work limited by file sizes and bandwidth – we seek to strike a balance between aesthetic taste and the necessity for small file sizes.'

This process required the ability to work creatively between the boundaries created by software knowledge and the technical, conceptual and functional requirements set by the client's brief.

Based on past experience and creative experimentation with the software, John and Mark identified the creative offerings of the 'shape tweening' option in Flash (1).

The software automatically generated interesting random shapes and forms, as a limited palette of simple shapes was used to construct the graphics to morph between. This was then further rationalized by converting the central morphing frame into a single keyframe, subsequently deleting the other frames. This method has the benefit of maintaining the visual morph effect and reduces not only the number of frames, but crucially, the processing required and the resultant file size.

The creative brief for dConstruct was to portray the diversity of the arts organization that commissioned the film in a short and sharp manner. It explored the concept of 'media' by its reference to many images representative of many media spaces and places, and their natural and unnatural connection in a visually saturated and globalized world as they morph from one to another. Mark did most of the animation and audio production for dConstruct, as its style evolved from his experiments. John developed the typographical titles and had input about how it would start, with the graphics emerging from the sides, what objects to include or exclude, the colour palette and the final editing including the length of holds, and so on.

←
Using the 'shape tweening' option in Flash, the software automatically generated interesting random shapes and forms that were used to construct the graphics to morph between in dConstruct.

→
The principle of keeping things simple is thoroughly tested out when designing for mobile content.

← ↙

The whale, fish, squid and seahorse were made from scanned objects such as colanders, electrical items, engine parts, cogs and keys.

I Ride Over Alphabet Town was somewhat different. Mark and John were provided with a photograph of a person sleeping, and a brief to visualize what they were dreaming of. The title of the campaign was 'Diesel Dreams'. The initial concept proposal stated: 'She has been studying in the sun, making occasional notes as she scours the many references. There is a slight breeze and her papers threaten to take flight. The pages of text and many literary images begin to dance in her mind as she falls asleep.'

The brothers landed the commission from KesselsKramer after the agency saw their animation series Not My Type and wanted them to make something like that. They agreed, but also wanted to add new ideas by including some colour elements to contrast with the graphic style of Not My Type. The concept and method of production were developed jointly, with Mark originating, sourcing the materials and making the fish characters in Photoshop from the scans of the objects.

The sealife, such as the whale, fish, squid and seahorse, were made from scanned objects such as colanders, electrical items, engine parts, cogs and keys (2).

**2
I Ride Over
Alphabet Town**

John developed and illustrated the two-dimensional characters and backgrounds. He then edited and animated the bulk of the characters, background elements and camera movements, while Mark created some of the internal movements of the seahorse and squid. Aaron McLoughlin provided the 3D animation of the paper and Markus Kellow wrote and produced the soundtrack.

In Cinebugs, Mark and John used keywords and phrases to define themes to explore visually, such as movies that matter, the difference between liquids and solids, a window into another space, place and time, and the value in experiencing other worlds. The need to combine the natural and digital worlds in the work was important because they wanted people to see that even though we use technology to make images, we still talk about and reference nature and the natural world.

Discussion between the pair is vital in these early developmental stages and is particularly centred around how to visualize the concept. Mark says, 'We talked of the layers and levels found within the themes of film and the making of film – this ultimately defined our dimensional space to zoom through.' This piece of text was an early description of the idea:

Fade from black as the camera moves down into a bird's-eye view of some leafy green plants. A number of butterflies (made from flower petals) sit on the leaves, moving in different ways. Momentarily, the wings and bodies of the insects align and form a rectangle. The image freezes for a moment and a white rectangle outline is 'burnt' onto the screen. The camera continues to move into the

← ↙

In Cinebugs, Mark and John used keywords and phrases to define themes to explore visually, such as movies that matter, the difference between liquids and solids, a window into another space, place and time, and the value in experiencing other worlds.

**3
Cinebugs**

centre of the rectangle and the screen fades up to white. The Movies That Matter identity appears.

The second piece is as the above one, but this time it is a scene of many beetles moving in different ways and different directions and rotations. Momentarily, they also align to form a rectangle. The third section shows a bird's-eye view of sycamore seeds falling, spinning down away from the camera. The rectangle theme is repeated once more. We're not sure how well this one sits in the set – but at least another fourth one would have to be generated. We think the key definition of 'matter' here is: value and importance, which can lead to ideas of influence or mimicry. Movies are influencing the natural world, to the point of creating a very unnatural form – that's how powerful cinema is!

As with the other films, the concept for Cinebugs and the method of production was developed jointly. The insects were mainly designed and composed by Mark using Photoshop and Illustrator (3).

John constructed all of the animation within the characters and composed them within the scenes. He added camera movements and did final edits, while Kellow again wrote the score and produced the music and soundtrack. All of the films feature software development using Autodesk Maya, Pro Tools and Firefox.

John and Mark work in a variety of ways depending on the platforms they are designing for.

However, the small-screen achievements of films like Birdcage (4) and dConstruct serve to highlight the challenge posed by designing for a format where the physical screen presence and resolution need to be aligned to an ability to generate motion, while still having visual elements that remain recognizable.

As with so many things, the principle of keeping things simple is thoroughly tested out when designing for mobile content.

4
Birdcage

Chel White
USA / chelwhite.com, bentimagelab.com

Harrowdown Hill
2006 / 00:04:30

<u>Harrowdown Hill</u> is Chel White's haunting and innovative music video for Radiohead frontman Thom Yorke. In July 2006, Chel was commissioned by Thom to conceptualize and direct an experimental music video for the song, which is based on the controversial suicide case of British scientist and weapons inspector David Kelly. The video does not reference the case literally, but rather uses metaphor and symbolic imagery as a quietly intense call to consciousness in an age of disinformation, pre-emptive war and unprecedented governmental secrecy. The haunting imagery achieves this uncomfortable feeling by including eerie underwater sequences, inventive experimental animation and time-lapse photography, together with manipulated historical footage of people demonstrating in the streets.

Acknowledged as a groundbreaking film by its many inclusions into festival and screening programmes, <u>Harrowdown Hill</u> is a clever visual montage of animation techniques used to enable the song's lyrics to transport the audience into a dream-like state around a potentially explosive and thought-provoking subject.

1
<u>small-gantics</u>

↗ →
Chel White's film includes an animation process that he calls 'small-gantics', where film clips are digitally manipulated to mimic the depth-of-field effects that macro photography can create, resulting in a world where everything seems miniaturized.

How did you become interested in animation?
When I was in high school I liked to draw and paint. My initial move to film was using animation as a way to make my drawings move. Within the same year, I started to investigate more experimental applications of the medium.

How long have you been an animator, director, producer or creator?
Not including school, 20 years.

Who or what inspires or influences you?
I am mostly inspired by the images, stories and characters that come from my dreams and that state of mind just between being waking and dreaming. When I was younger, it was surrealist painting that really inspired me.

Describe your studio environment.
I have an office, I have an area for shooting and, depending upon the project, I have a number of talented people who work with me. My home base is Portland, Oregon, which is quickly becoming a cultural mecca for animators and filmmaking in general. We recently hosted the Platform International Animation Festival, for instance. But it rains a lot, so take heed before picking up and moving here!

What is your own personal definition of animation?
Any form of moving-image-making created a frame at a time.

Is your film funded?
Yes. It was funded by XL Recordings and was commissioned by Radiohead's video commissioner, Dilly Gent.

↗ →
An early test of 'small-gantics' shows a photograph before and after digital alterations.

The mood and lyrics of the song encouraged Chel to think about a general visual aesthetic that had an otherworldly sensibility.

Chel explains, 'Thom Yorke and I discussed the concept of "soft time" as it applies to images and the manner in which a story is told.

We both wanted to avoid a literal interpretation of the song's lyrics, which reference the British scientist and weapons inspector David Kelly and the controversy surrounding his death. My intention was to rely mainly on metaphoric images. Some of the film's metaphors include the eagle-eye views and the jittery animated eagle. As with all of my films, I mainly prefer to leave the interpretations up to the viewer. The dream-like qualities in Harrowdown Hill were derived in various ways, from the jittery, uneasy quality of the eagle animation to the forced miniaturization of the landscapes, the latter of which blurs the edge of reality and questions the audience to ask whether they are full-scale or tiny models.'

Chel prefers to leave room for creative discovery, and experimental animation tends to be the most spontaneous and explorative. Harrowdown Hill was made inside four weeks, and Chel surrounded himself with people who he trusted to create and diffuse the desired feeling into the film. This crew consisted of animators, compositors, producers and cameramen. Even at an early stage, Chel was clear about how he wanted the audience to react to the film: 'I wanted people to find it interesting and unique.

I like to take people to a place they haven't been to before.

For someone to say they are inspired to make their own films is always the highest compliment.'

As the film progresses through four distinct sections, the images are derived from a number of different experimental techniques, blurring the gap between animation and live-action. The piece begins with aerial shots of vernal landscapes, eventually leading to cities. These scenes were manipulated frame by frame in the digital realm to mimic the depth of field found in processes such as macro photography.

The resulting effect is a kind of miniaturization of the real world, in what Chel calls 'small-gantics' (1), a possible interpretation being a visual representation of the shrinking of cultural and political diversity worldwide.

The aerial shots were soon joined by the stop-motion animation of an eagle hovering above, suggesting both heroism and a dark presence. This process started with the building of the eagle, which was welded together from pieces of salvaged scrap metal, and then photographed in stop-motion in various outdoor locations (2). The animator/filmmaker David Russo and his crew created the eagle scenes.

Midway through the film, the audience sees archival footage of people protesting in the streets, from England's poll-tax riots to race riots in the United States. To make this imagery unique, a process of placing glass rods and lenses between the film and the video transfer scanner was applied, creating a wobbly and abstracted effect with a dream-like quality.

This treatment was also applied to one long underwater shot of Thom Yorke drifting down into a dark abyss, shot on location in a giant special-effects pool in Los Angeles (3).

Finally, the video ends with a breakneck montage of time-lapse photography, created by Mark Eifert, interspersing and contrasting the natural and human-made worlds (4).

The time-lapse incorporated a motion-controlled camera that allowed repeat movements to take place in the same location but at different times of the day.

2
eagle

↑ →
Although the finished video has a highly crafted finish, some of the elements were created by hand, including this eagle, which was welded together from pieces of scrap metal. The eagle was shot in stop-motion in various locations and in stop-motion sequences by animator/filmmaker David Russo and his team.

The production of the film relied on certain technology, some of which was 80 years old, such as the 35mm film cameras used for the stop-motion and time-lapse sequences, and some of which was completely current, such as After Effects. The latter was the most significant piece of software for producing the film, although Shake was also used, together with Final Cut Pro to edit the material.

Chel's advice to potential animators is suitably telling to his belief that content is more important than technique: 'Maybe it goes without saying, but not all animation has to be character-based. Don't be afraid to take chances and explore new territory. Don't fall in love with a look before you have thought it through as a finished film. Animation takes a long time. Give the concept for a project a little time to germinate, then decide if it's really the right one to dive into.'

Asked to pinpoint the skills and attributes necessary to be successful, Chel answers thoughtfully: 'Patience and perseverance are among the most important characteristics of a good filmmaker, along with devotion to a project. Talent and great ideas can only be realized with a strong level of commitment.

A great idea is only the beginning and is in some ways the easiest step.'

In Chel's case, an ability to see the possibilities latent in a project and, crucially, an ability to unlock those thoughts into a creative piece through independent thought are key qualities that make Harrowdown Hill a successful film, but more importantly, a fitting epitaph to the memory of David Kelly.

←
Various pieces of historical footage were manipulated to create a wobbly and abstracted effect with a dream-like quality. The same technique was used for the images of Thom Yorke drifting down into a dark abyss.

3
underwater
photography

4
time-lapse

→
The video ends with a montage of time-lapse photography, created by Mark Eifert, interspersing and contrasting the natural and human-made worlds. The time-lapse incorporated a motion-controlled camera that allowed repeat movements to take place in the same location but at different times of day.

Grant Orchard

UK / studioaka.co.uk

Lovesport:
Love Paintballing

◉ featured on DVD / 2007 / 00:02:26

The Lovesport series created for QOOB provides the perfect vehicle for Grant Orchard to explore humour, using the simplified language of Flash merged with everyday observations on his way to work in his central London studio. A surprise hit, Grant's series of different sporting events further tested this marriage of ideas and flexibility of process to the limit.

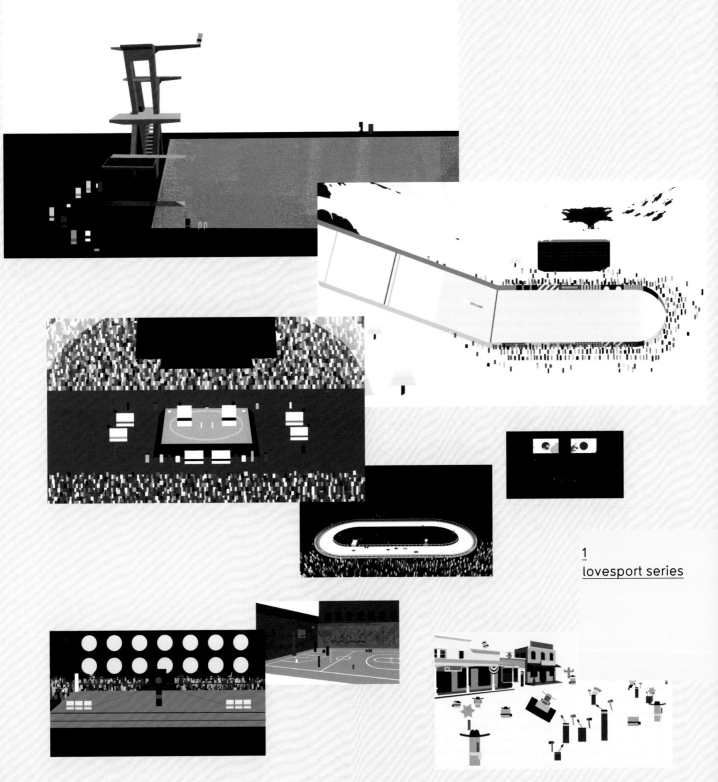

1
lovesport series

How did you become interested in animation?

Like any kid, I loved my trips to the cinema to see any animated film that was on. The Jungle Book and Ralph Bakshi's Lord of the Rings were solid favourites. Any commercial or set of titles that were animated on TV got me sitting up like a hungry puppy. I remember being particularly gutted that The Pink Panther suddenly became a live-action film after the titles!

It was only until Channel 4 launched a season of animation programmes called Fourmations, when I was around the age of sixteen, did I think of animation as being something tenable, something that didn't seem completely out of reach. Fourmations screened short animated films from around the world by filmmakers like David Anderson and Stuart Hilton, including interviews with them, often in their studios, which looked brilliantly grubby and creative. Before this, I would look at Disney films and think it was amazing but untouchable.

I went to Art College and studied graphic design. I continually needed several images to explain any idea. I think the tutor got a bit fed up with it and suggested animation or film might be a better fit for me. I didn't realize that you could actually study animation. She found there was only one college in the UK that did a full-time course in animation at the time, so I ended up there.

How long have you been an animator?

I graduated in 1995 and became a 'runner' at an animation company called Pizazz Pictures. I was running for about a year when I got given the chance to do some 2D animation assisting and art working. Over the next three years I went from assisting to animating effects and secondary characters on commercials to lead animating. Around 1998 to 1999 I started directing various commercials for StudioAKA.

The first advert I directed was John Webster. I rather luckily won the pitch based on a couple of drawings I'd torn out of my sketchbook! It went on to win various awards and stood me in good stead for more directing work. I took a break from working at StudioAKA for a couple of years to make my first short film, Welcome to Glaringly, commissioned by Channel 4 (after watching Fourmations on Channel 4 as a teenager, this felt brilliantly cyclical). I also set up a small inter-disciplinary art collective called The Hope&Anchor, which was non-profit making.

I returned to StudioAKA in 2006 to continue directing commercials on a full-time basis, although brilliantly, we've managed to fit in non-commercial projects such as the Lovesport series as well.

Who or what inspires or influences you?

Reading generates a lot of ideas and, I suppose, just by the nature of what we do, our exposure to visual stimulus is pretty high. I'm sent and see incredible work virtually every day on the Internet now. If you pair that up with living in London, which is such a visually noisy place, my inspiration filter is stuck wide open.

Moments when ideas really pop into my head are when I'm in between places, like cycling to work or on a long car journey. It seems to be those quiet moments that my brain will squeeze out a nugget of an idea with possibly some infusion of all the things that I've seen, read and heard over a period of time. In a nutshell, time out seems to inspire my ideas and work.

Describe your studio environment.

White walls, glass tables, a fair bit of junk like books and CDs scattered around my computer.

All overlooking an alleyway with the odd druggie and a fashion shoot going on. It's great. It's also full of arty creative types who you can have a good conversation with about arty creative things.

One of the best reasons for working in a studio is that kind of daily chat. When I worked from home for a couple of years I definitely missed that.

Is your film funded?

Yes. It was commissioned and funded by QOOB. After seeing a film I'd made called Park Foot Ball at onedotzero, they came up with the idea of doing a series of them based on world sports.

It wasn't a lot of money, but due to the designs being as simple as they were, it was realistic to try and do them in tandem with any commercial work that was going through the studio at the same time.

Additionally, QOOB were fantastically enthusiastic about it, and apart from some initial suggestions for the sports they were completely happy to let us get on with it without any approval or censure from them.

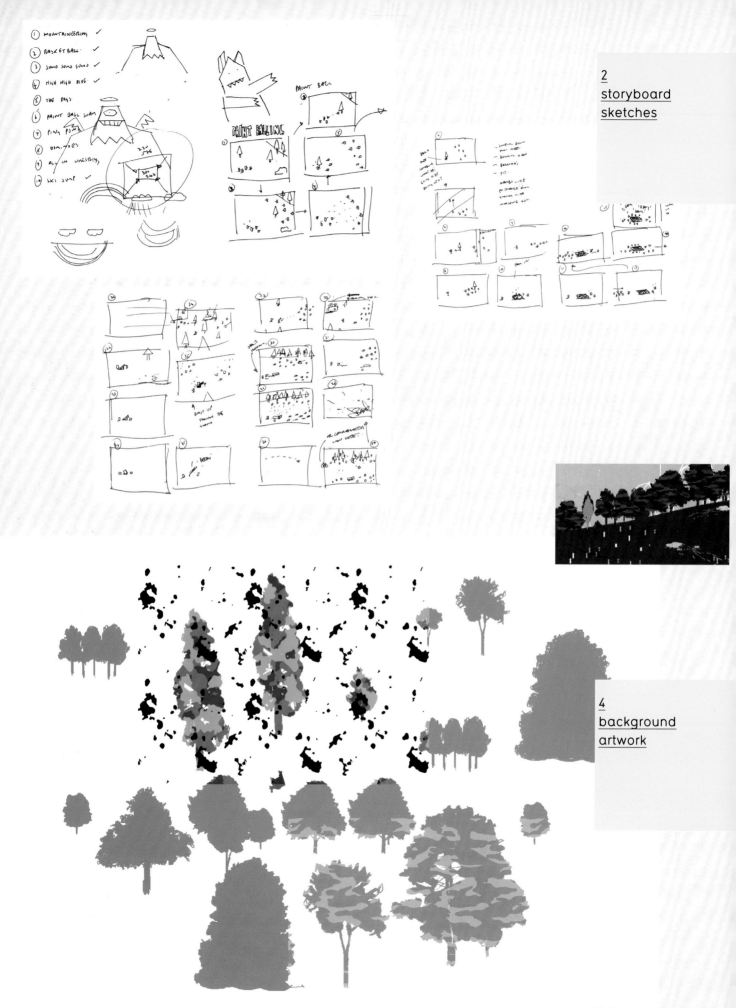

2
storyboard
sketches

4
background
artwork

Park Foot Ball originated as a way of Grant learning After Effects. Simple rectangles were created because he didn't have time to design proper, fully rendered characters just for a test. Grant tried animating a little run on the spot, and then the classic animation ball test that every animator gets. After that, he experimented with bezier curves in After Effects and introduced a few more characters to kick and head the ball at one another.

Grant thought the different coloured little squares running around on screen looked really attractive, largely because he always hated putting too much detail in characters but loved character animation, so the process turned into a bit of an experiment to see how much personality and readability he could get into them. While the idea for a match was born in 2001–2, it took him nearly four years to complete, due to paid work commitments, getting bored with it, or being frustrated about never really being very good at animating in After Effects.

QOOB saw the film and came up with the idea for a series. Grant explains, 'I never intended to do anything like that again, but the client was very enthusiastic, and although I wasn't sure if there

was enough creative scope to stretch to a series of ten films, I kept thinking of different sporting scenarios that were funny.' With Paintballing, the aesthetic of camouflage and large paint splats work simultaneously together, and he insisted the brighter the paint, the better.

Grant had been paintballing once, and comments, 'no matter how serious about it the people are around you, it seems to have that inherent air of silliness. I think the people who go regularly, who buy their own guns, want desperately for it to be "real". It just gave me that "What if..." idea. What if a paintballing game became as serious and well equipped as the real thing? I thought something that is essentially quite small becoming gloriously epic was quite funny.'

For the Lovesport series, Grant took the script outline and visualized it by doing a really quick thumbnail storyboard in his sketchbook (2).

He would then scan these into Photoshop, turn them into Targa's and import them into Premiere so that he could cut them into an animatic (3).

After this, the process of shot selection and most of the elements that would be required became obvious.

Artwork was then created in a combination of Flash and Photoshop, although this process is somewhat reversed for commercial work, where fully rendered artwork is followed by a storyboard and an animatic, but due to the tight schedule on the series, Grant didn't want to spend too much time on designing stuff he might not need.

For Paintballing, Grant acted as the writer, designer and director. Initially he wrote around twelve script outlines of varying detail and length to show QOOB. When the production started, he took those script ideas and outlines and worked them up as quick thumbnail storyboards, as he describes, 'It's all visual gags anyway, so it seemed the best way to develop the ideas.'

Due to the extremely tight turnaround on the Lovesport jobs, Sue Goffe, the producer, staggered their production time by devising a six-week schedule for each one. For example, with Paintballing week one was spent storyboarding and animatic work was conducted. A storyboard would be created in Grant's sketchbook as quickly as possible, scanned into the computer and the animatic cut in Premiere. Usually certain shots wouldn't work or needed to be re-staged, so further drawing of more panels were required and re-cut accordingly.

The following week was dedicated to the designs and layouts. He began by creating all of the characters in Flash, followed by the backgrounds (4).

Grant comments, 'With Paintballing, it's a one-shot film, so I imported a QuickTime of the animatic into Flash so I could see what elements I needed in shot at any one point. I then generated a run cycle for one of the characters and, following the animatic, I mapped out the route and speed of the action. This gave me an idea of the size and shape of the background we needed.

I then generated a graphic that contained a massive landscape that we could do all the animation in, and then pan along as a whole. In this instance the designs and layouts were generated in tandem.'

By weeks three and four, he was able to move onto the animation. Like all the Lovesport films, Paintballing had just one animator working on it. In this instance, it was regular StudioAKA animator called Phil Warner.

Taking the Flash file with the layouts and designs Grant had created, Warner proceeded to animate everything chronologically over what should have been two weeks, but due to the sheer amount of characters and action in it, took him nearer four (5).

This was mainly due to the fact that towards the end the computer he was working on was taking up to about five minutes to execute any command, due largely to some images having around 900 layers. Grant reveals that, 'It might come across as being extraordinarily cumbersome but it seemed the best way at the time of doing it.'

Week five was spent compositing, adding the camouflage to all the trees (created in Photoshop and then vectorized in Flash). The paint explosions and splashes were all comped in where Warner had previously roughed those elements in as a guide.

A series of shots of paint being splashed on paper and a series of water balloons being dropped into a tray of red ink were filmed. After choosing a selection of the best ones, the footage was taken into Flash and rotoscoped (6). After adding all this into the animation, it was exported from Flash as one level and brought into After Effects, where we did all the camera shakes.

In the sixth week, the sound was finally ready to be added. Nic Gill (who had done all the sound on Park Foot Ball), did all the sound effects at his home recording studio and then cut them to the final image on Adobe Audition, including the music he had generated for the titles and credits.

Using this kind of schedule we were able to always have three films in production at any one time. Grant is quick to praise others for their help, 'I had Sue Goffe who was the producer, plus three animators working on Paintballing – Phil Warner, Gideon Regal and Sander Jones. Nic Gill did all the sound. Sander Jones also did a lot of the AfterEffects work, but if he was busy animating, we could pool the resources of a couple of other AFX people within the company who were, luckily for us, in-between commercial jobs. Finally, there was the studio co-ordinator, Ren Pesci, who managed to keep everyone working happily.'

Paintballing alone took nearly two months to complete (7). The whole series was five months in production, not including scripting and development which took a few weeks' work.

6
rotoscoping

5
flash animation

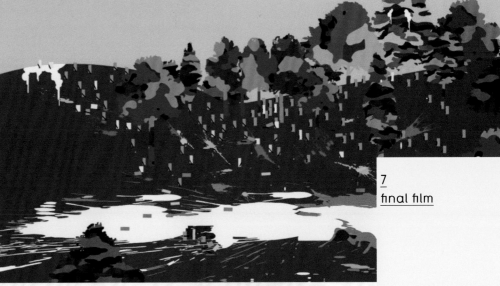

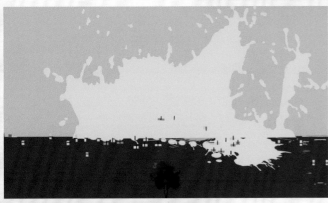

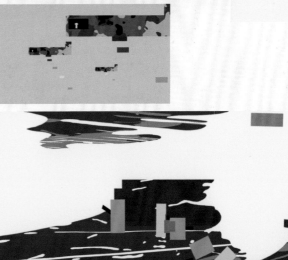

Max Hattler

Canada / headgearanimation.com

Striper v0.1

◉ featured on DVD / 2006 / 00:00:30

Experimental animator Max Hattler uses the medium to see the potential for mixing different art forms into condensed forms of storytelling, and regards technique as being merely a tool for enabling that process to appear for the audience. His films often have a very different visual feel as a result, encouraged by his organic way of creating and producing work. While films like Collision have a powerful undercurrent of rhetorical commentary about the War on Terror, Striper v.01 is happy to document a subject that to others might be immaterial, but to the observant Max Hattler is a thing of beauty and intrigue.

Inspired by numerous cycling expeditions through London, weaving in and out of the busy city traffic, Max found himself looking closely at his immediate proximity. The streets are so plastered with signage, with primary colours competing against the texture of the road, exploded scale that causes fracturing of form and abstraction, not to mention conflicting and contrasting messages dictated by these glyphs. The urban topography of London provided Max with an interesting starting point, to only use what was already there and document the everyday, but re-packaging it to make the subject a thing of vibrancy and excitement rather than frustration and annoyance experienced by the rush-hour crowd.

↗ →

Inspired by time spent commuting to the Royal College of Art on his bike, Max documented his observations of the graphic topography of London through thousands of digital photographs.

1
photography

How did you become interested in animation?
It happened through a joint interest in visual arts and music/sound, catalyzed by encountering making animation films at Goldsmiths College in London. I was never, and am still not, all that interested in cartoon characters and funny films.

How long have you been an animator?
I always enjoyed scribbling and dribbling onto paper, and had my first exhibition of paintings in a café in my hometown Ulm, Germany, when I was eleven years old. Admittedly, this was more of a joke between my parents and the owner. But I did end up selling a painting for 50 Deutsche Mark and it made me think about the possibilities of combining earning a living with what I enjoyed doing naturally. Soon after that I got my first computer, an Atari ST, which was soon superseded by a more graphics-oriented Commodore Amiga (500, and then an Amiga 2000).

While my friends always wanted to play Bubble Bobble and watch 32-colour low-res porn, I was more interested in using the computer creatively.

When I was fifteen, I embarked on making a jump and run computer game with a friend. His friends had successfully made a game and sold it to a publishing house, so we got very excited by the idea of following in their footsteps. He did the coding while I started designing and animating the characters and backgrounds – my first stab at animation. Unfortunately, his school workload soon increased to the point where the project had to be abandoned. My interest switched, and I spent the next few years using computers and electronics to make music.

I released a couple of songs with Uwe Jahnke's brainchild Toon (1996) and with my father Hellmut Hattler's project Hattler (2000). But when confronted with the question of what to study, I felt that I should challenge myself and go for something slightly more theory-based, less self-involved than straight art or music. Studying Media and Communications at Goldsmiths fulfilled this need, but it also opened up, through its Animation practical specialization module, a perfect opportunity to amalgamate my previous image, sound and time-based interests. After graduating, I studied visual effects in Madrid and then worked in Berlin as a visual effects artist on films like Good Bye, Lenin! Encouraged by my Goldsmiths graduation film Alpraum (2001, co-directed with Martin Heaton) winning a couple of awards, I returned to London to study at the Royal College of Art, where I graduated with an MA in Animation in 2005. Since then I've been making more independent works like Striper v0.1 and Drift, and I started performing live visuals. I also direct music videos and commercials.

Who or what inspires or influences you?
Whims, moments, atmospheres, random bits and pieces. My work tends to grow organically, through trial and error, rather than through storyboard or script. As a result, it is more open to outside stimuli while it is being made, and the direction can change from one day to the next, depending on the temperature or what I read the night before. I like that. It keeps the making process exciting.

Describe your studio environment.
At the moment, I spend much of my time at Bermuda Shorts, a production house here in London that currently represents me as a director. I have a desk there and split my time between my own projects and commercial work. It's inspiring to be surrounded by other filmmakers, including Run Wrake, Filipe Alçada and Susi Wilkinson who are also part of the extended RCA animation family. If I need quiet time then I tend to work from home. Most days all I need is a laptop, so I'm quite flexible. I also like taking my work with me when I'm travelling.

↑ → ↘

The final film stills from Max Hattler's Striper v0.1 show how sensitive compositional cropping and selection can turn everyday objects (in this case, road markings) into something of sublime abstracted beauty.

Striper v0.1 is Max's shortest film, yet it took the longest to be completed. Initially, the plan was to develop a four-minute film called Striper, putting the film together while he was still at the Royal College of Art.

Max started taking digital photographs over the course of a year, 'Wherever I went, I spent a lot of time taking pictures of the streets (1).

People came up to me asking if I was all right, and my friends shouted abuse at me for not keeping up with them.' This process meant finding signage that was different, but it also meant composing the material in ways that abstracted the subject. Part of the film's documentary subtlety is in its ability to reposition material for an audience, and the realization that the images are made of composited road markings is not immediately obvious.

In order to achieve this subtle shift, Max spent time trying to find movement between the photographs, involving viewing thousands of digital images on his laptop.

This process was linked to parallel lengthy conversations with Mexican electro-acoustic composer Pablo Gav, about sound-image relationships. But then Max got sidetracked into other projects, namely Nachtmaschine and Collision. He first made Nachtmaschine, an experimental video to his father's music, based on animating photographs. Originally, Max wanted to continue making Striper straight after that. But when Nachtmaschine was completed, the compulsion to do something quite different thematically was overwhelming; something that didn't involve photographs, and dealt with the politics of the day – the result was Collision.

He occasionally made sequences for Striper, but never quite got totally absorbed with the project. The idea agreed between Max and Pablo Gav was that the animator would hand the composer image sequences, and that he would respond by making sounds. Max comments, 'These sounds would then feed back into the image-making, and the resulting images would be presented to the composer again. Eventually, we'd end up with a truly collaborative piece. When put to the test of real-world constraints and without a fixed deadline, this approach didn't lead to much.'

Eventually, with Pablo about to return to Mexico, a finished four-minute track was pressed into Max's hand. Inspired by, but definitely not synced to the images, Pablo suggested that it could be used as he saw fit. Max remembers, 'More time went by, and I had to pay the bills.

It wasn't until I was approached by RUGA, a Barcelona-based DVD magazine, asking if I wanted to include some work into their upcoming issue, that the film took on a much-needed urgency (2).

So that's what I did. I decided that it would be better to make Striper v0.1, and maybe one day a v0.2, rather than drag it out any longer.'

He doubts there will ever be a second version, or indeed a four-minute epic. Max believes that local conditions sometimes dictate the creator to produce work that is more economical in terms of content, but that it still resonates with the audience. 'With a longer film, I could have been more clever, elaborated more, and surely shown it in more festivals but then I never spent a prolonged period of time on the film, it ended up always being something on the side. Such are the constraints sometimes of making work... still, I think that the basic premise comes across in Striper v0.1, and it's that what counts.'

In terms of a process, Striper v0.1 comes together where movement is also created from similarities in sequences of disparate images. Since Striper v0.1, Max has made more films and videos, and while techniques and processes change from one project to the next, photography remains, expressing an occupation with texture and space that runs through his work. Drift (2007) uses single photographs and compositing to get close to the subject. In collaborations with the band Economy Wolf, Max's Mount Allen (2007) employs pixilation, while Theme for Yellow Kudra (2006) uses live action and he is currently making a music video for an electronic artist based on photography and compositing.

Max believes that technological advances have helped audiences become more adept at finding new experimental work, but that with this freedom come certain economic constraints, 'You could argue that in the digital age, the Marxist struggle for the means of production is over. And even distribution, it seems, is opening up. Almost anyone in the west, and many elsewhere, can now, in theory, make films or music and get it distributed. But at the same time, media ownership is concentrated in fewer and fewer hands, with new platforms like MySpace or YouTube being routinely incorporated into the portfolios of big media corporations like News Corp. or Google. And while it might be easier to make and distribute work, it becomes harder to make a living from it. Instant access to everything also means infinitely more competition for those who make the work, and less willingness to pay for it by the audience.'

The use of digital technology has been instrumental to Max, 'With a digital camera I can take thousands of pictures. The computer gives immediate access to them, and enables me to animate and edit them into a film at virtually no extra cost through After Effects. In principle, the processes involved in making Striper v0.1 were very straightforward and the film could have entirely been made with analogue equipment, like a 35mm camera, home or shop processing, and animating the material under a rostrum camera. However, it would have been prohibitively expensive.'

Romain Segaud

France / romainsegaud.com, passion-pictures.com

The Guardian: Reinvented

2005 / 00:00:30

Arguably the newspaper that has the greatest kinship to design, The Guardian has undergone some striking and well-publicized redesigns over the last decade. The cut-throat world of news media, now extending across a broad range of platforms, guarantees that readers are continually being enticed by new formats, designs and approaches to tempt away even the most ardent of followers.

Agency DDBLondon approached Passion Pictures to use animation as a way of both informing and enthusing a potential new readership. The Guardian: Reinvented, produced by Michael Adamo, is French director Romain Segaud's attempt to bring the whole newspaper redesign to life.

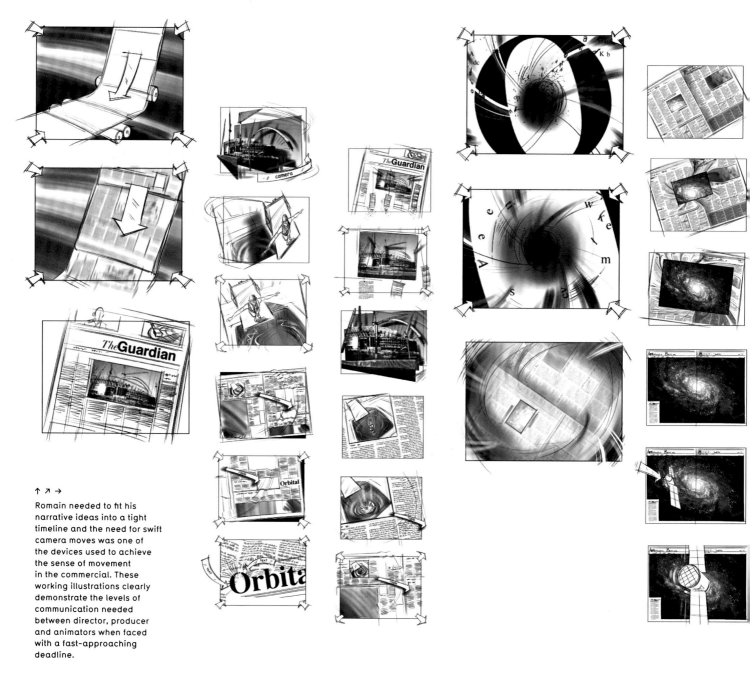

↑ ↗ →

Romain needed to fit his narrative ideas into a tight timeline and the need for swift camera moves was one of the devices used to achieve the sense of movement in the commercial. These working illustrations clearly demonstrate the levels of communication needed between director, producer and animators when faced with a fast-approaching deadline.

How did you become interested in animation?
I was fond of comics and movies and I wanted to do both – animation gives me the best of both.

How long have you been an animator and director?
I started as an animator when I finished school in 2002. At that time, I worked exclusively for Pierre Coffin, who is a director at Passion Pictures in London. I worked at different companies, like CUBE for example, where I did a video called Bip Bip before moving on to do more commercials at Partizan. In 2005 I became a director at Passion Pictures myself.

Who or what inspires or influences you?
My references are as broad as George Méliès, Norman McLaren, Jan Svankmajer, Sbig, Pixar/Disney, Oskar Fischinger and Michel Gondry, with whom I had the chance to work with on the documentary I've Been Twelve Forever.

Describe your studio environment.
As a director, I don't really tend to have a 'studio'. Instead, I supervise a whole project but I'm more attached at the pre-production part, whether that be generating the ideas, storyboard, shooting board or the creation of the style frames. I direct while a team of 2D and 3D artists develop the film under my supervision.

What is your own personal definition of animation?
Animation provides the re-creation of the world. You have to use it as a tool to regenerate life in an entertaining way.

Is your film funded?
Yes – it's a commercial.

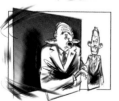
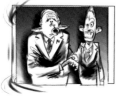

Following DDBLondon's successful pitch to the British broadsheet The Guardian, a number of agencies were contacted and supplied with a script detailing the ideas surrounding the themes of reinvention and reshaping for the relaunch of the newspaper. Romain's showreel was one of a number sent to DDBLondon and was felt to capture the essence of the idea that the agency was looking for. Romain met with the agency team soon after and began brainstorming ideas around the script, quickly putting ideas together, moving them around and testing them until he felt the visuals succinctly illustrated the idea, and ensuring that the piece had a definite beginning, middle and end.

During the pitch, the client had seen Romain's suggested visual treatment. As the project developed, discussions between the director, agency and client became a weekly occurrence, although the balance between artistic freedom and client expectations had to be sensitively managed by DDBLondon, as Romain explains: 'The agency had to be very careful when they showed the work in progress. If they showed too much they were concerned that the clients would want to change a lot of things, but equally, if they didn't provide the material until nearer the end, there was a feeling that the client would be left out of owning the process.'

With ideas and approval for the treatment confirmed, Romain worked with the storyboard artist Alex Hillkurtz, who had worked on Tim Burton's Corpse Bride, to realize the sequential flow of the ideas (1).

Romain stresses that commercials require a different kind of mindset from creating short films; 'I worked on the storyboard and the subsequent shooting board (the animatic) to get the right timings for all the shots. We had to fit our narrative ideas into 30 seconds, and believe me, this step shows you if you're right or you're wrong. Either you have the correct number of ideas or it seems too sparse or overcrowded!'

1
storyboard

The finished 2D storyboard provided the necessary information for the 3D artists to create their simple two- and three-dimensional shapes for the first animatic that would show positioning of objects, cameras and potential moves.

Following further client and agency approval, the animatic became the reference point for the entire CGI team. All of the textures for the objects, such as the crane and even the newspaper itself, were created in Photoshop, although acquiring source material was not straightforward: 'It was hard for us to create the newspaper textures because the new design of The Guardian was top secret. I mean very, very confidential. We only had good reference near the end of production, a few days before the new launch.' Around a dozen CG artists worked on the commercial, modelling the basic shapes, rigging, animating and then applying the necessary texturing and rendering before finally compositing.

Throughout this process, Romain was on hand to direct: 'My job was to provide answers and insights when someone has a question like "What type of printer are we showing?" or "Which section of live footage are we using?" A frequently asked question was "What's the camera move? Where? When?" and these continued right the way through the two-and-a-half month cycle that the commercial took to complete.'

The reliance on the versatility of Photoshop for the commercial's look was matched by using Softimage XSI, After Effects and Final Cut Pro to composite and produce the finished film (2). This process was managed in-house at Passion Pictures. The visually completed commercial was then sent onto the band Massive Attack, who created the soundtrack that would accompany the images.

Romain is clear about the advice he offers to budding animators: 'In order to succeed in this, you actually have to like animation; I mean you have to watch animated film – frame by frame. And after you've analyzed, you have to practice. All the very good people I know around me have a real passion for it. They really need to express themselves.'

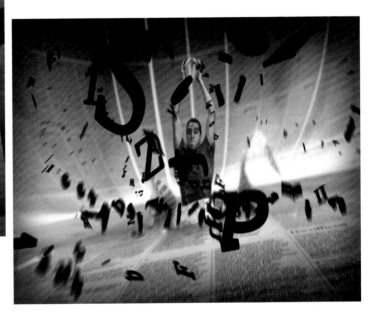

↙ ↓ ↘ →
Under Romain Segaud's direction, the commercial comes alive through a series of creatively originated ideas and a mixture of production processes. <u>The Guardian: Reinvented</u> articulates the message that the broadsheet is progressive and dynamic in its appetite to speak to the readership about current affairs, helped by the pacing of the commercial.

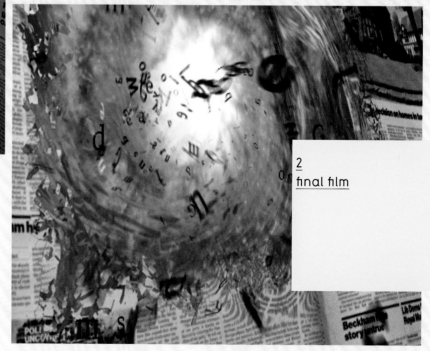

2
final film

Theodore Ushev

Canada, Bulgaria / ushev.com

Tower Bawher

2005 / 00:03:00

Theodore Ushev's childhood in Bulgaria in the 1970s provides the dramatic backdrop for the film Tower Bawher, described by the National Film Board of Canada as 'a whirlwind tour of Russian constructivist art'. Using Georgy Sviridov's stirring music that once opened the Soviet regime's Friday newscast, Theodore pays homage to artists of the era including Vertov, Rodchenko, Lissitsky, Popova and Stenberg by creating a film conceived in homage to the glory of the proletariat.

The film plays on the theme of movement, as Theodore creates a design on screen that symbolizes a continuous development towards a utopian summit, with grand, futuristic forms pointing to a positive future that end up buckling under the weight of a fallen ideology. All of this is constructed using the full measure of Sviridov's score Time, Forward, and enabling sound and rhythm to co-exist with line, form and dynamic visual rhythms. It is perhaps significant that, in this film, Theodore worked entirely using music as his inspiration.

How did you become interested in animation?
By chance, really. I was an art director in a web agency in the late 1990s, doing all the Flash animations for fashion websites. This is how I started doing animation. Apart from this, I had a formal education in animation in my secondary school, with one movie done there, which won some awards in student animation festivals.

How long have you been an animator?
I've been an animator for four years. I've been a creator in different forms all my life. I was a designer, poster artist and illustrator.

Who or what inspires or influences you?
My father, Propaganda Art, the avant-garde and artists from different times. The visionaries. Non-conformist artists, who want to influence and change the world, no matter how utopian it seems to be.

Describe your studio environment.
I work at the National Film Board of Canada (NFBC) studio. It is a standard cubical, nothing special. But somehow, I enjoy it, because it gives me some comfort, and loneliness, so I can concentrate myself into my projects and works.

What is your own personal definition of animation?
Art. Social manifesto. This is the Art as well. Not an Entertainment. It teaches me that movie-making is a passion, and allows for self-expression, like every other form of art.

From origination to production, how long did your film take you to make?
Five weeks.

Do you find the current cultural climate that you are producing work in inspiring?
Yes, in terms of the NFBC, as they give me all the freedom and the good vibes to create, and indeed, exist. I'd say no, in relation to the role and power of the state and the political situation. Or maybe yes, as the current world cultural climate reminds me of my old childhood in the 'censorship' communist country under the Soviet regime, which my country, Bulgaria, was part of. Well, now I live in a free country, Canada, but still there is a 'Big Brother' on the other side of the border, so in many respects there is no difference with the old censorship times I knew.

↙ ←
Constructivist-inspired graphic elements give Tower Bawher an identity and an ideology born out of what Theodore Ushev describes as a 'therapy' in response to Sviridov's triumphant score.

1.1
image construction
and final film

↓ ↘
Scanned graphic elements are composed using Photoshop, following extensive research into the colours and shapes used by the propaganda artists Rodchenko, Vertov and Lissitsky.

1.2
image construction
and final film

Tower Bawher was made in just a few weeks. For the record, bawher is, as Theodore readily admits, a bit of a nonsense word. The word tower in Russian is <u>baschnia</u>, but because of the Cyrillic alphabet, a foreigner will read it like <u>bawher</u>, so <u>Tower Bawher</u> was perfect as a title. The project began in April 2005. During a particularly restless night, Theodore woke up and remembered an idea he had to use the score, <u>Time, Forward</u>, by Russian composer, Georgy Sviridov from his memories of being a child in Bulgaria (he moved to Canada in 1999). While the television hummed in the background, his father worked on his own personal drawings and paintings, and also on more conventional propaganda posters that he made solely to earn a living.

The memories of these Friday nights struck a chord with Theodore. It was like an absurdist stage decoration. Before the news, there was usually a Russian children's programme scheduled. Typically, it featured very, very slow Russian animations like Norstein's <u>Hedgehog in the Fog</u> where Theodore admits that he would usually fall asleep. Then, suddenly, he would be awoken by the uplifting Sviridov music, with turning globes, and the lines of the dynamic building of Communism.

Theodore explains, 'I was not able to sleep during the entire filmmaking process. It was like being in a trance, like I travelled back 30 years with a time machine. I didn't think about festivals, or if the movie will be finished. I was just diving into my memories, like a "Cartesian theatre". It was like a letter. I was in a hurry to show it to my father, because I planned to make a short vacation in Bulgaria. It was done for him.'

When pushed further, he is adamant, 'In many respects, I don't know how I did it. It was an epiphany. <u>Tower Bawher</u> was a therapy.

It is also a tribute to those artists who continually struggle to escape from the ominous and numbing shadows of bureaucracy and censorship.'

<u>Tower Bawher</u> is a litany of lines, shapes, colours and sounds. Despite evoking a feel and a mood not unworthy of archival nature, the film is very definitely made using modern technology. <u>Created in Photoshop, using various multiple scans and filters and then exported into After Effects and Flash for production, the visual effect is images that appear to dart around the screen at an alarming rate, in vertical, horizontal and diagonal paths reminiscent of the Constructivists fondness for the triumph of functional form, creating a visual and emotional tension and release in tandem with Sviridov's score (1.1 and 1.2).</u>

Theodore is more concerned about describing the role that producer Marc Bertrand played in helping the film achieve its desired voice. As well as providing him with an environment that gives him freedom to create, Marc's help in piecing the film together enabled Theodore to gain a much-needed alternative perspective on the thoughts, emotions and deeds he wanted the film to encapsulate. The result is that <u>Tower Bawher</u> is an examination of how endless and mind-numbing bureaucracy and suppression can be pierced by a quest for truth, meaning and harmony, even if this search ultimately only promises but can never quite deliver its own utopia.

The film gives seductive glimpses of the life beyond a totalitarian state existence, but what breaks is a shatteringly false dawn.

<u>Tower Bawher</u> has had a diverse reaction from its audience, as Theodore explains, 'Everyone reacts depending on their level of education and knowledge. Some of them view the movie as a superficial MTV-like spot. Others, with more serious backgrounds, understand my message. Some even get the personal struggle portrayed behind the film as well. This movie, as with all the movies that I have done, has many levels of perception, and I accept and I'm comfortable and happy with all of them. I don't get angry if people take it just as a formal abstract non-narrative music video.' Given the nature of this project's origination and its trance-like development, such sentiments might seem surprising, yet this is a film that is refreshingly honest about notions of invincibility and faded grandeur, perhaps best summed up by Theodore's advice to potential filmmakers, 'Don't follow any advice. Except advice from your lovely grandmother, especially if she is rich, and has an inheritance to give to you.'

↗ →
<u>Tower Bawher</u> explores the foiled utopian promise of communism.

Jonathan Hodgson

UK / hodgsonfilms.com

Forest Murmurs

◉ featured on DVD / 2006 / 00:12:32

'Sitting alone on a park bench in Hampstead Heath one summer's afternoon, I was listening to fragments of overheard conversation from passers-by. Wandering home across the heath, I found myself increasingly fascinated, making countless brief connections with the numerous accents, languages and styles of speech to be heard and the equally varied topics of conversation. I realized that the voices in this space could be seen to be as important in defining the place as the landscape itself. There and then I was inspired to make a film portrait of a specific location using overheard conversation as the principal means of describing the place.'

Jonathan Hodgson's Forest Murmurs explores a place where he feels an outsider, discovering unknown territory that has a degree of notoriety. Associated with countless rumours and urban myths, Epping Forest, a patch of ancient preserved forest to the northeast of London, became the source of inspiration with a long-established reputation for lawlessness and clandestine activities (1).

The film contains a surreal narrative based on overheard conversations meshed with historical accounts of villainous acts. These are visually described using a rich patchwork of expressive forms, including animated nineteenth-century engravings, found sound, text, hand-drawn animation and HDV-captured documentary footage, carefully montaged to give Forest Murmurs an unnerving and sinister quality. Described in the synopsis as 'a psycho-geographic exploration of the forest', this film studies the presence of fear, triggered by perceived dangers and resulting atmospheric imaginings that draw the audience into a dark world full of suspense and intrigue.

1
treatment images

How did you become interested in animation?

I was studying illustration at Brighton College of Art, but felt unhappy with the course. Friends from my Foundation course at Solihull College of Technology in the West Midlands had gone up to Liverpool Art College and seemed to be having a great time. I went up there to visit them for a weekend and fell in love with the city. I decided to transfer, but the only course at Liverpool that you couldn't do at Brighton was Animation. I had no ambition to become an animator at the time, but I lied. It was only after I'd succeeded in transferring to Liverpool that, thanks to the influence of animation lecturer Ray Fields, who was a brilliant teacher, I began to realize the potential of animation as a serious art form.

How long have you been an animator or director?

I started studying animation in 1979 but I didn't officially start working until after leaving the Royal College of Art in 1985.

Who or what inspires or influences you?

That's a big question because there's a huge range of stuff that changes all the time. I'm not really influenced that much by the work of other animators, and I've never had the ability or inclination to slot in with what's going on in animation. I find the animation scene to be, on the whole, an incestuous, stifling cultural ghetto and I think that the reason animation is not generally taken seriously as an art form is because a lot of animators only really engage with other animators and don't care what is going on culturally in the rest of the world.

What has influenced and inspired me, apart from life itself – which is definitely at the top of the list, includes:

Painting, drawing and sculpture by artists such as Albrecht Dürer, Ronald Searle, Robert Crumb, David Hockney, Peter Blake, Picasso, Roger Hilton, Matisse, Masereel, Steinberg, Burra, Debuffet, Miro, Klee, Bawden and Ravilious, Paolozzi, Tapies, Beuys, Grosz, Henry Moore, Stanley Spencer, Basquiat, Warhol, David Carson, Lucien Freud, The Chapman Bros., Jonny Hannah, David Shrigley, Tracy Emin and Paul Noble.

Writers: Margaret Attwood, William Burroughs, Albert Camus, Charles Bukowski, George Orwell, Dylan Thomas, Will Self, Ian Sinclair.

Live-action films and directors: 1960s 'Kitchen Sink Realism' such as Tony Richardson's A Taste of Honey, Lindsay Anderson's If, Mike Leigh's early stuff like Bleak Moments and Hard Labour, Ken Loach's Kes, Coen Brothers' Blood Simple, David Lynch's Blue Velvet, Shane Meadows' Dead Man's Shoes, Andrew Kotting's Galivant, Patrick Keiler's Robinson in Space, Nick Broomfield's Kurt and Courtney, Mike Figgis' Leaving Las Vegas, Martin Scorsese's Taxi Driver and Goodfellas, Robert Altman's Short Cuts, Alan Clarke's Made in Britain and Rita, Sue and Bob Too, Polanski's China Town and Repulsion, Wim Wender's Wings of Desire, Nuri Bilge Ceylan's Climates and Lars von Trier's Idiots.

Photographers: Robert Frank, Martin Parr and William Eggleston.

Television programmes: Larry David's Curb Your Enthusiasm, Dad's Army and Steptoe and Son.

Music: Arvo Pärt, Bach, Phillip Glass, Beethoven, Bob Dylan, Neil Young, The Beatles, The Stones, The Clash, Sex Pistols, Subway Sect, The Fall, The Smiths and Pulp.

There are a few animators who don't fit in with the rest and it shows in their work. I wouldn't say I am particularly influenced by any of them, but I do have a grudging respect for Robert Breer, Stuart Hilton, Caroline Leaf, Len Lye, Phil Molloy, Yuri Norstein, Jan Svankmajer, Quay Bros, Tim Webb and Run Wrake.

Describe your studio environment.

I share a studio space with three other people, all working independently in a variety of areas in art, design and media. The space is part of a larger studio of around 20 members. It is run as a co-operative that provides workspaces for artists and designers working as sole traders or in small-scale collaborations. I have the equivalent of about 2.5 desk spaces with an Apple G5 and G4, plus an Intel G5 PowerBook, all of which I use constantly. I have a Sony HVR Z1 HDV camcorder and a Canon 400D digital stills camera. Occasionally, depending on the nature of the project and budget, I will work with one or two others.

What is your own personal definition of animation?

Recreating the pictures from my mind's eye in a format that can be seen by others.

↖ ←

Jonathan created a number of visual treatment images as well as a written treatment for presentation to film London's London Artists Film and Video Awards (LAFVA) scheme to secure funding to make Forest Murmurs.

Forest Murmurs was initially intended to be based on found sound and overheard voices recorded in situ, but quickly developed into an exploration of the myths and mundane reality of the area, through three distinct but overlapping paths: the history, the present and the imagined. The historical section required a lot of research. Several useful books were sourced about the area and Internet searches turned up interesting leads.

Additionally, Jonathan visited local museums and questioned many people with a knowledge of the area, while a conversation with the writer Iain Sinclair was particularly helpful in establishing a wider context for the area (2).

The present section was largely based on sound recordings made in the forest, mainly at the weekend when more people were around. The conversations were the starting point for sequences of quite spontaneous streams of consciousness that would later be captured as drawn animation sequences, sometimes illustrating figuratively the conversations that Jonathan had overheard and sometimes clarifying muffled recordings with animated text.

The imagined sections delved deep into Jonathan's psyche: 'The experience of making the film was at times nerve-wracking. Hanging around day after day making covert recordings not just of picnickers and dog walkers, but also bikers and drug dealers, not surprisingly resulted in my transformation, in my imagination at least, from hunter to hunted. Having gone there to find a sinister presence in the forest, I came to see myself as I imagined others saw me, a sinister character lurking in the undergrowth. While making the film I was constantly warned by friends and loved ones that what I was doing was potentially dangerous and I should be careful.

Several bodies had been found in the forest and I fantasized that mine might be the next.'

The visualization of these unplanned paranoid imaginings was the third element and took the film to its logical end – Jonathan's own burial in a shallow grave.

For several months over the summer of 2005, Jonathan visited the forest at weekends taking an HDV camcorder and a DAT recorder connected to a pair of binaural microphones, which were ideal for covert recordings (3).

Most of the recordings were made around the tea huts and beer gardens near the High Beach area of the forest. A lot of the live action was, out of necessity, shot hand-held from a distance with a zoom lens, although he also used a macro setting for close-up details of the forest. Jonathan found the resulting process away from the forest both time-consuming and frustrating: 'During the

2
notes and sketches

↖ ↑
Most of these images and text are taken from notebooks where thoughts and ideas concerning the research and day-to-day experience of making of the film gradually became the basis for the film's script.

3
covert recordings

week I'd edit the sound and the HDV footage and start to put together a cutting copy where I tried to make a coherent shape for the film. After some weeks, I started to work on sections of animation relating to the sound I'd recorded, but most of the early animation was discarded. After months of tearing my hair out, it became clear that my original concept wasn't going to work and I had to start researching the history of Epping Forest. Once I'd created animation for some of the most interesting stories dating back to the eighteenth and nineteenth centuries, the film became a lot richer visually and more meaningful.'

Going back repeatedly to the forest to record sound and shoot footage became more and more unnerving for Jonathan, as people started to recognize him and asked inevitable questions about what he was doing. This proved to be an important catalyst: 'It was around this time that I suddenly realized that my anxiety about the filmmaking process might be the missing ingredient. It became clear that if the film was more autobiographical, describing with narration the difficulties I encountered while making the film, it would help to make a solid connection between myself as the filmmaker and the subject of the film – in fact, my state of mind would become the subject, finally allowing the film to make some sense to an audience.' A year into production, with a sense of impending desperation hanging over him, this revelation was an important turning point both in the film's creation and in Jonathan's ownership of the film.

Back in the studio, production of <u>Forest Murmurs</u> took on a more enjoyable air, and with live action and recording sound complete, the animation itself took on an increasingly confident experimental rigour.

Parts of the film were created from old etchings and photographs, some depicting actual scenes from the forest collaged together with collections that came from other sources. These animated collages were created to portray an atmospheric journey through time, and this material was juxtaposed carefully with the live-action footage and stills. <u>The frames were constructed in Photoshop with the help of a couple of studio interns (4), added to the text, drawn animation, maps, signage, fabricated newspaper articles and time-lapse footage and then imported into Mirage and After Effects to be animated (5).</u>

Jonathan used the skills of some distinguished supporters to construct the soundtrack: 'I got loads of help, advice and information from friends and acquaintances. Stuart Hilton, who is a groundbreaking and inspirational filmmaker in his own right, composed the soundtrack, which took the film to another level, as did the sound design

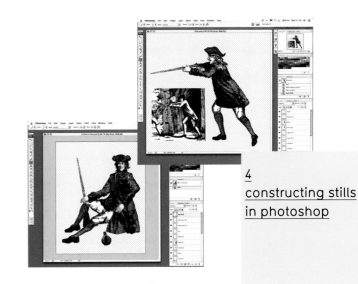

4
<u>constructing stills in photoshop</u>

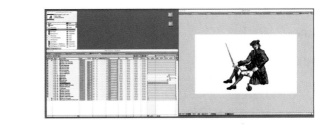

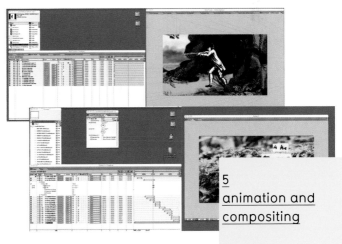

5
<u>animation and compositing</u>

company Fonic, whose sensitivity to the subject matter and attention to detail is quite breathtaking.' The film was produced using Final Cut Pro.

Jonathan was solely responsible for much of Forest Murmurs – creator, scriptwriter, researcher, director, editor, cameraman, animator and stills photographer. Apart from some artworking, he did everything except for the music and sound design. He describes the final stages of production as being something of a whirlwind: 'The last few weeks were very rushed because the film had to be completed for its premiere at the London Film Festival in the Film London showcase. The last stages of the film were the composing and recording of the music and the sound design, both of which improved the film immeasurably.'

Jonathan is particularly grateful for the support he received in both the year-and-a-half pre-production phase and in terms of distribution, 'I certainly needed financial help and Forest Murmurs would not exist without the support of the Arts Council and Film London's LAFVA scheme. Film London was also quite helpful with feedback sessions about the film's progress; they would often play the devil's advocate, which is not always that reassuring but certainly quite grounding and reminds you that there is a potential audience to please.'

The making of Forest Murmurs has been particularly significant for Jonathan: 'I never expected people to be ecstatic about it because it's not a particularly "feel-good" movie and I never intended it to be. Perhaps not every aspect of the film is quite resolved to the extent that I would like it to be. It's not a perfect film, if such a thing exists, but it was only ever intended as an experiment. Having said that, the bits that work for me are as good as anything I've done. It's personally one of the most experimental, thought-provoking and complex films that I've made. Certainly it's one of my most original ideas and that has been borne out by the generally positive feedback I've had from most quarters, and from a few people whose opinion I respect. The response to Forest Murmurs has been the most positive of any of my films.'

The experience of making a film with a documentary bias has given Jonathan a well-deserved break from commercial commissions and has opened his eyes to potential future projects: 'There will always be ideas and themes that have been touched on in the past that have the potential to be developed further in future projects, but it's

not always that obvious straight away. I certainly don't feel inspired to make another film like Forest Murmurs for quite a while because there are lots of other ideas I want to try. It seems that creativity is cyclical and I often go back to my earliest films in order to develop ideas that I didn't even see at the time. One thing that I keep coming back to, time after time, is the challenge of visualizing a state of mind, an abstract thought, an indescribable feeling and finding ways to communicate this as honestly as possible, through a uniquely personal response to the events and situations that I have experienced at first hand.'

Jonathan is resolute in his advice for upcoming animators based on his own successful experience: 'Making an animated film is an extremely arduous and longwinded process and the rewards are often small compared to the effort that goes into producing it. Don't even start to make a film until you have hit on a really brilliant and original concept that has the potential to take the world by storm.'

Jonathan is equally uncompromising when answering a question about the key skills and attributes needed to be successful in the field: 'I'd say having an original vision, together with dedication, patience, tenacity, organization and self-belief are all vital. A desire and ability to communicate and the ability to take and respond positively to criticism definitely help, plus you need to develop a strong drawing ability for 2D animation or modelmaking skills for 3D animation. Furthermore, an ability to think sequentially, good editing skills, an understanding of the dynamics of narrative structure, a spatial sense plus a good working knowledge of at least some of the industry-standard software packages such as Photoshop, Flash, After Effects, Autodesk Maya, 3D Studio Max, Final Cut Pro and Avid are necessary.'

Forest Murmurs is a film made in response to an idea about concept rather than process (6). While Jonathan freely admits that technology has helped create significant parts of the film, he is also very aware that a fertile imagination and a need to inform through animation fuels his work. He believes that films that 'experiment with narrative to create a sense of authenticity that is closer to real life experience and feel more believable' are of most interest to him.

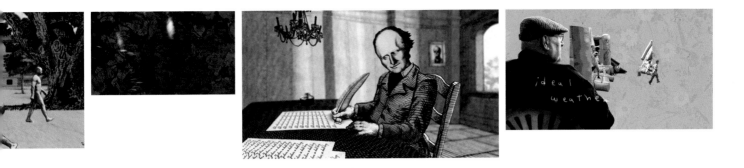

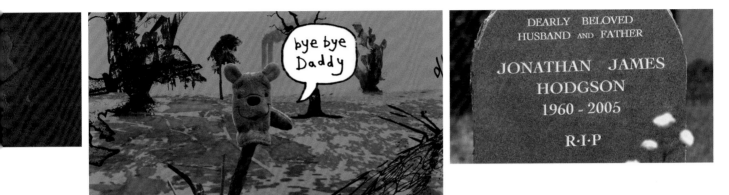

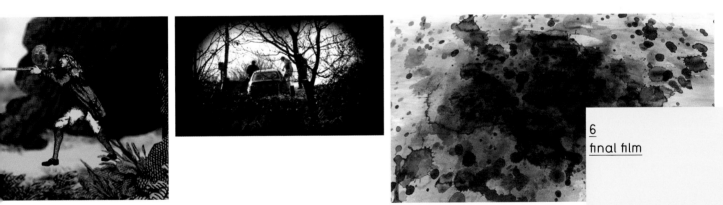

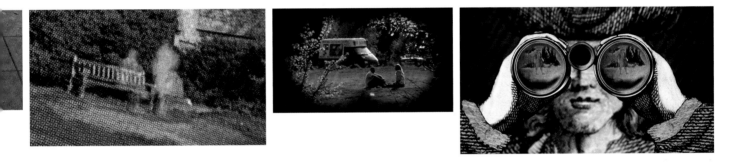

6
final film

Stop Motion & 3D CGI

Stop-motion is the technique that perhaps best embodies the subject of craft in animation. Used primarily for the capture and recording of three-dimensional models, stop-motion requires degrees of patience, rigour and understanding at least comparable to cel or drawn animation. Three-dimensional models may be made of malleable material, such as clay, or are 'jointed' models or puppets known as armatures, although equally they can be inanimate objects.

The history of the technique stems from two main veins, which – unsurprisingly given the breadth of this subject's international appeal – lie at polar opposites from one another. On the one hand are European artists' films, typified by the work of Jiri Trnka and Ladislaw Starewicz, and creative programming for children's television, exemplified by Aardman's The Amazing Adventures of Morph (1981). On the other hand, special-effects animation for Hollywood feature films have also successfully used this technique to create maximum impact on their audience.

The process of stop-motion animation traditionally relies on simple movements to each and every object in a set that is required to move. These are shot incrementally on a camera frame and the process is repeated again and again until the frames are eventually seen together in quick succession, thereby creating the illusion of movement. Film made in this way is created by dedicated enthusiasts who revel in an extraordinary attention to detail, the artistry of the form and its ability to transport an audience to a magical place that is engaging and very distinct.

Perhaps unsurprisingly, stop-motion animation came out of experimentation and improvisation with film through the work of J. Stuart Blackton and Albert E. Smith and later Arthur Melbourne-Cooper, Emile Cohl and Giovanni Pastrone. The work of Starewicz and Willis O'Brien, who eventually helped created King Kong (1933), progressed the technique either side of the Atlantic, but it was Ray Harryhausen who took the form to new heights with two must-see films, Jason and the Argonauts (1963) and Clash of the Titans (1981).

In this historical line-up, the work of George Pal deserves a special mention, as does that of two of his close compatriots, Trnka and Jan Svankmajer, all of whom have influenced the work of creators producing work in the field today such as The Quay Brothers, Tim Burton, Henry Selick and the Japanese animator Kihachiro Kawamoto.

But some of the most complete and celebrated examples of stop-motion, or more properly Claymation, are Nick Park's creations through the Aardman studios in Bristol, UK, particularly the short feature films A Grand Day Out (1989), The Wrong Trousers (1993) and A Close Shave (1995).

While stop-motion animation has achieved extraordinary popularity in the world of children's entertainment, it is certainly not restricted to that field. Indeed, it has been successfully used in information, commercial and educational contexts. Although 3D CGI technology is advancing at a rapid pace, the authenticity and individuality of stop-motion, in many respects like live theatre, ensures that films are given the attention they deserve.

The connection with theatre extends beyond notions of authenticity, as the technique of stop-motion is akin to acting on stage. Many animators, including Suzie Templeton in this section, have referred to the process of acting and, in particular, to the degree of over-dramatization through movement and gesture of the models required to register these visual statements on film. Similar adjustments are also often present in pre-production situations such as storyboarding, script development and in technical areas such as camera holds and advanced lighting techniques.

The processes described give a clear indication that stop-motion often involves extraordinary levels of teamwork and shared knowledge to make ideas a reality. The film Peter and the Wolf (2006), directed by Templeton for Breakthru Films and showcased in this section, was very nearly six years in the making. It had a crew in excess of 200 people, spread throughout several countries during the pre- and post-production phases. Added to that the level of risk involved in funding and producing this type of project, and it quickly becomes clear that stop-motion is a very special form of animation.

Smith & Foulkes

UK / nexusproductions.com

Coca-Cola Videogame

2006 / 00:01:00

Commissioned by agency Wieden + Kennedy in Portland, Oregon, on behalf of Coca-Cola, directorial pairing Alan Smith and Adam Foulkes have created a feel-good film in Coca-Cola Videogame. The deftness of touch needed to transport an experienced and knowledgeable audience base into a world that goes beyond the limits of games like Grand Theft Auto means that the film encapsulates its target market largely by suggesting the future possibilities of the game and game play in general. By default, this sense of showcasing the future also espouses the identity of the brand.

Here, Ray, the toughest tough guy in the toughest part of town, spreads a little happiness through a world of thugs and lowlifes, ending with the mean streets turning into the biggest street party, all in tandem to the Paul Williams vintage track You Give a Little Love. In just 60 seconds, Ray turns from being a possessed aggressive driver in a monochrome setting, who thinks nothing of mowing down pedestrians and crashing into fire hydrants, into a character who puts everything right with the new Technicolor world, after downing a chilled Coke from the fridge of the local convenience store.

 The storyboard is worked roughly into colour to give the animators, directors and clients a sense of the mood of the piece.

→ Adam and Alan created these rough storyboards in direct response to the script, showing key frames where significant action points would occur in the commercial.

1. We start on the rear view of a beaten up car dodging traffic.
2. As the camera pulls up the car continues to drive at speed
3. The car fishtails round a corner
4. narrowly missing an old blind guy who is slowly crossing the road.
5. The trunk swings out and nails a parked car that explodes as onlookers run for cover
6. The car carries on regardless

1
storyboards

2
animatics

↗ Even though this drawing is rough and sketchy, there is already a clear indication of the pace of movement that Adam and Alan wanted to inject into the commercial.

→ This early 3D animatic enabled Adam and Alan to witness the pace of movement between the characters and check camera angles. Here the figures and the horses have been rigged and have had an initial render applied, together with a suggestion of a basic lighting source.

How did you become interested in animation?
We both came from more graphic design backgrounds, but found the concept of a single design somewhat limiting. It was far more fun to make it move and have a soundtrack. We wanted to tell stories.

How long have you been animators and directors?
Ever since we were students, but professionally for about ten years.

Who or what inspires or influences you?
We always look at a script with fresh eyes and then dip into a vast history of cultural influences when we're searching for inspiration. It could be Pop Art, theme parks, 1970s British comedy, graphic novels or Martin Parr photographs.

Describe your studio environment.
It is a bit of a mess, it has to be said, with books lying around from various jobs. We try not to spend all day staring at a computer screen, then we can actually talk to each other. The pub is good for that.

What is your own personal definition of animation?
We started off editing together bits of live-action footage with graphic elements along with more traditional drawn animation. To us it's about how to get the idea across, no matter what the technique. Animation is more the composite of all these, used to tell a story. When we write a script, for example, we focus on the ideas first, then when that works we might say, 'Why don't we make the main character a puppet?' or 'Can we reduce the environment down to a single sketchy line?' That's why each of our jobs tends to end up different from each other.

↘
This series of images depicts the different dance styles that each of the supporting characters would perform as part of the street theatre that made up the backgrounds.

<u>3</u>
<u>choreography</u>

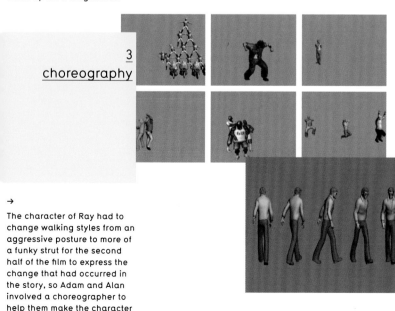

→
The character of Ray had to change walking styles from an aggressive posture to more of a funky strut for the second half of the film to express the change that had occurred in the story, so Adam and Alan involved a choreographer to help them make the character believable.

Adam and Alan were invited to pitch for the job by the US office of the agency that had used the pairing before for a Honda commercial. <u>Wieden + Kennedy were impressed by the duo's pitch, which played on the myriad of possibilities thrown up by the script, and in particular, the idea that difference between good and bad could be highlighted by the shift between a restricted colour palette and full colour, with the product acting as the trigger (1).</u>

Initially Adam and Alan spent several weeks throwing around hundreds of ideas. They wanted to see which ones flowed into each other best, and wanted to push the boundaries of what the audience might find believable within the unreal realm of the videogame landscape.

By brainstorming and loosely storyboarding these thoughts and ideas, Adam and Alan eventually produced an edited animatic that could be approved by the agency and the client. This collection of information helped the team of animators in turn to visualize what they were making. The soundtrack came about as a result of an inspired find by friend and music collector Johnny Trunk. Not everyone was convinced about the visual and sound pairing at first, but after a couple of plays everyone was hooked to the point of continually humming the track.

<u>Back in London, with the visuals and soundtrack approved, the pair decided to start work openly on a 3D animatic (2),</u> where they could plan out the events in a real space, 'We had to know, for example, how far the main character, Ray, could walk in a certain amount of time, and how other characters could be introduced into this space. It all had to be choreographed precisely.

<u>To help us, we enlisted the help of a professional choreographer (3),</u> not only to synchronize the movements of the main characters the audience would see, but for the all-important dance sequence that happens at the culmination of the film.'

To that end, a number of dancers were employed to act out the roles of the different characters and adopt the different personalities in the film, all of which was recorded on film for detailed reference. For instance, the character of Ray had to change walking styles from an aggressive posture to more of a funky strut for the second half of the film to delineate the change that had occurred in the story.

Alongside this process, Adam and Alan began the task of designing the characters and the city architecture to provide a sense of continuity. This then allowed an intensive modelling, rigging and texturing process to be undertaken before the animators could finally get to work. Once in production, the pair directed a crew of up to 30 people, including specialist modellers, riggers, animators, compositors and film texturers. Since neither were gamers, the ability to imagine a world beyond what was possible in that type of environment helped contribute details such as some unusual and complex camera moves.

Eventually everything came together in the compositing phase (4), with a few minor alterations along the way. The animation scenes were created in 3D Studio Max and composited in After Effects FX.

Unsurprisingly, Coca-Cola Videogame took nearly six months to complete from conception to delivery. Given the intensive nature of the project, for such high-profile clients, Adam and Alan needed to retain a certain degree of distance from the project by maintaining their cultural diet. 'It's good to keep an eye on as much cultural brain food as possible, without going mad.

We are as much influenced by trash TV as by High Art.

As far as the animation industry goes, there are lots of great people making great work, more so now because the easier access to technology has democratized the industry. You just have to make sure that you are doing the work the way you want to do it, rather than be distracted by others.'

Adam and Alan have some very pertinent advice for potential creators, from the perspective that they share as a creative partnership: 'First decide what role you want to do. Specialize in one thing to start with; it could be design, editing, effects or character animation or directing – you don't have to do it all because that's what collaboration is about. If you want to direct, then concentrate on writing and ideas, taking risks, surprising people, and forming your own identity.'

Coca-Cola Videogame retains a charm and a sense of optimism, a spirit not altogether easy to keep on track given the length of time creating the project. Adam and Alan believe this in part is down to the way that they work as a pairing. 'We're noted for our patience (5).

Days go by sometimes and you can't see any obvious result for your efforts, but it comes together in the end.

You also just need to do stuff over and over again until it looks just right – if you're directing then your main skill is knowing when it looks just right.'

4
compositing

Two preliminary frames taken from the concluding scene of the commercial show how the layers of supporting characters, objects and background were built up in low resolution before being enveloped, textured and lit in the final render.

A selection of the final stills from Coca-Cola Videogame show Adam and Alan's humorous take on the world of the videogame. Since neither were gamers, the ability to imagine a world beyond what was possible in that type of environment helped contribute details such as some unusual and complex camera moves.

5
final film

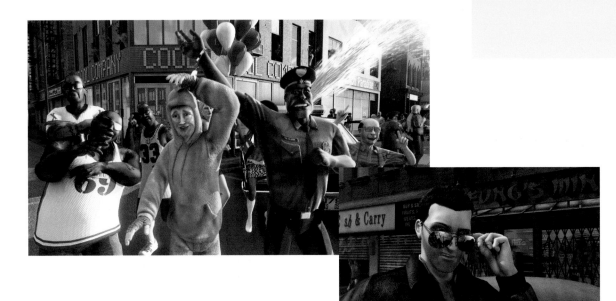

Marc Craste

UK / studioaka.co.uk

Lloyds TSB
For the Journey

⊙ featured on DVD / 2007 / 00:04:00

A BAFTA for the film JoJo in the Stars rightfully propelled director Marc Craste towards becoming a household name, yet this is one in a series of highlights spanning a twenty-year career in animation. Marc's work exudes very personalized observations and his attention to detail and references to other sources of inspiration are very much in evidence, not just through feature films but also in commercial work.

Personal interests seen in other work, like the interest in proportion and the scale of the character within the landscape are evident in the showcased film. While this Lloyds TSB: For the Journey plays on the simple idea of a couple who are bank customers journeying through life, the work has important implications for the way financial operations reconsider the relevance and importance of customer relations in a world of online banking where dialogue and personal service is being reconfigured.

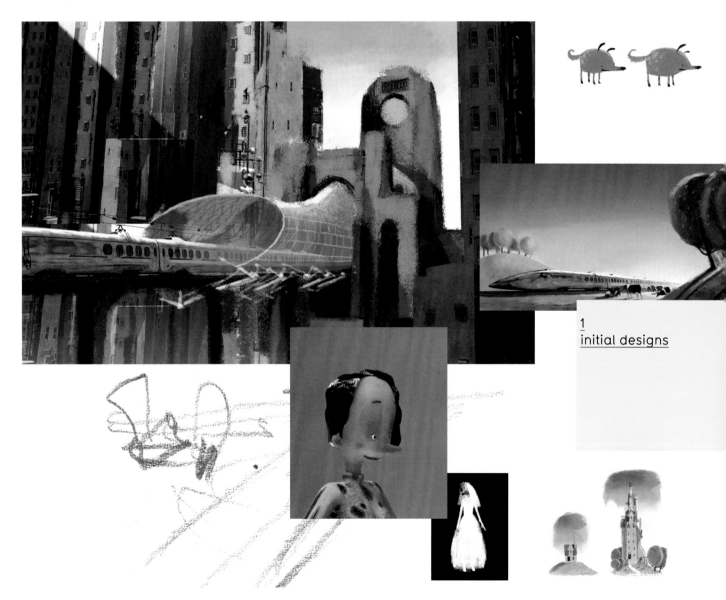

1
initial designs

How did you become interested in animation?
I saw Disney films as a kid. I was knocked out by the artistry involved.

Who or what inspires or influences you?
There are a handful of films I saw in my late teens that I've realized made an indelible impression. Other than that, mundane day-to-day things tend to do it for me.

Describe your studio environment.
Roughly 30 people work in-house at StudioAKA. It is now predominantly CGI, although there are a few light-boxes still floating around.

Is your film funded?
Yes – and being a commercial for a big bank, pretty heavily at that.

Explain how you came up with the idea of creating your film.
The concept of the train as metaphor for the bank, and the couple's journey through life all comes from the advertising agency. My job is to tell that story as efficiently and effectively as possible in 60 seconds.

How do these ideas manifest themselves visually?
The original script had a lot of ideas. The 'time-lapse' effect used in the advert was a way of helping speed through all the material. For example, the newlyweds moving into a new home, having it converted, having a baby and seeing that baby grown into a small child was done in one shot. This, in turn, led to other scenes in which we played with time to make the storytelling more interesting.

Describe your role in the making of your film.
My creative input is mostly up front as a director. I draw the initial designs, experiment with the conceptual ideas and plan the storyboard. After that the studio takes over, translating designs into CG and creating the world around those ideas. From there, my job is predominantly to oversee, approve and liaise with the client.

In the case of Lloyds TSB: For the Journey, the commissioning agency knew that they wanted to work with Marc and StudioKAKA, but usually there would be a pitch for the work, competing with other studios from around the world.

Once the script had been submitted, Marc began liaising with the Head of CGI, Andy Staveley, about how the script would be broken down into key areas that required specialist planning and development, including any characters that required specific lip-synching, unusual expressions and further background characters. Further planning then allowed the pair to categorize the set elements, including the number of exterior and interior shots, particular primary elements such as the train, the cathedral and the folding house, special effects such as the floating flower petals and any additional graphic sequences such as logos or trademarks.

Marc began work creating a series of initial designs (1), including singular character designs and additionally some of the characters placed within an environment, with some further conceptual work to illustrate an approach.

This sequence of events happened in around a week and the key designs, together with the storyboard (2) was sent to the agency for client approval.

2
storyboard

←
Marc's characteristic drawings provide the team with key references to create the commercial.

→
The basic storyboard is constructed to show key frames for approval by the client.

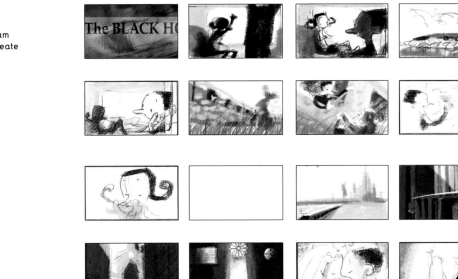

While Marc was working on these elements, the CGI team were busy collecting reference for passenger trains and presenting him with their findings, as Andy comments, 'Within hours of the go-ahead we had an image sheet of passenger trains to present to Marc. Discussions focused on the elements of research he wanted to see in the Lloyd's train and then one of the 3D modellers began to construct the train on the computer. It was vital that this process happened in consultation with the director.' As the head of CGI, Andy's role is a fine balancing act, ensuring that evolving projects, often with extremely tight deadlines, are allowed to develop but not impinge on the carefully planned production schedule.

Once everyone was happy with the overall design, Marc personally storyboarded the script ready to be presented again with the soundtrack. At this stage, a member of the CGI team had created the Block-o-matic (BOM), a three-dimensional version of Marc's storyboard, to enable the director and the agency to see how the 60-second film was taking shape, as Andy explains, 'The BOM is vital to any 3D production. From an approved director, agency and client BOM we have the foundations for making a commercial, enabling not only the director to see the composition and cut of the advert, but also it helps the 3D team plot the exact camera positions of each scene, allowing us to plan how much set will be required and to what resolution these elements need to be rendered.' Following this phase, it became easier to establish the overall scale of the film and Andy was able to divide the creative and technical tasks to each member of the team.

The StudioAKA CGI team is split into two closely liaising entities, namely 3D animators who create and supervise the animated components of each project and the 3D Generalists, who act in the capacity of modellers, riggers, texturers, plus lighting and compositing. For Lloyds TSB: For the Journey, the production time of 11 weeks meant that the roles became all-encompassing as the CGI team battled against the very short deadline.

Following approval of the BOM, the main characters were built, rigged and enveloped by five generalists.

The rigging process (3) involved creating skeletons and animated rigs in 3D, building geometric shapes around this structure akin to Marc's vision and passing these 'structures' to the animators, while at the same time, the character modeller would be sculpting the finished character (4), complete with all of their details and quirks.

When ready, this sculpt was enveloped onto the rig and the 'figure' was exported. Other rigs, including the characters hair, facial features, were then created in the same way.

3
rigging

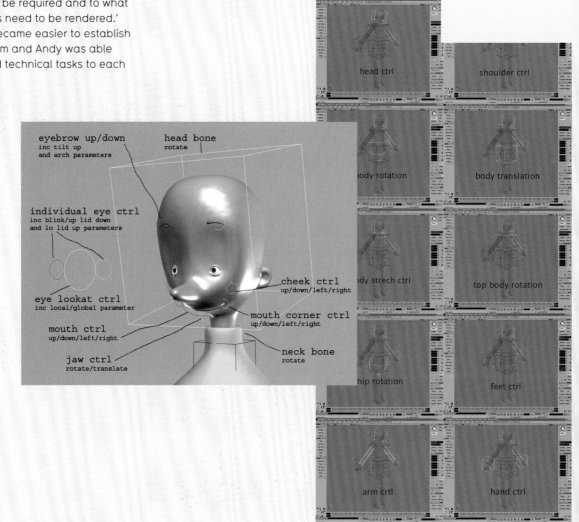

↗
The creation of skeletons and rigs brings Marc's original drawings to life, while enabling scope for subtle storytelling.

Having this ability to produce elements in parallel with one another cleverly enabled the animation process to continue even though some of the characters and environments hadn't completely been textured or given their final details, but crucially, the project was still able to run on schedule.

As Andy states, 'The real requirements with reference models is the discipline needed by the two or three people working on them simultaneously, as the lines of communication have to be good to allow the animator to know they are working with the latest version of that particular character. Reference models can also assist the animator because it is much easier to animate in low resolution with speedy playbacks before enveloping the character in high resolution for playback to the director.'

↓
These images demonstrate how the two main characters, Jane and Pete, age through the commercial.

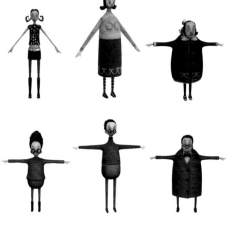

↘
As this triptych illustrates, the initial character studies of the Flower Girl are computer generated to provide familiarity and continuity with other characters.

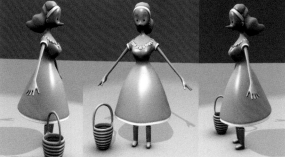

Much of the commercials enchantment is created through the imaginary world that the train passes and that the characters inhabit, and the set design was carefully masterminded by Marc and the CGI team at Studioaka. A combination of artistic prowess and technical ability, the scenery for Lloyds TSB: For the Journey required that the 3D modellers could effectively render the stylistic nature of Marc's vision, while at the same time not be too difficult to texture effectively. The ability to subdivide the backgrounds enabled this process to be undertaken in manageable chunks, where components could be swiftly refined in low resolution before applying a high resolution to envelop these structures.

This process was running parallel to the character development, but as Andy explains, it was already time to start creating the special effects, 'We knew that components like the folding house, the confetti and the drifting flower petals were pivotal storytelling components that Marc had designed to try and expand the idea that a series of lives were being played out in less than half a minute. It was difficult to achieve, and technically extremely difficult to deal with the weightlessness of the forms, but in the end it worked really successfully and gives a dream-like quality.'

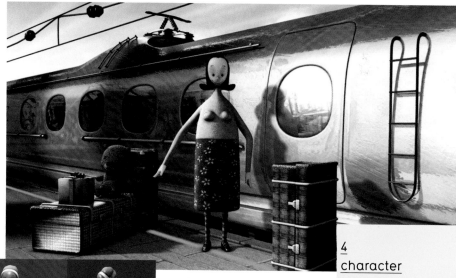

4
character
modelling

The folding house sequence (5) provides a great illustration of the way in which the StudioAKA team worked tirelessly on this commercial so that it would match up to Marc's vision, as Andy comments, 'This type of scene really requires tight integration of the 3D team and again, the schedule would simply not allow us to tackle this section in a linear fashion.

A generalist modelmaker determined the growing house, together with the positions of the camera and the train, while the animator ensured that the characters had time to leave the train, progress through the evolving house, exit through the door and rejoin the train again.

This operation was undertaken by two people, in a matter of eight days, with a further three or four to apply all of the evolving material textures, together with the complex lighting transitions of moving from day to night and back to day again. The only way of achieving this workload is having a team who are dedicated and completely co-ordinated.'

Marc and the commissioning agency met with Lloyd's to approve the commercial, together with a series of final realized key frames to showcase how the finished commercial would appear once it had been fully rendered, including sophisticated lighting additions and additional textured elements. Any changes that were to be made would be easier to enact before the final render had been conducted. With client approval, the technical director was given the footage to apply various passes to create the final cut of the film. Andy explains the process, 'The technical director usually lights, renders and composites the job, predominantly using After Effects.

A single scene for Lloyds TSB: For the Journey typically involved between 30 and 40 passes (6), including beauty, dirt, shadows, depth, reflection and so on. Each pass was additionally separated out to all of the main characters and their sets, so it is an involved process to say the least.'

However, the logic to this process of thousands of individual renders is obvious if the client requests changes to a particular component, as it can be isolated and corrected relatively easily, and is certainly simpler than pulling the whole film apart. All of StudioAKA's post-production is done in-house for precisely this reason.

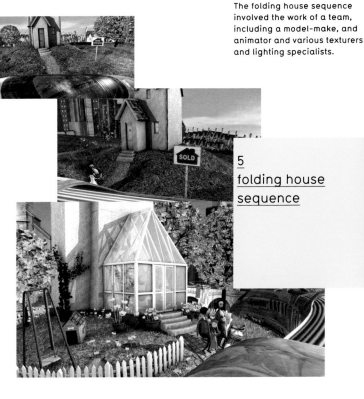

The folding house sequence involved the work of a team, including a model-make, and animator and various texturers and lighting specialists.

5
folding house sequence

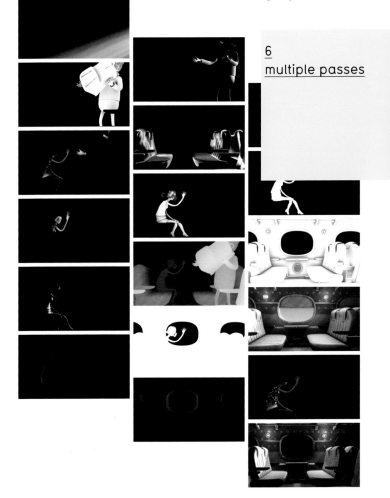

These images show some of the passes applied to imitate shadows, reflections and lighting.

6
multiple passes

Lloyd's have since gone on to commission more commercials following the success of For the Journey, and their current marketing campaign is testament to the huge commercial and critical success of the adverts.

Despite the huge presence of CGI in the series, the figures retain a sense of believability and warmth, testament both to the visionary magic of Marc and the exacting standards of Andy and the rest of the StudioAKA CGI team (7).

7
final film

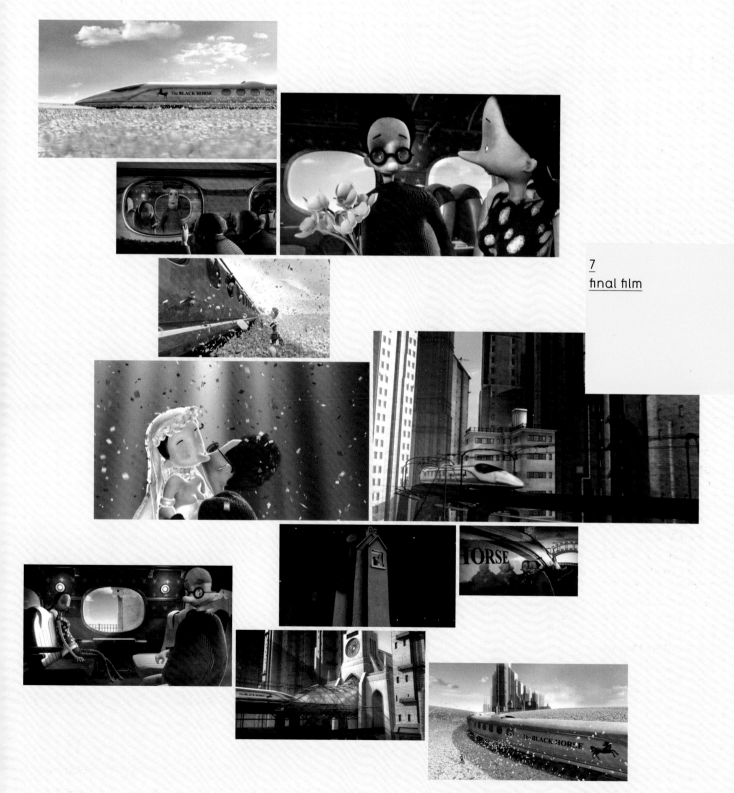

Claude Chabot

France

Apnée

◎ featured on DVD / 2006 / 00:04:00

Apnée is the beautiful, sumptuous first film from French director Claude Chabot. Following a stint working with the inspirational filmmaker Michel Gondry, on high-calibre projects for The Rolling Stones and Smirnoff, Claude wanted to create his own film using frozen-time effects to heighten the tension around a simple but arousing story. Here, the camera appears to float in the air, seemingly defying gravity, and acts as the starting point of a story where a determined photographer, a public figure, his girlfriend and the mysterious driver of a blood-red racing car are all transfixed in a timeless universe. The photographer appears to be safe, protected by his lens but time is working against him.

Seeing Chris Marker's film entitled La Jetée (1962) left a real impression on Claude, exploring the idea of telling a story using a succession of pictures with no voiceover. From that moment on, he became obsessed with time, and wanted to tell a story investigating the relationships between time and space. Despite continuing to work in commercial CGI, Claude found the time to follow his dream in getting Apnée made and distributed.

1
storyboard

2
set modelling

How did you become interested in animation?
I have been working as a CGI artist for many years now. That gave me the opportunity to develop various animation techniques using both live action and CGI. What I am most interested in is to recreate fictional environment from real life elements.

How long have you been a director?
I really started work as a CGI artist in 1991 after I graduated from college, but I didn't start working on <u>Apnée</u>, my first feature animation, until 2001.

Who or what inspires or influences you?
Essentially, I'm inspired by big 'artists' such as Bach, Ingres and Kubrick because they were all looking for a form of classicism, an ideal of perfection.

Describe your studio environment.
A friend of mine once asked me if he could come and film me and my team at the studio for a photo documentary. He gave up the project after a day at the office with us when he realized that people were simply sitting in front of computers, like any other office job!

What is your own personal definition of animation?
Every time I have tried to pigeonhole a subject into a definition, I've found multitude of exceptions to contradict it.

<u>Apnée</u> is originated and developed around three defining principles, namely paradox, mystery and ambiguity. Essentially, these acted as strong defining parameters for Claude, both in the years leading up to the creation of the script and the resulting time taken over the production. Claude explains that the role of paradox, 'Enabled the contrast between the camera's movements and the stillness of the characters, or the time-jumping theoretically impossible in an uninterrupted sequence.

The invisible time-jumping sequences allow part of the reality to resist investigation, changes are only visible afterwards, the technology fails and the mystery is omnipresent.'

Claude was the central figure throughout the making of <u>Apnée</u>, writing the synopsis, directing the shooting of the film and working both on the 3D animation and in a post-production capacity. It was important for him to determine early on the relationship between the characters because, 'The viewer doesn't know. Is there really an accident? We don't know if the photographer is dead because all the characters are still in the movie. Even the point of view is ambiguous, between objectivity and subjectivity."

Claude first started working on drawings and produced a rough storyboard (1). He then researched specific locations in Paris that he felt embodied the nature of the story and then went with his crew to record the locations at night (2).

Claude explains, 'We took photographs using close up and long shots to texture and model the 3D environment. We used the pictures to recreate the street in the studio, and filmed the different moments in time with the cast for two days.

Each scene was then painstakingly photographed by five synchronized digital cameras.'

←

Claude's team searched Paris for the right location to set the film, illustrated in the first third of the panel. The photograph was then rigged and enveloped creating an artificial cloak in Renderman (panels two and three) to mirror the frozen nature of the characters.

Each scene was then in turn modelled in 3D using both ImageModeler and Autodesk Maya (3).

Using both actors and accessories from the photographic series, the modelled images were exported into the program Renderman, used specifically to create the all-important textures that give Apnée it's distinctive look and feel, and so helping to create the ambiguity between the actual and the unreal.

Working on a part-time basis, often alone, this process took almost five years for Claude to complete (4).

He was ultimately responsible for testing out different variations of both imagery and sound until he was satisfied with how the film looked and felt, 'We worked on the post-production for some time. Many versions have been worked on in low resolution to improve the finish of the film. The soundtrack was completed on the low resolution version while I was finishing the high resolution visuals to save time.'

Claude acknowledges that without the dedicated crew, Apnée would have taken far longer to complete, 'We had a 20-person crew, four actors, some photographers and all the general film crew for the shooting process. In addition I also had ten graphic designers helping me with the design of both the 3D environment and modelling. While some worked only a few days, others stayed for a number of weeks. I am particularly grateful to Stephane Scott, who composed the music and to Dominique Dalmasso and Xavier Langlet who were responsible for finalizing the DTS master.'

The film has been widely received by festival audiences and jury selection teams. While Claude is pleased with these plaudits, he is keen to emphasize that the film does more than simply explore a particular set of technologies, 'I am using computer technology because it is the way people are producing animation these days, if I've been working in the Stone Age I might have used a shadow play, the result would probably have been slightly different but we are not supposed to focus on the technique here, what is important is the result.' To that end, Claude is intent on focusing on more traditional methods using actors and cameras for his next film.

His determination to complete the project has been admired by many, but questioned by some. Being a director can sometimes require a single-mindedness that others find difficult to accept as Claude explains, 'As a director you will have to overcome all the obstacles you are undoubtedly going to come across, and most of all you'll have to resist well-intentioned people who truly want to help by changing just a little the way you are working. Being obstinate is probably the best quality you will need to succeed.'

← ↙

Three triptych panels from
Claude Chabot's <u>Apnée</u>
illustrating the process of
creating the main characters
from the film. The images of
the photographer show the
fully rendered and textured
version, the skeletal rig and
the first render respectively.

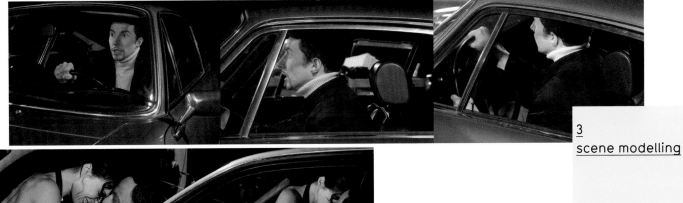

<u>3</u>
scene modelling

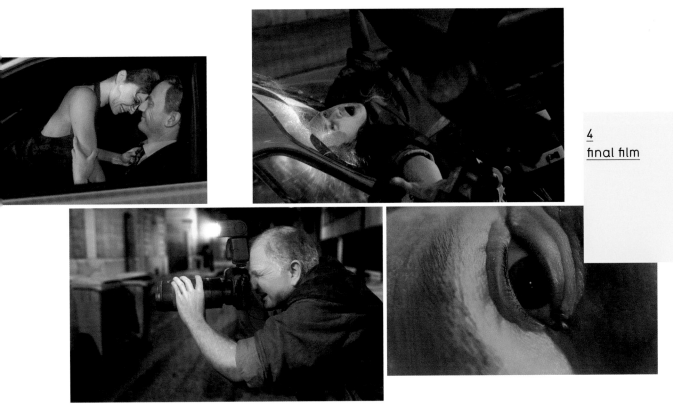

<u>4</u>
final film

Robert Seidel

Germany / robertseidel.com

_grau

© featured on DVD / 2004 / 00:10:01

The astonishing visual beauty and delicacy of Robert Seidel's _grau is framed by the desire to attempt to catch a moment where time appears to stand still and we recognize how fragile life can be. One winter night, as Robert drove home from a university where he had been researching for the film, he almost got crushed between two trucks; the one in front braked hard while the one behind could barely stop. Thankfully nothing happened in the end, but the event and Robert's reaction to it prompted him to consider his past and to capture this in a finalized state.

_grau examines the aftermath of a car accident through the short moment where all condensed memories rush by. These past events are presented in a sculptural structure that emerges, fuses and erodes on an emotional level to finally vanish. The film is not a plain abstract, but instead a very intimate snapshot of a whole life within its last split seconds of existence.

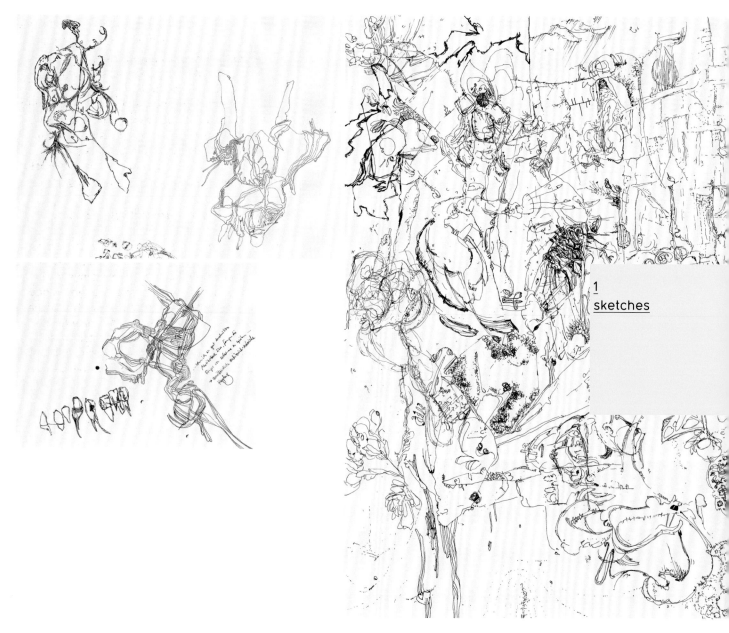

1
sketches

How did you become interested in animation?

Besides a childhood fascination for colourful and sometimes surreal animation from the DEFA studios of East Germany where I grew up and other Eastern European studios, my dad introduced me to computers (a C64) in the beginning. I was amazed what imaginary worlds could be created in games and how you could relate to some crudely moving pixels on an emotional level.

After a while, I realized that it was more exciting not to consume passively, but to create my own works. These were still images and a little programming at first, then a growing fascination for 3D rendering, which finally turned into animation. After my first more or less experimental short Lightmare, I spent a lot of time researching, as I felt I was facing problems that had already been solved by others, and found a world of highly inspiring animation artists.

How long have you been an animator and producer?

My first serious animation, Jenseits von Salat (Out of Salad), which was more than just playing around with ideas, was done in 1999. My teacher hated it and told me to study computer science instead. I was so discouraged that I stopped for over a year before starting to work on Lightmare.

As all of my pieces are fully created by me, I never really thought about film-specific terms. In addition, I didn't learn animation at university because there were simply no animators, so my vocabulary is somewhat weak in that field. But you could say I became a producer in 2004 as _grau relied on lots of people to co-ordinate its construction.

Who or what inspires or influences you?

My first inspiration is nature, with its endless colours and forms, and all the beauty and drama within landscapes, animals and plants. Food inspires me a lot too. A good meal is like a sculpture, where every part is well chosen, prepared and arranged. I even studied biology for a year because I wasn't sure what I liked most.

My second source of inspiration is fine art, telling us how to perceive the world differently and there are, of course, computers, with their endless possibilities to combine things without ever being afraid of breaking something. Besides that, my imagination is sparked by friends and family. They give another dimension to some of my often very personal and abstract ideas. And I like to be surprised by the thoughts of viewers when I present my films, as this adds another layer of meaning.

Describe your studio environment.

I work in my little flat in a grey building block in an area called Winzerla, a part of my hometown, Jena. It's basically a mess, reminiscent of the studio of Francis Bacon. Sometimes I would like to have a bigger space so that I don't only spend time in front of the computer or drawing, but when I'm fascinated by an idea the studio becomes invisible to me, mostly until I need to find something under the stacks.

What is your own personal definition of animation?

Animation is creating movement between frames, but also giving the possibility to create something unlikely within every following frame. I love it for sparking the imagination, rushing through images or creating formations changing so slowly that the spatial and temporal perception is challenged. Animation can be experimental, entertaining or explanatory in images, movement, sound and narration, all of which makes it a very complex art form.

←
A large number of sketches were created in pre-production. After the turning-point in the story development, these encompassed a more personal feel, ranging from reflecting memories to a diary view of the moviemaking.

All of the imagery for _grau was created by Robert, using drawings, paintings and other 'real' sources that were then subjected to distortion and filtration before being placed into the film. Robert explains: 'I tried to create a very personal vision that was based on "me", showing very different moments in a continuous stream.'

In the beginning, the film wasn't about a car crash, but instead based on a discussion the creator had with a friend, centred around whether life was only 'black and white' or, as Robert argued, there was the 'in-between'. He wanted to create a pure, abstract film and forget about all the commercial sufferings, and _grau (the German word for 'grey') became that reality.

The film started with ideas and a lot of sketches to sort out which events could be strong and possibly worth pursuing (1).

In parallel, Robert worked on the computer trying to recreate them and achieve some unique moving quality.

'I felt that it was better not to create everything with full digital control, so I decided to go out of my room and capture parts of my body like my head, brain and teeth and their movements with the help of certain scientific methods. For example, the furry structure is based on an MRT scan of my brain.'

Scientists allowed Robert to use their expensive technology to capture images of body parts and developers created bridges between his ideas and the virtual reality on screen, a feat difficult to achieve without the specific tools.

When the car crash almost happened, Robert was able to shape out ideas more clearly, because it wasn't about the 'in-between' in general, but instead all the thoughts, memories and recollections that were ambiguous. As _grau begins, the accident itself is visible; sparks fly, glass shatters and the headlights refract into pure colour. After this event, everything turns almost black and white. The canvas begins to open up, showing the nostalgic formation of bracelets against the white winter backdrop, where more miniature parts of the condensed life unfold. Robert describes this editorial decision: 'Some components expand arbitrarily; others turn up because they were important incidents in my life. In the end, the "decision fur", based on the geometry of my brain, shows where every hair represents a decision. All the hairs together build up to a "thorn", a metaphor for the accident itself. So in the last stages of the film you see the diagram of a whole life and the fatal action that ends it.'

Robert began to rearrange all the fragments in an attempt to come up with segments that fused the different parts together, creating an unconscious, biographical flow (2.1).

However, the process of creating a visual vocabulary that represents something that can't automatically be described was a challenge, especially when its cognition might not immediately be shared by someone else in the audience. Robert explains, 'As soon as you look at it, you are shifting the subject's perception. And looking at some person or actor won't create the same brain patterns.' In the end, the film provided a vehicle for people to become lost in the mesmeric quality of the sound and image landscape; Robert realized that people saw different qualities and brought their own conclusions away from seeing _grau.

Having worked for two years on commercial 3D animation projects, Robert thought that he had a trusted source to create his soundtrack, but, as he reveals, some plans don't always reach fruition. 'This person was planned to create the soundtrack, as he was a musician who wanted to produce CG movies and I helped him on a full-time basis to reach that dream. But as honesty wasn't his virtue I desperately needed to find new musicians at the last moment.' Luckily, musicians Heiko Tippelt and Philipp Hirsch helped, creating the collaged sounds freely, based on seeing some roughly cut film versions and talking with Robert.

Without the computer, it would be impossible for Robert to realize his ideas and to achieve the complex level of visual interplay present in the film. His curiosity to experiment with technology in the form of his PC and programs like 3D Studio Max and After Effects enabled him to blend the abstraction of crude, ambiguous pixels with the complex and absorbing technologies for photorealism. Despite his reliance on technology, he is quick to express his views about the limitation of technology alone, preferring instead to express his ideas about content: 'It's really not about the software, but the time and ideas you spend creating something it wasn't intended for. Nobody asks a painter what brushes he used, but everybody believes certain software creates an artwork instantly.

I like to connect potentially rough ideas that leave much space for the viewer with the possibilities of complexity the new technology provides to explore something emotional, abstract and organic.'

→
The prismatic beginning of _grau shows colourful reflections of breaking glass, turning metal and flying sparks. This pseudo-reality fades into the white winter background where the memory sculptures of Robert's life become visible.

→
A build-up of black dental structures, recreating the feeling of the braces that Robert used to wear, connected with all the reactions and feelings related to them.

→
The tranquil scenery is based on a 3D scan of Robert's head. Here the soundtrack by Heiko Tippelt and Philipp Hirsch disappears completely, leaving only environmental motorway noises. This works impressively in large cinemas, leaving the audience wondering. At the same time it is a comment on the fact that even the most isolated places in this world don't have their own, untouched soundscape anymore.

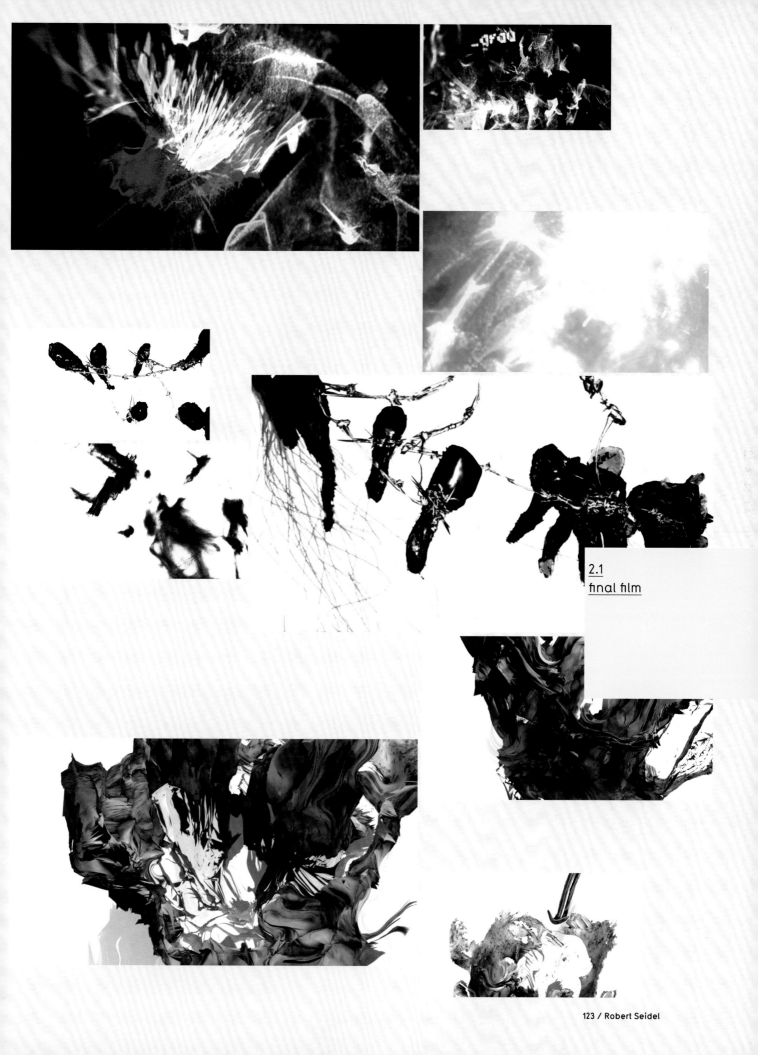

2.1
final film

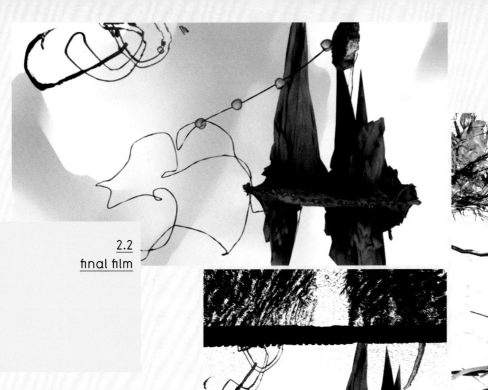

2.2
final film

↑ →
The skull turns into a needle and begins to deform a button. In combination with fragments of fishing lines, hairs and lice brushes, this metaphorically signifies a dense portrait of childhood.

↑ →
At the end of _grau the 'decision fur', based on an MRT scan of the animator's brain, shows up. In this furry structure, every hair strand represents one decision in Robert's life, ultimately resulting in the accident itself, represented by the thorn.

← The twisting and fusing metal flowers resemble parts of the motorway, cars and bodies intertwining dramatically into a morbid sculpture against the glowing winter backdrop.

← One reading of this growing and fading fragile bone structure could be the microscopic view of the body transformation during the car crash but, as Robert states, the audience are welcome to find their own interpretations.

The whole production was an exhausting but wonderful time (2.2).

It generated a lot of ideas that were never used in _grau but that will be refined in other long-term projects. While the production took about nine months, the basic idea had been conceived roughly two years prior to embarking on the film. Robert suggests that the thinking behind the film goes back further still: 'It surely took my whole life to be able to create _grau, as all the things I learned and experienced went into the making. That's something people tend to forget. _grau is still my strongest piece, because after that I only created smaller projects, even though I have another extensive project. Currently, I'm not yet able to realize the ideas on an emotional and technical level. And I have to make a living or like to spend some time on festivals, so it's hard to concentrate, as I never get to the point where I feel free to work on it.'

Robert's work is thoughtful, engaging and exacting, brought about by a quiet, observant view of the world that surrounds him. He is a reflective filmmaker in many ways, one who is in tune with the audience because one suspects he enjoys being an audience member himself. He is wary of the cultural climate in which his work is viewed; 'I believe it's good not to try to create something for the audience but for yourself and if it's strong enough it can connect.' Robert also states that, 'There is certainly a pressure to survive as an artist and some people like this, exploring and inventing things because they have no other chance. But I feel somewhat overwhelmed by that. When I do a job, I need some time to get back to my senses, but usually the next job is calling or something else distracts. I think these times honour fast, exciting work rather than slow, dense ideas and so everything I did after _grau has a different tone while I struggle to maintain its complexity to allow a broader reading.'

Robert's advice to other animators is measured and deliberate too. 'As a human being, first take a broad look at the world. Then add some animation and finally develop your own style over the years. Animators who know only the commercial or the experimental sphere miss a lot of the beauty this medium has to offer. Some beginners tend to think they invented the wheel, but people like Oskar Fischinger or Maya Deren probably created something more beautiful decades ago. Understanding the technical side of animation also won't prevent you from creating something original – there is always hard work and not a "make perfect movie" button involved.'

Suzie Templeton

UK, USA / suzietempleton.net

Peter and the Wolf

◉ featured on DVD / 2006 / 00:32:00

BAFTA award-winning director Suzie Templeton's charming adaptation gives a new visual twist to Prokofiev's much-loved story of a world where small boys can succeed where adults fail, where they can capture wild wolves and overcome terrifying bullies. Created specially to be accompanied by live orchestral performance, the film manages to tread a very fine line between providing a visual ambience while not completely detailing the narrative. Indeed, the synergy and dynamism between the images and the music is one of the film's great strengths. This has earned Suzie and the team at Breakthru Films and Se-ma-for Studio in Lodz, Poland, many plaudits, including an Oscar for Best Animated Short Film.

The film centres around a boy named Peter, who lives in poverty with his over-protective grandfather. Rejected and bullied by all the local children, his only friend is a dreamy duck who lives in the yard. One day they find a crazy new playmate, a rumpled old bird, who encourages Peter to defy his grandfather and venture out into the dark forest. There they encounter his grandfather's worst fear – a very hungry and menacing wild wolf. But Peter is made of strong stuff and finds extraordinary courage from deep within. After a fierce struggle, he catches the wild animal on the end of a length of rope and in triumph he takes his fearsome opponent to the nearby town. For a while, it seems he is the local hero. But he has grown, and he soon realizes that he cannot, with integrity, entrap another wild spirit. With great danger to himself and to the dismay of everyone else, he frees the magnificent wild creature, which runs back to the forest.

1

sketches

←

The original full-length drawing of Peter's character was translated into a scaled plan for the armature to be made.

126 / Suzie Templeton

How did you become interested in animation?
Seeing Jiri Barta's <u>The Vanished World of Gloves</u> really inspired me and then later, Wallace and Gromit in <u>A Grand Day Out</u> was a favourite.

How long have you been a director?
I studied animation between 1996 and 2001 and have worked as a writer and director since then.

Who or what inspires or influences you?
I am inspired by many things, including painting and other visual arts, music, books, memories, feelings, people, experiences and stories.

Describe your studio environment.
At the moment my work is in a development phase, and I'm working at my friend's studio in Amsterdam.

Early in 2002, Suzie was approached by Hugh Welchman, a producer at Breakthru Films, and Mark Stephenson, a conductor, who asked her if she'd be interested in adapting the story of <u>Peter and the Wolf</u> for live orchestral performance. Suzie describes her reaction: 'Had they not suggested it, I don't think I would have chosen something so well-known and well-loved, and more importantly, a piece that exists so brilliantly in its own form without need of visual representation. I hadn't listened to <u>Peter and the Wolf</u> since I was a child, but as soon as I did I was gripped by the music and filled with creative desire.' The idea of working with live performance was hugely inspiring for Suzie, and she saw within the story great scope to explore our fascination with the wild and longing for our lost relationship with nature and animals.

Suzie wanted to stay faithful to Prokofiev's music but, at the same time, to allow the film and the story to develop its own life. She was also clear that she wanted the film to be multi-layered, enabling it to work for both adults and children. The most difficult part of the film's preparation was scripting to fit a pre-existing and well-defined narrative and musical shape. Suzie explains that a key decision regarding the film's construction was made as a result: 'Because the intention was for the film to play with live orchestral performances, I decided to drop the spoken word in the form of narration or dialogue and to tell the story only with music, action, design and other visuals.'

Suzie adapted Prokofiev's story into a script and storyboard, fitting each story beat and arc to the pre-existing score over a period of two years. <u>The writing took the shape of a conventional script, although Suzie worked with sketches (1) as well to plan the action.</u>

In particular, key sections like the rope sequence between Peter and the Wolf required much visual working-out at this stage. The script itself was extremely difficult for Suzie to write: 'First, the film was on a totally different scale to my previous two films, so the story requirements were all new to me. But the most difficult element was writing, in effect, back-to-front, so rather than allowing the ideas to find their own intricate final shape, the challenge was to create story and character situations to exactly fill an existing detailed musical form.' In parallel with wrestling with the script, Suzie also designed the main characters and did an animatic section of the film for marketing purposes.

The storyboard and animatic would be crucial to communicating with the specialist puppet animators at Se-ma-for. After scripting, Suzie made a very rough thumbnail storyboard, but it was immediately clear that it would be better to work directly on screen in a timeline with the music. She jumped straight into the animatic phase and, because the storyboard was so unprocessed, much of the basic scene drafting was carried out in the animatic. In many ways, this approach proved ideal creatively, but it was extremely time-consuming, taking a year to complete between England and Poland.

Suzie worked with Martin Clapp using Autodesk Maya to create the detailed animatic: '<u>The final Maya animatic was extremely detailed and formed the basis of all planning, whether that was set design, set splitting, scheduling, camera position, basic action or acting (2).</u> The animatic gave us a visual form of communication that was especially useful in our multi-national team where language was often an obstacle.'

<u>2</u>
animatic

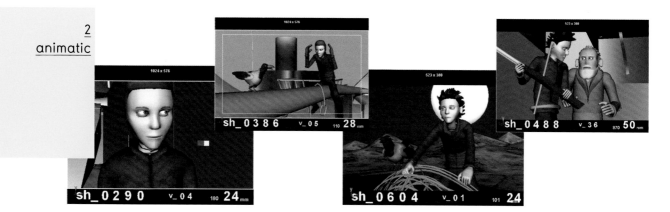

Work then began designing the characters. Modelling Peter's head was the very first task undertaken in Poland. As the crew's talents weren't known to the team travelling from England, an open competition for anyone who wanted to develop a Plasticine maquette of Peter's head under Suzie's direction was initiated. Suzie explains, 'Very soon, I was working with 13 sculptors making maquettes of Peter, which combined my original illustration of Peter's face with some photographic and artistic research and with the boy character from my previous film Dog.

There were many interesting interpretations of Peter, but the work of one sculptor Ewa Maliszewska, really stood out (3).

We seemed to understand each other, despite not being able to speak a word of each other's languages. After about ten versions, Ewa managed to capture Peter perfectly – exactly as I had imagined him, but even more beautiful.'

Then came the laborious process of converting the Plasticine maquette into a working puppet. This involved much more work, many techniques, specialities and materials. Several sculptors worked on each character, whether that be hands, body, head, skin textures and different expressions.

Moulds were created from the sculpted body parts; a silicone expert was brought in to develop the skin textures; a make-up artist painted the silicone; armature makers developed the metal armatures and the finishing department made items such as clothes and hair (4).

Suzie worked with a production designer to design the set. 'I began working with Jane Morton (Ratcatcher, Morvern Callar) during the scripting and animatic processes and Martin Clapp created a model of her plans, again using Maya. We were then able to adjust the plans according to the requirements of the studio and do a lot of technical planning using both the animatic and the Maya set design. Jane could not come to Poland so she handed her designs over to Marek Skrobecki, who finished the more detailed elements of design and oversaw the build. The main forest and town sets were made in 1:5 scale, while the interior of the grandfather's house and some duplicate locations were constructed in 1:3 scale, allowing more detail in the puppet design.'

Most of Suzie's daily work during the shoot involved setting up each shot, of which there would be several per day, in two shooting locations (5).

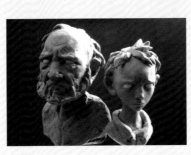

Plasticine maquettes created by the Polish sculptor Ewa Maliszewska and directed by Suzie would become central reference figures throughout the development of Peter and the Wolf.

3
character design

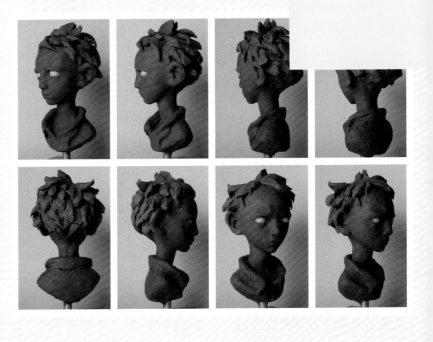

The character of the duck, carefully sculpted, is ready to be given its downy feathers by the modelmaker.

4
finishing puppets

Peter's head is beautifully finished by one of the talented team at Se-ma-for.

128 / Suzie Templeton

Choreographed dope sheets were created from the animatic allowing frame-by-frame direction of the movements in addition to working with the animators to pose the characters and to communicate exactly what was needed from the acting in each shot.

The cinematographers would light the shot as the set decorators worked and made sure the animators had enough access to the puppets. As soon as the shot was ready to shoot, Suzie moved onto setting up the next shot, so the entire process of animation was generally done without her. This made the act of communicating with everyone essential.

Suzie edited each shot into the film as soon as it was shot to make sure that it worked: 'I always tried to do this urgently before the shot set-up was dismantled, just in case a few extra frames might be needed or some small adjustment or additional work was needed to cover any mistakes, because we didn't have any time for re-shoots. Crucially, I had already done much of the editing work, including editing the frames within each shot, before the final editing phase, considering there were 30 or 40 internal edits in some shots.'

For the final editing phase, the editor of <u>Peter and the Wolf</u>, Tony Fish, came out to Poland for ten days and the edit was fine-tuned. As things were so tight, shooting still continued during this phase so there was a very finite time to spend on the edit. After the premiere, Suzie then went to Oslo for a further month to work on the online edit.

<u>It was a huge crew and production effort, with almost 200 people involved in various stages of development and production. Despite the gruelling schedule, Suzie is clear about the effect Peter and the Wolf has had on her career: 'This film was a very steep learning curve for me in learning to work with a crew. I feel prepared now to make a full feature film.' Given the reaction that the film has received, the wait might be lengthy but will surely be worth it (6).</u>

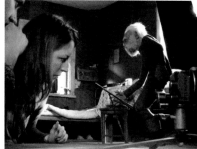

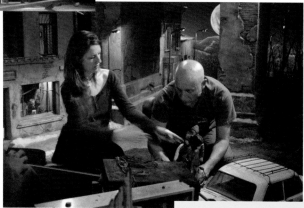

↖ ↓
Suzie's daily work during the shoot involved setting up each shot in consultation with the animators and the director of photography.

5
on set

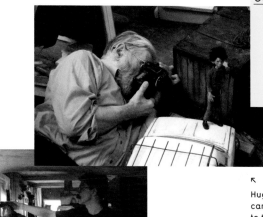

↖
Hugh Gordon, behind the camera, gives a sense of scale to the set and characters.

←
Lighting levels on set are carefully adjusted by an electrician.

← ↑
The animators make incremental adjustments to the models by hand, and use tools like tweezers to create minor and delicate movements.

129 / Suzie Templeton

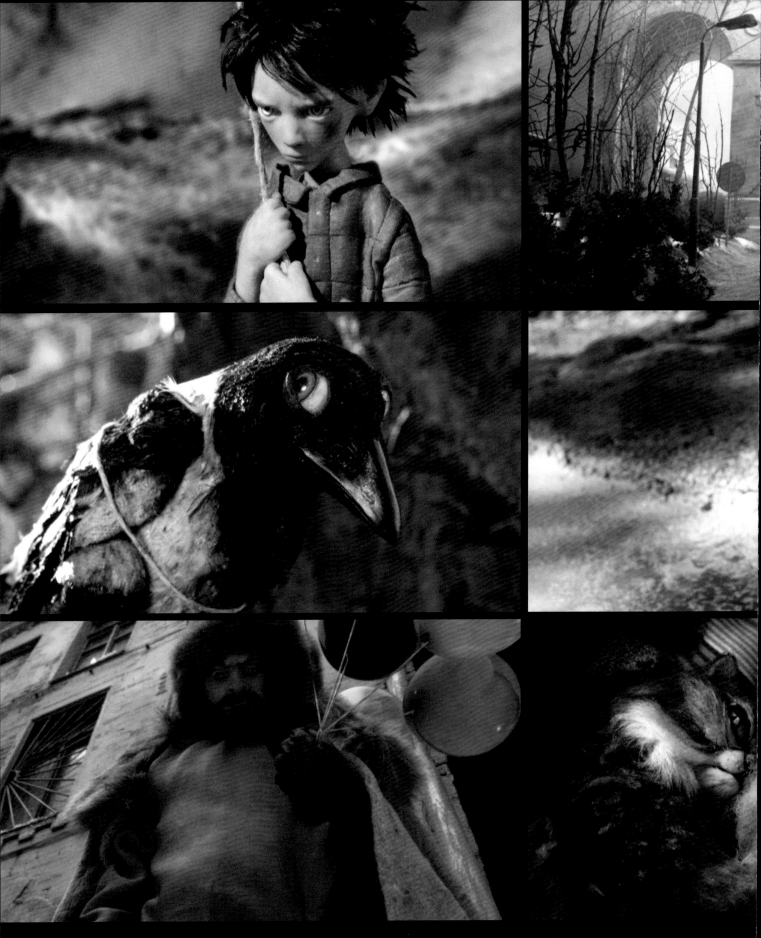

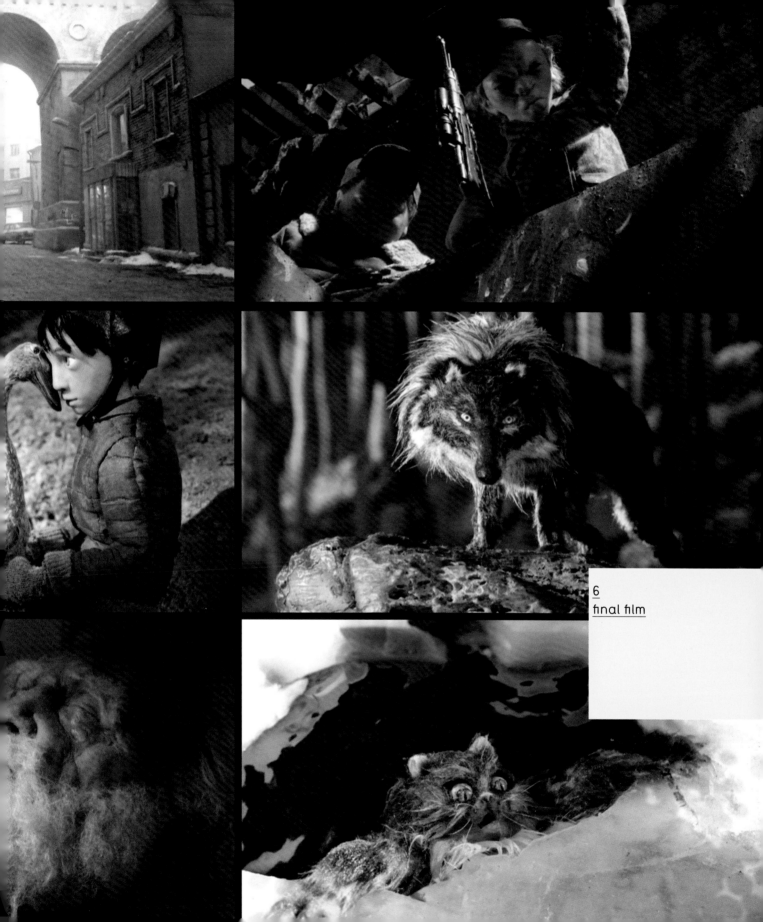

6
final film

Guilherme Marcondes

Brazil / guilherme.tv

Tyger

◉ featured on DVD / 2006 / 00:04:30

The hugely chaotic and complex city of São Paulo proved a rich source of inspiration for Guilherme Marcondes in creating the award-winning Tyger. This animated short film uses puppetry and computer animation to tell the story of a giant tiger that mysteriously appears in a sprawling metropolis, revealing a bewitching hidden reality in an otherwise ordinary night. The film is an amalgamation of several ideas collected over a couple of years and originates from a desire Guilherme had to depict his hometown in a project that would capture the vibrancy and complexity of São Paulo.

William Blake's poem The Tyger gave Guilherme an opportunity to explore visual narrative through a variety of mixed techniques strongly related to music. Tyger allowed these ideas and inspirations to come together in the same piece of work and can, perhaps, be said to illustrate his thinking process: many small fragments that later connect into a much larger landscape of visual, emotional and thought-provoking imagery.

<u>1</u>

puppet construction

←

Following advice received from several puppet makers, the multi-jointed tiger is first carved and pieced together before being painted by hand.

←

Puppeteers Cassiano, João and Fábio pose with the main character.

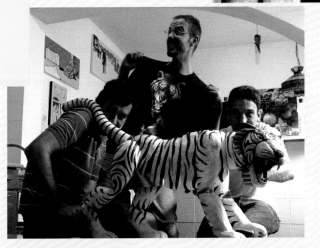

How did you become interested in animation?

As long ago as I can remember, I was already drawing. I drew obsessively as a child. I also watched a lot of animation on TV. I guess I was always interested in it. Professionally, I only decided to work in the field when a friend invited me to design some characters and do some assistant work in an animation studio he owned called Lobo, in Brazil. I was in Architecture School back then so I had to split my time between that and the internship.

How long have you been an animator, director and creator?

My very first animation film was done during my internship at the animation studio. That was late 1999. I directed, animated, did almost everything. It was very simple, of course. I've been working with animation ever since.

Who or what inspires or influences you?

Besides film, I love comic books, pop music and architecture. Movies can give you direct inspiration showing palpable solutions the directors find to solve the problems in their own films. I think it's also good to look for inspiration in other fields of art to break the loop of self-reference. I'm interested in works that are somehow crossovers of art forms, like music videos, soundtrack music, installations or video art related to architecture.

Describe your studio environment.

I've been working from home here in Los Angeles in the last few months so I'm in a private space now. I used to work in a studio, sharing space with other people so I couldn't create all the mess I wanted to! It's great to have open books, sheets of paper and magazines everywhere.

What is your own personal definition of animation?

Animation is just a film technique; any frame-by-frame film technique. It may be disappointing to some animators to say that but I don't mean it in a disrespectful way. It's all film to me. It doesn't matter if it's animated or live action or both. Most directors will choose to work with only one of those means but there's no essential separation between them. Digital technologies are currently helping the audience to understand that. Now there is a much greater number of production mixing techniques because it's easier to do.

Guilherme is clear that the history and contemporary experience of living and breathing the soul of São Paulo was a huge driver for the origination and production of Tyger, and, in turn, believes that the poem ably provided a structural framework to help channel thoughts and visual statements about the city.

As he explains, 'The way all the styles and techniques clash to form the final image is the visual translation of the way I like to work.

One thing people always ask me is why there are visible human silhouettes manipulating the puppet. That's a reference to a line in the poem that questions the origin of this supernatural animal; "Was it created by God?" "Is it the image of a human desire?" There's no answer to that in the text. I thought that using the direct puppet manipulation and showing the controlling dark figures was the perfect visual translation of that mystery.'

Tyger was produced in response to a successful grant application that Guilherme had made to Cultura Inglesa, which included his concept for the film, a collection of rough frames and visual references, together with a list of potential collaborators. With the money approved, Guilherme started work in close partnership with his wife, Andrezza Valentin, to develop the script. He acknowledges her vision for the film in the early stages: 'She's always with me in the early stages of any of my projects. She has a fine-arts background so that helps me to see films from a different perspective.'

The influence of this second opinion manifested itself in how Guilherme managed the rest of his production team. Although he had clear ideas about certain elements, such as the atmosphere he wanted in the film, he was open to advice about how best to achieve this. 'The rest of the team had a very precise brief from me of what I wanted to achieve in terms of the mood of the film, but I didn't give them much visual reference. I wanted everyone to give his or her fresh input. It was like posing a single question to everyone, waiting for their individual answers and then putting it all together to form a unique vision.'

With a rationale firmly established, Guilherme started designing and building the tiger puppet (1). He arranged meetings with the puppeteers from Cia, Stromboli to understand the best structure to create for the tiger that would enable maximum movement, in accordance with the action scenes planned.

Away from the studio, he explored and shot photographs of São Paulo at night to use as backgrounds to juxtapose the puppet against. Although he took most of the photos during the first two months of production, the necessity to return and shoot some more complex material became

obvious further into the post-production phase. The additional image-collection process wasn't without its difficulties, as Guilherme recalls: 'Those were photos from locations that took me longer to get clearance to enter. Eventually, realizing I wouldn't get permission to photograph some of the buildings, I had to sneak in and get my photos regardless – at the last minute.'

With the puppet created and ready for camera, the team had two weeks to rehearse the shots and try to solve other problems like lighting, shot selection and any camera moves (2).

In hindsight, Guilherme reflects that this situation wasn't ideal, 'but we practised enough to make the shoot easier. We had two full days that ended up being a couple of 12-hour-long shooting sessions.'

In parallel with the team working together to capture the puppetry sequences, illustrator Samuel Casal was inventing and creating the characters that change into animals in the film, using Illustrator. These vector images were then given to production company Birdo Studio, where they were animated using Flash. Later, in the post-production phase, Guilherme received the finished animated character files one by one over the course of a month to edit into the final film. He is grateful for the technical support he received in the making of Tyger: 'Other than the grant from Cultura Inglesa, I had the help from a Brazilian production company called Trattoria. They were kind enough to provide me with a couple of people and computers to help me in post-production and they let me use their studio to shoot the live-action sequences.'

The soundtrack came about as something of a coincidence. Guilherme asked friend and long-time collaborator Paulo Beto to create an original score for the film. He started working on it, but Guilherme almost immediately needed the track guide to start editing. As time was precious, Guilherme requested a track previously recorded by Paulo's band, Zeroum, that he had heard prior to starting Tyger, sensing that it perfectly captured the spirit and the pace of the film. Guilherme explains, 'The song fitted perfectly to the film so I just asked him to make some modifications to adapt it. It's amazing how much it sounds like the track was made for Tyger in the first place.'

The post-production phase was intense because the film had 60 shots and the Brazilian animator had only two months to finish them. The process was once again not without its complications: 'We shot sequences using a Sony HDV camera. That's a bad idea when you have green screen. I found later that the compression made our keying process a lot more painful. Although I had some help to key out the green screen and eventual rotoscoping, I composed the film in After Effects all by myself. That included animating the neon plants. The editing is mine

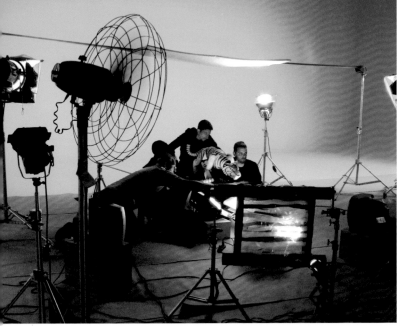

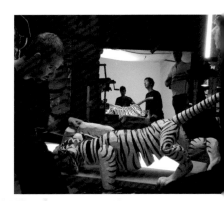

↓
A mirror provides a reference point for both the puppeteers and director as the scenes are shot.

→
Guilherme Marcondes on set – a serene character in a bustling world.

too. I had to work with lots of placeholders because there were a few background photos and animated characters missing until the last two weeks.' The post-production was all done using a single Macintosh G5, edited in Final Cut Pro and composited in After Effects.

Tyger is not the first short film that Guilherme has made, but coming from a world of commercial work where he had to adapt his process to serve advertisers' needs, he is buoyant about the experience the film has given him:

'The great thing about making your own independent short is that your process is submitted to your creativity only – excluding budget and time limitations, of course (3). A lot of the film was creatively open until the last minute. That would never be allowed in any commercial work.

That's what I want to do in my next film – develop my own process in a longer and more ambitious structure.'

Fittingly, the film premiered at a Zeroum concert and the experience clearly had a positive effect for filmmaker and audience alike; 'It's still one of the best screenings of Tyger. I expected people to be arrested by it, like music. In addition, I like people to be intrigued by the symbols in the film later on. Judging by the wide range of hidden meanings I overheard people found in the dark figures 'controlling' the tiger, it seems like it worked.

The role of technology is not lost on Guilherme, even though the 'star' of the film is an ancient puppet technique, as he confirms, 'All of the post-production was digital. It was the only way to put all those disparate elements together. I first showed my film online. I had 100,000 downloads in just two weeks. The film has been available for several years, so the peak has passed now but I still have an average of 200 downloads a day.' Tyger has been shown at more than a hundred film festivals, broadcast on numerous television channels and screened before features in cinemas, but Guilherme's website is still responsible for the largest audience share.

The film's popularity has enabled Guilherme to look for other opportunities to create more personal projects while juggling a successful commercial career. He is aware of the difficulties in balancing his time to satisfy everyone, a situation he sees as being familiar for lots of his colleagues: 'I struggle a lot to keep doing my short films and split my time between commercial work and personal projects. I know most directors are in the same situation. Each director will have a completely personal experience and perspective, but what seems to be the common denominator is that they all have to be very stubborn to keep doing it.'

2
on set

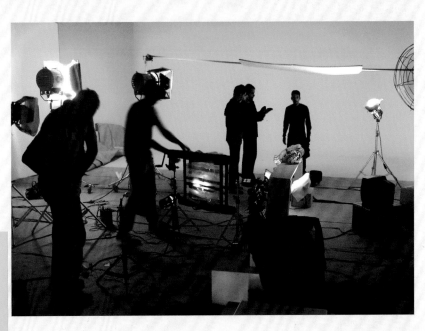

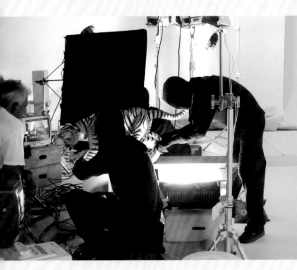

← ↑
The puppet action sequences were shot at Trattoria's large studio over a two-day period allowing room for the puppeteers to move and for the sequences to be correctly lit.

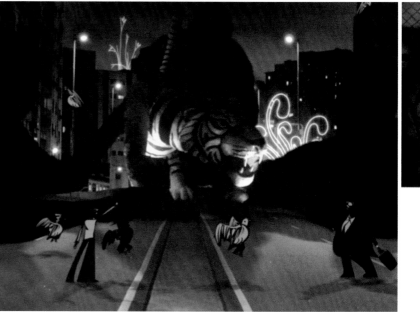

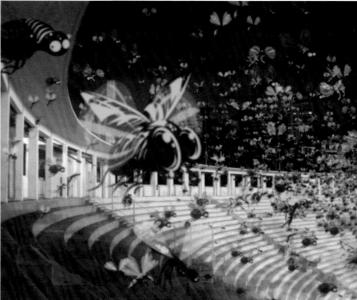

136 / Guilherme Marcondes

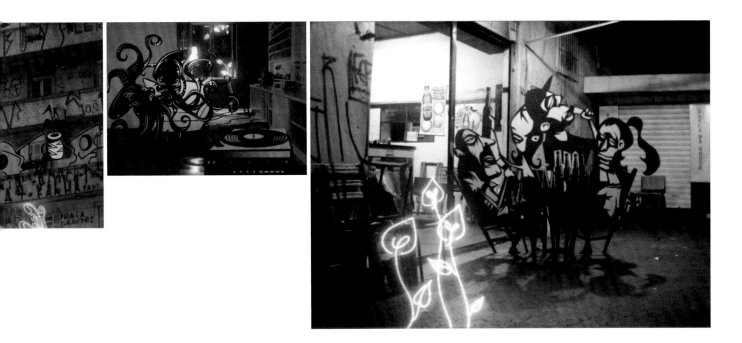

3
final film

Clyde Henry Productions

Canada / clydehenry.com

Madame Tutli-Putli

2007 / 00:17:00

In nothing short of an amazing first flight into professional feature animation, Montreal- based Clyde Henry Productions (composed of artists Chris Lavis and Maciek Szczerbowski) has an internationally recognized hit on its hands in the shape of Madame Tutli-Putli. Nominated for an Academy Award for Best Animated Short Film and critically acclaimed by leading international film and animation festivals around the world, the film has set new standards in the realm of stop-motion animation, with an extraordinary attention to detail and the myriad of inventive ways in which Chris and Maciek have sought to art-direct the visual and metaphorical transitions between 'real' and 'imagined' worlds.

David Bryant and Jean-Frédéric Messier's epic soundtrack provides the perfect backdrop as Madame Tutli-Putli catches the night train complete with her entire collection of worldly-possessions and the dark memories of her past life. As the train journey rumbles from day into night, we follow her descent into a blurred world where, travelling alone, she is confronted by both sympathetic and menacing strangers. The demons of her past life are brought into close proximity and through dealing with them, she is lifted into a sphere of intrigue. A triumph of planning and production, here Chris and Maciek reveal some of the secrets behind the creation of Madame Tutli-Putli.

↓

Chris and Maciek, surrounded by hundreds of materials in their studio, perfect the art of the perfect stop-motion model mixture and try to work out a lightweight structure for the armature to support the silicone skin and stand up to the rigours of filming.

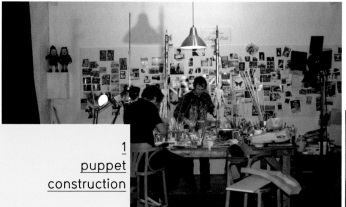

1
puppet
construction

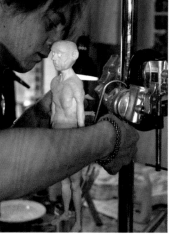

↙ ↓

Maciek at work on the custom-built armature, as a bare frame and later with a Sculpey modelled body.

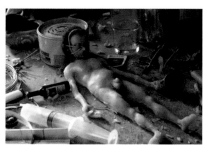

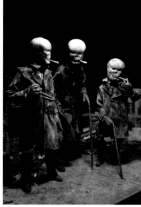

↑ ↗

The studio table became home to an increasingly unlikely set of supporting characters through various media and material experiments.

How did you become interested in animation?

We are not interested in animation per se as much as film. For us animation is a silver bullet, to be used only for fantastical and unusual effects. It starts with story; some stories want to be told in animation, some in live-action film, and some in a hybrid of the two.

How long have you been an animators and directors?

We've had a company called Clyde Henry Productions since 1997. We have managed to make a living doing everything from commercial art, posters, comics, and film since that time.

Who or what inspires or influences you?

We are inspired by filmmakers – the usual suspects; Kubrick, Lynch, the Brothers Quay, but even more by authors, painters, or even articles in the paper. A week of camping ought to stimulate more original ideas than a week spent watching movies.

Describe your studio environment.

Tending towards the messy and chaotic. We use computers but they are forever fighting for the dignity of a clean table.

What is your own personal definition of animation?

We are doing our best to not get too caught up in creating theories. They are inevitable but it's best to approach each new project with a total disdain for your past.

The National Film Board of Canada describes Madame Tutli-Putli as 'a film that takes the viewer on an exhilarating existential journey…(introducing) groundbreaking visual techniques…(created with) painstaking care and craftsmanship in form and detail that bring life to a fully imagined tactile world'. In order to create a film like this, key visual and sensory research was absolutely vital to the audience believing the world that was to be presented before them.

In much of Chris and Maciek's previous work, the brooding presence of sinister and creepy atmospherics was never far away and their intention was to create something that took this idea to a new level.

The filmmakers decided to do some first-hand investigation and, in 2002, they boarded a train that would take them on an adventure across the vast landscape of Canada that lasted just a little under a month. Maciek explains that, 'it forced us to throw out a lot of clichés. We had written a movie that had more to do with other people's movies then our own experience'. This forced isolation also gave them a focus to the project and meant that they could see first hand the idea of using the carriage compartment as a stage set and also more intricate observations, like the eerie play of light across the carriage occupants as the train rumbled on through dense forests. Importantly they also had the opportunity to strike up conversations and friendships with their fellow travellers.

These interactions unearthed a number of stories, legends and anecdotes, all of which Chris and Maciek stored for possible future reference. While the presence of the passengers was one thing, a lasting impression of empty dining cars, silent spaces and the impending darkness created quite another sense of moody desolation, that chimed perfectly with a visual aesthetic the pair craved for the film.

Back in the studio, Chris and Maciek experimented with ideas around the origination and development of the puppets, costumes and the all-important sets (1).

In a scene resembling something more of an animator's kitchen, they tried different combinations of both natural and synthetic malleable materials like plaster, latex and silicone over the course of a year to create the perfect mixture for the moulds to be made.

'Silicone was by far the best material for our purpose,' says Chris. 'It's durable and most importantly, translucent. It eats light in much the same way skin does.' Having already rejected traditional stop-motion armatures, the pair had instead created their own versions using lighter aluminium components, following months of tests with smaller samples to test the pliability and strength of the characters and knowing that they would need to stand up to the rigours of filming in a variety of conditions.

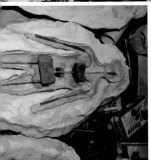

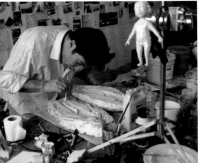

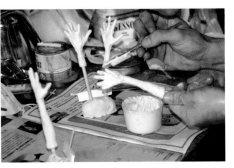

↑ →
Plaster moulds are made for the specially created silicone to be poured to create the models, while a collection of hands are crafted to be able to inter-change onto the main frame of the puppet in different stages of filming.

The creation of the costumes was similarly detailed. Chris and Maciek relied on the knowledge brought to the project by costume designer Lea Carlson and the suggestion of using actress Laurie Maher as the reference for Madame Tutli-Putli meant that trips to salvage second-hand materials from a variety of outlets could be tested out on a real life source. Specific items such as the iconic red dress, gloves and stockings of the main character were highly finished by hand, through a mixture of custom dying and hand-sewing to achieve the extraordinary level of detail needed to complete the look. Even the thieves' leather coats were buried in earth for a few weeks to age them before filming began.

With such highly specified and detailed characters, the film demanded that the sets were equally researched, sourced and constructed to an impeccably high standard. Again, Chris and Maciek turned to salvaged and recycled objects and materials, seeing the possibilities in the trash that they had accumulated. Some of their most surprising finds came from the most unlikely sources, such as fluorescent lights stripped from a martini bar and broken and discarded door mirrors from cars parked near the studio, that became redeployed as reflectors to shine light sources back onto characters in the set. The train's windows looked out onto specially painted backdrops to enclose this mysterious world.

On set, the earlier research and planning paid dividends in helping Chris and Maciek realize their vision. <u>Although each and every element of the shot, whether that was characters, lighting, props or camera moves, had to be correctly positioned by hand for every frame (2)</u>, the decision to use Laurie Maher meant that many scenes could be choreographed and improvised beforehand, so that distinct personalization of key gestures and movements would look both natural and convincing.

Chris is clear that Laurie's involvement in the film was instrumental, 'Casting Laurie was one of our greatest pieces of luck. Though an inexperienced actor, from our first rehearsals Laurie imbued Madame Tutli Putli with an emotional weight that had been lacking in our script and storyboards. We began to shape Tutli's gestures around Laurie's unique personality. Tutli became her and she became Tutli.'

The sense of depth in the main character's emotions was then further enhanced through Chris and Maciek's patient handling of the puppet, creating and breathing life into a collection of scraps, albeit beautifully put together.

But what makes <u>Madame Tutli Putli</u> such an astonishingly accomplished stop-motion film is the attention to detail applied in the production phase through the sensitive and detailed use of particular special effects. Chris and Maciek's original research again paid handsome rewards in the collusion with portrait artist Jason Walker, as Chris explains, "Jason is an old friend of ours, and we have worked with him for many years. He did a number of effects on our previous commercial work. We always knew he would work on Tutli – it was just a matter of figuring out what he would do. He was there from the very first meeting when we discussed the possibility of human eyes on a puppet. Though we were very much involved in rehearsal, lighting, and filming the eyes, the compositing technique was Jason's own creation and he spent years perfecting it."

←
Madame Tutli-Putli in front of the camera in her hand-crafted costume. The Wunderbar is the piece of equipment between the model and the camera, which was used for precision placement.

2
animating

↑
Only the slightest of touches were needed to move the character in the set to the desired position but this skilled job became more and more pressurized as the film got closer to completion.

Using the puppets as a lead, each shot was scrutinized and a similar human facial expression was filmed so that eye movements could be juxtaposed over the model. Chris explains, 'Once the live-action eyes were filmed, Jason then individually positioned, digitally scaled, painted and re-timed the footage for nuance and believability of gesture' (3).

This startling – and slightly unnerving – aspect of the character design enables the audience to get closer to the emotions of the film, challenging and questioning the space between viewer and participator.

↓
The filmmakers shot Laurie against a green screen so that superfluous details could be easily removed in the editing process.

↓
The time-lapse camera set up in the studio records Jason applying make-up while Chris (standing) and Maciek prepare the camera and try to ensure that the lighting in the environment remains constant.

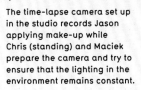

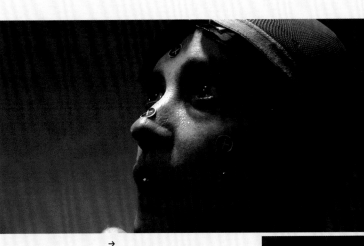

↗
Jason places registration dots on Laurie's face to try and keep the collected photographs calibrated.

→
The target enables Jason to achieve the exact placement, scaling and angle of the eye to be matched from one frame to the next.

3
eyes

↑ →
The layers of imagery making up the central character are mapped out by Jason using After Effects.

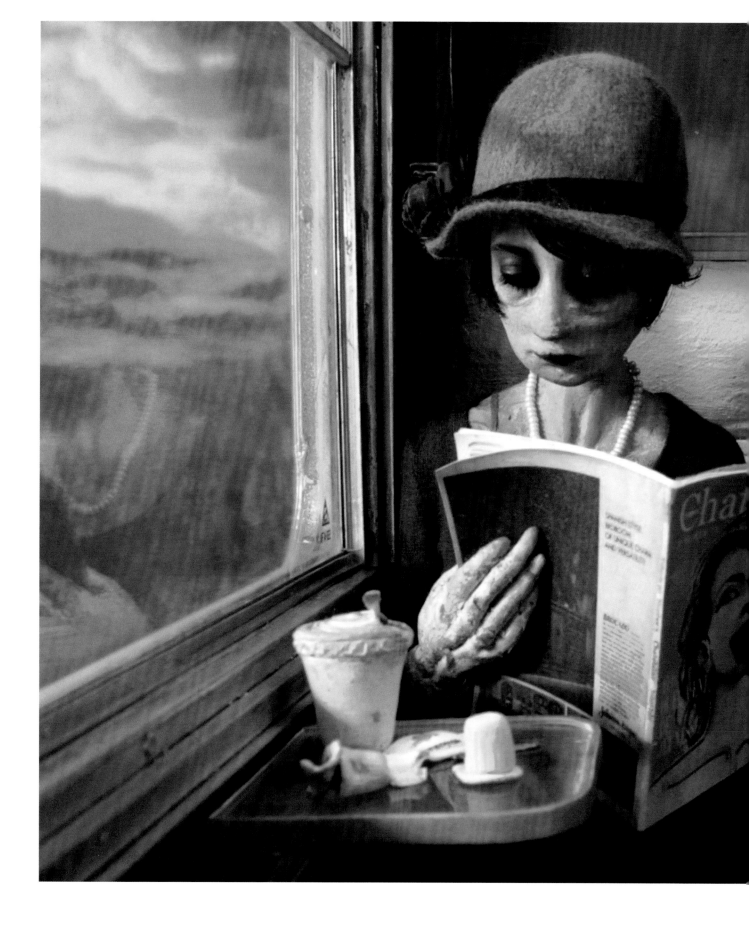

142 / Clyde Henry

As members of the audience, we find ourselves often in intimate moments with Madame Tutli-Putli. The progression of the story starts to question whether we are watching her, or she is watching us and this tension is focused through Jason's painstaking special effects with the eyes. Jason says, 'Being a portrait painter gives me a unique insight into characters because of the discipline of the subject. Studying observations through the camera lens and moving image allows me not only to achieve a likeness but I can go beyond that – like getting beyond the mask – and really start to examine the soul of the sitter.

I wanted the audience to watch the story rather than the effect, so getting the precise details about Laurie's mannerisms and movement absolutely right became almost an obsession. Madame Tutli-Putli was an exercise in perseverance. We all held on and we just couldn't let go.'

While shooting the eyes, it was necessary to meticulously prepare Laurie for her scenes. After applying her stage make-up, Jason used his experience in preparing portrait sitters to explain the detailed moves that Laurie would need to perform in order to capture these minute but vital technical details, as he explains, 'We applied exactly the same make-up that Chris and Maciek had been using on the model of the main character to achieve a parity between the real and model-made images and tried to exactly reproduce the lighting effects around Laurie that were in place with the three-dimensional model. I introduced Laurie to the principle of the Wunderbar (a colour coded analysis of the puppet's head movement) and I stuck tracking dots onto her face to stabilize the registration of the camera and Maciek invented several contraptions from recycled balsa wood to ensure that Laurie's chin was always a certain distance from the lens of the camera. The attention to detail was critical – I'm a perfectionist and it had to be right.'

'It was an excruciating process,' adds Chris, 'We began by rehearsing the movements, perfectly replicating the puppet's actions. Jason was in charge of making sure that Laurie's head was always in precisely the right position. After Laurie had learned the movement choreography, Maciek and I would add the emotional element; anxiety, fear, or whatever the scene required. When everyone was satisfied, we would shoot multiple takes, trying to capture emotion and intention and at the same time follow the puppet's actions. Often a shot would have great acting, but the positions would be off, or vice versa.

This was frustrating to say the least, and many a session ended with tempers flaring and nerves frayed all around.'

This microscopic precision in an intensive high-pressure environment seems to have plunged Chris, Maciek, Jason and Laurie into a world where the edges of believability started to blur. Jason confides that on several occasions, where arduous shoot sessions could last up to three hours in a single sitting, the three would look across the studio to Laurie taking a break drinking coffee and remark, 'That's Madame Tutli-Putli, she even drinks in the same way!' Laurie's dedication to the film was truly remarkable and she gave away a lot of herself to make it work. For that, she deserves immense credit.'

From the bank of material shot, Chris and Maciek would sit and review hours of footage, looking for exactly the right gestures, postures and nuances that started to express the entirety of the character of Madame Tutli-Putli, while Jason would additionally examine each sequence for its technical virtues, meaning that only a fraction of the material committed to film was used in the final cut. From these selections, Jason painstakingly pieced together the sequences, frame by frame, superimposing the human eyes over the model and matching up Laurie's skin against the silicone of the model in an act of breathtaking craftsmanship. The high quality of the finished work once again pays homage to the principle of extensive preparation, yet the extraordinary level of continuity present in the work is testament to the decision to use Jason's skills throughout, rather than a team of special effects artists.

There is little doubt that Madame Tutli-Putli is a bespoke piece of work, from the original script, through to the construction and delivery of the visual and audio sequences (4).

Far from creating the musical score in isolation, David Bryant and Jean-Frédéric Messier brought together a diverse and experimental range of musicians and performers to echo the extraordinary visual presence of the film acoustically. The experimental aesthetic nature of the film was inspiring, and similarly left field attempts were made to bring a sense of originality to elements such as sound effects, for example the decision to use blowtorches and dry ice on the steel strings of a decrepit salvaged piano to mimic the noise of the train on the tracks, while the amalgamation of noise created from the section of the film where the train runs away is formed from equally unlikely sources, including a bear growling, a choir singing, a roaring jet engine and the unerring scrape of a screwdriver against an electric guitar.

This brief indication of the process can only hint at the true nature of the hours of sacrifice, commitment and resolve put in to make the film. A credit to the pioneering spirit of stop-motion, Chris and Maciek have achieved far more than that with this beautiful and haunting film. That it represents a step up in quality is in little doubt, but that it has embraced technology using the same traditional guiding principles that can be applied to stop-motion, yet has not been superseded by them, says much for the support of the National Film Board of Canada and the purity of the artistic vision of Chris and Maciek.

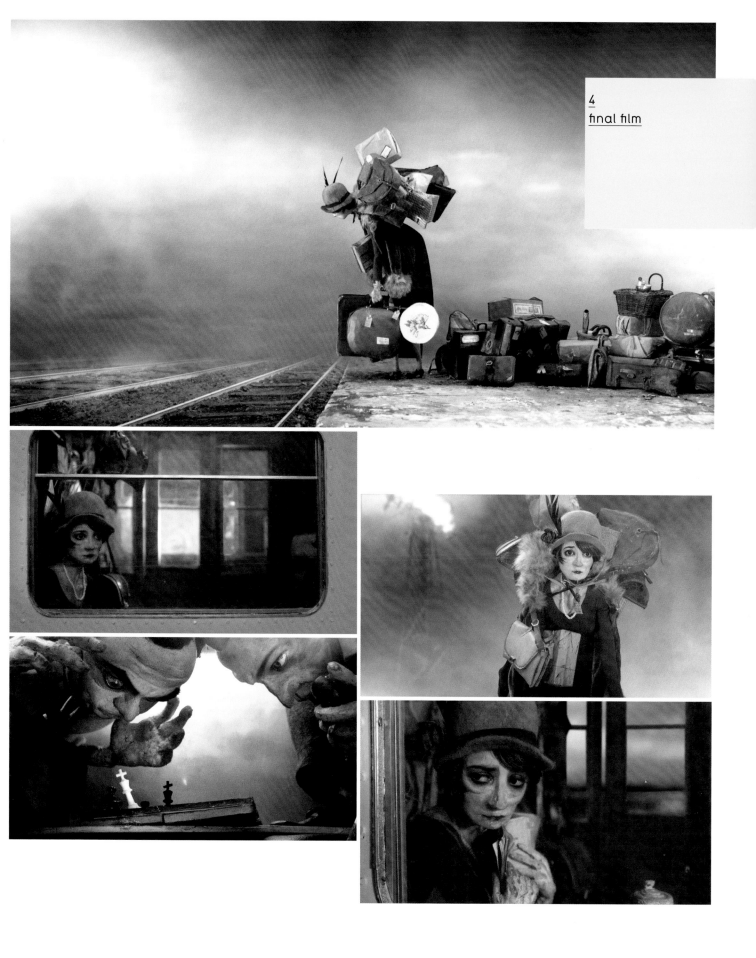

Unorthodox

To some degree all animation is, by definition, experimental. There is uncertainty in even the most bolted-down scripts, the tightest production schedules and the most fraught filming sessions simply due to the presence of the natural element of chance. Even the term 'alternative' can be misleading, as it assumes we are all conditioned or experienced in the same way, regardless of background, gender, race or class. As a subject with such a relatively short history, animation positively explodes with expectancy, on the part of both creator and audience, and the term 'unorthodox' here attempts to provide a framework around how works that connect with this description might be defined.

As discussed earlier, Disney's impact on animation cannot be underestimated, nor indeed can the substantial technical revolution that has created more virtual output from the larger studios recently. But in keeping with the experimental, forward-looking nature of the discipline, some creators have revolted against these aesthetic and technical formulas, instead forging a path that is original in its authorship, tenacious in its desire to question and present a new take, and altogether more closely aligned to its avant-gardist cousins in other arts and cultural disciplines.

This form is constantly changing, evolving and regenerating. Far from existing in a vacuum, the animator producing unorthodox work may not describe him- or herself as an animator, but rather as an artist, a director, a composer or a writer. Far more likely is a desire to express themselves, their ideas and their fears and aspirations through the form of animation, seeking to place work before a different audience and using that as the catalyst for creating future works.

While this might imply that all unorthodox work is 'personal' in nature, the reality is that more and more commercial clients are recognizing the virtues of being allied to something bespoke and different, and the constant desire to stand out from the crowd creates perhaps greater opportunities in this area than had previously been the case. Of course, this creates a tension between what might be perceived as unorthodox and what is perhaps denoted as being mainstream, but only if the former is seen as a minority activity. In this book, 'unorthodox' does not follow such assumptions. Instead, I would argue that the term 'unorthodox' animation in relation to technique or process implies the unexpected, the surprising and, on occasion, the enlightening.

If this section is difficult to categorize literally, the historical influences are equally tricky to pin down, as the definition of orthodoxy has inevitably shifted over time. One might point historically to the work of Oskar Fischinger, Lotte Reiniger and Berthold Bartosch as being significant creators, and this legacy was pursued still further by the technique-based experimentation eagerly conducted by Len Lye and Norman McLaren. Of course, Lye and McLaren's work was also heavily underpinned by content concerns, but it is clear that both filmmakers saw a connection with the wider arts agenda encompassing dance, sculpture, painting and that quality that over-arched all of these interests, namely performance.

Interestingly, the concept of the performance of the film is acutely discussed by a number of the following contributors. In some instances, the films have even been created with the idea of an accompaniment to live performance, either through narration in Phil Rice's Male Restroom Etiquette, soundtrack in Paul Fletcher's Dreamlake or visuals in Deborah Harty and Phil Sawdon's pivot. What is clear from this section is that the audience are in some way included in the work and that this is not an accidental occurrence but a designed and considered activity, either in the origination or development of the piece.

If we also accept that the stance of unorthodox animation pervades specific elements including but unrestricted to (un)scripting, the repatriation or reappropriation of sequencing, the interconnectivity between sound and vision and the role of auteur as creator, director and/or producer, it becomes increasingly apparent that there are a variety of opportunities to create truly original and inspiring work. In so doing, these works acknowledge the audience's intellect but raise the bar in relation to their expectations of what the activity of unorthodox animation could mean.

Johnny Hardstaff

UK / johnnyhardstaff.com

Light Lighter

◎ featured on DVD / 2008 / 0:01:00

Having had no formal training as an animator, Johnny Hardstaff made his first experimental film, <u>The History of Gaming</u>, in Photoshop, gluing together the individual frames to achieve a work that has been the subject of much debate since its first screening. His innovative and often challenging work with the moving image in both commercial and non-commercial arenas has received international acclaim. Not one to shy away from criticism, Johnny is passionate about animation as a vehicle for the communication of ideas, developed from his education as a graphic designer.

Known for his hybrid live-action/CGI animations and extraordinarily skilled draughtsmanship, Johnny resolutely refuses to be defined or pigeonholed either professionally or artistically. He currently works from Ridley Scott Associates studios in London on solo and commercial projects that embrace a range of visual mediums. <u>Light Lighter</u> is a 60-second television commercial that aims to make viewers aware of Toshiba's significant research and development activities.

1.1
<u>final film</u>

How did you become interested in animation?
It's not that I ever 'became' interested in animation as such; it's more that I am a product of animation. Most televisual content for children is animation-based, and so it becomes a natural language.

I would say that I am more interested in graphic languages than in animation. However, animation offers me the opportunity of breathing life into graphic narratives. When I left Saint Martins, I had had no experience of animation whatsoever. I felt very frustrated by the commercial world of print-based graphics, and longed to generate hybrid graphic experiences that were in some way tangible and immersive. I was more interested in attempting to convey a sensibility that could be said to exist, so I slipped into animation without ever thinking that I was about to make an animated film. It seemed entirely natural to experiment with communicating this graphic sensibility by making it move.

Although I am a director with Ridley Scott Associates, known for animation, I have always believed myself to have no great directorial aspirations in terms of features and the like. I had always looked at animation and filmmaking from a designer's perspective. Suddenly that's not the case any more. I still look at animation much as a designer might, but now I'm hungrier. I want to create a long-format film. I just want to do it differently. With commercials I'm simply teaching myself my craft.

Who or what inspires or influences you?
On a superficial level I'm sure lots of things slip under my radar and inspire me, but largely I try to remain beyond the influence of others. It all feels like a form of dilution – diluting yourself with the thoughts and concerns of others. I do get very excited by the work of various artists, but it's largely everyday things that really inspire me. Industrial ephemera. Odd things that I find that suggest new narrative arcs and interesting directions. I like

real things, and I like making things real. Making them exist. It's the Latin <u>animus</u> in my animation. Breathing life. Overall I am largely only interested in developing original work, and so the work of others can be nothing but an impediment. I've always seemed to believe that having 'heroes' is a big step towards ensuring that you yourself never do anything wonderful or of note.

Describe your studio environment.
My workplace is currently packed into a very large number of crates all meaninglessly marked 'fragile', en route to its final resting place – a white early 1960s Kubrick-style home set amid lots of trees. Once reassembled, it will be a large orderly collection of unmade scale models, animatronics, toys, props, artefacts, curios and masses of books relating to my childhood interests. My studio environment is a place for regression into childhood narratives and childish things.

What is your own definition of animation?
I don't believe that animation needs to occur upon a screen to be deemed 'animation'. A child playing with toys 'animates' a narrative. The illustrator Chris Ware animates within his <u>Jimmy Corrigan</u> strips. A traditional Japanese mechanical puppetmaker in the <u>karakuri ningyo</u> tradition 'animates'. I like the word 'animation' as it is hopelessly broad and facilitates myriad approaches. I don't see it as being primarily a screen-based medium any longer. Animation can now be completely invisible. The film of mine featured here is a perfect example of this. It is very much an animated film, and yet it appears not to be. Everything moves now, openly or secretly assisted by animation technology in some way or other.

<u>My personal definition of animation would be the breathing of life into something, whether paper-based, digital, sculptural or whatever, in a formerly impossible way in order to say something new or ideally profound (1.1 and 1.2).</u>

←↙↓↘
Light Lighter explores Toshiba's research and development commitment through Johnny's hungry desire to do things differently.

TCR 09:53:00:13

Johnny was approached by Grey Advertising, London with an audio script and was asked to write a visual treatment that would convey the research and development activities being undertaken at Toshiba. Given the nature and feel of his previous films, the project represented a great opportunity to experiment with the representation of ideas that did not necessarily have a physical property.

Johnny explains the thinking behind the origination of Light Lighter: 'The first thing was to develop a tone for the film. I wanted it to be more Oxford University than in any way "sci-fi", and I wanted it to be series of shots that made viewers wonder what it is they're looking at.

The narrative is more driven by motion than meaning. I wanted to impel the viewer onwards in a compelling and relentless manner, rather than actually impart any technical information.'

With the treatment agreed by the agency and the client, work began on storyboarding the film in detail. Unlike many commercial projects, the purity of the idea was carried right through the project, as Johnny acknowledges: 'It's quite remarkable how the film utterly reflects the storyboard. One would expect things to change substantially along the way, but this is a verbatim delivery of the boards. Hopefully that is less about a failure of the imagination and more about knowing when something is working.'

The storyboards were handed to the in-house production team and a production process was mapped out in relation to the six-week schedule. An animatic was quickly constructed using shots taken directly from the storyboard. From this simple sequence, the team could map out the CGI components in increasing detail. The CGI was generated through Maya, After Effects and Photoshop on Mac/BOXX PC cross-platforms.

Johnny directed a two-day shoot where most of the live-action elements were captured, always with an eye on the CGI components that would need to be integrated when the images were composited. The live action was all shot 35mm on ARRI 135s. While the CGI modellers continued with their sections, Johnny shot more live action; 'I visited the National Physical Laboratory, where I shot the ferro-fluid responding to electro-magnetic fields.'

Back in the studio, compositing using After Effects began the CGI and live-action segments were embedded shot by shot. These were directed

by Johnny, who is quick to praise the help he received in the creation of the commercial: 'While I directed and designed all of the elements, whether shots or composition, I needed a team of four modellers and animators to make Light Lighter a reality. I also needed the help of a compositor, a producer, a production assistant, a number of runners, a telecine artist, and of course, on the live-action shoots, a whole crew of people including a DOP, a gaffer, focus pullers, a grip plus various art department personnel. Even a hand model was required. Perhaps 40–50 people worked on this project in one capacity or another.'

Light Lighter has been a positive experience for Johnny: 'I've found this project very exciting. As a process, I've learnt a lot this time, and it has been great fun. I've enjoyed it immensely and it has rekindled my appetite for making films. Interestingly, it has also sparked a desire to work in long-format film. I think the process that I adopted for this film makes me think anything is possible. This film was, I think, a watershed in relation to my own confidence. I now feel capable of anything, live action or animation, and particularly a hybrid of the two. That is what interests me most, and that hybrid strikes me as contemporary realism.'

He finds the current cultural climate inspiring: 'I like wielding industrial language systems, and I enjoy counteracting them in personal work. I am hugely excited by the commercial political climate and am inspired by this clash between two worlds. I like mass-media projects, and there is something oddly compelling about honing and delivering corporate directives to millions of minds. I am unashamedly seduced by corporate visual language systems. Yes, I can decode them, and yes I can encode, but am I immune? No.'

Johnny recognizes the importance of remaining true to his original intentions: 'There are too many definitions of "successful", most of them in some way fiscal, but my definition of success would be that hopefully one becomes a spirited and versatile auteur who produces poignant and important works throughout their life. To do that, I imagine that all you need is determination, persistence, the ability to remain detached and aloof from conventional ways of doing things, an inability to "play the game" and a remarkable and original mind.

Originality is the only currency now if you're shopping for anything worthwhile.'

1.2
final film

Deborah Harty &
Phil Sawdon

UK / www.humhyphenhum.com

pivot

◎ featured on DVD / 2006 / 00:01:45

pivot documents an act of drawing; drawing that is dynamic, physical and progressive. The process is expressed as mechanical, repetitive and methodical. The tone is robotic but reflective, darkly poetic and thought consuming. It communicates at a multi-sensory level, is over-stimulating, invasive and repetitive. The sound is descriptive of the action of drawing but is unpleasant and confusing adding to the dark, crowding and chaotic feel of the film, which is reminiscent of a horror movie.

pivot is made to communicate the physicality of drawing while demanding discourse as it challenges notions of drawing as a media-specific activity. Deborah and Phil are not strangers to working on collaborative drawing projects and these manifest themselves through a variety of outputs, including animation. Here they provide an insight into how they collaborate.

Triptych 'A': Reflecting on Drawing Practice as Knowledge **Δ'/∞ Page 2**

I think the fascination and the fear of the white page is the site in which one enacts differentiation as soon as a mark or sign is made. It changes the non-ness and establishes a place of action. As soon as that act occurs the paper becomes something.[1]

source material

ersation', *The Stage of Drawing: Gesture and Act,*
blishing and the Drawing Centre, New York 2003 –

1

↑

pivot is made in response to the Triptych drawing research project instigated by Loughborough University, Kingston University and Dublin Institute of Technology. Here, Deborah and Phil reflect on the questions posed through initial research around the theme using quotations, symbols and words to define 'drawing'.

→ ↗

The recycling of original footage creates additional layers of meaning. The compositions emerged and developed through a process of responsiveness and rigorous meaningful play.

by Johnny, who is quick to praise the help he received in the creation of the commercial: 'While I directed and designed all of the elements, whether shots or composition, I needed a team of four modellers and animators to make Light Lighter a reality. I also needed the help of a compositor, a producer, a production assistant, a number of runners, a telecine artist, and of course, on the live-action shoots, a whole crew of people including a DOP, a gaffer, focus pullers, a grip plus various art department personnel. Even a hand model was required. Perhaps 40–50 people worked on this project in one capacity or another.'

Light Lighter has been a positive experience for Johnny: 'I've found this project very exciting. As a process, I've learnt a lot this time, and it has been great fun. I've enjoyed it immensely and it has rekindled my appetite for making films. Interestingly, it has also sparked a desire to work in long-format film. I think the process that I adopted for this film makes me think anything is possible. This film was, I think, a watershed in relation to my own confidence. I now feel capable of anything, live action or animation, and particularly a hybrid of the two. That is what interests me most, and that hybrid strikes me as contemporary realism.'

He finds the current cultural climate inspiring: 'I like wielding industrial language systems, and I enjoy counteracting them in personal work. I am hugely excited by the commercial political climate and am inspired by this clash between two worlds. I like mass-media projects, and there is something oddly compelling about honing and delivering corporate directives to millions of minds. I am unashamedly seduced by corporate visual language systems. Yes, I can decode them, and yes I can encode, but am I immune? No.'

Johnny recognizes the importance of remaining true to his original intentions: 'There are too many definitions of "successful", most of them in some way fiscal, but my definition of success would be that hopefully one becomes a spirited and versatile auteur who produces poignant and important works throughout their life. To do that, I imagine that all you need is determination, persistence, the ability to remain detached and aloof from conventional ways of doing things, an inability to "play the game" and a remarkable and original mind.

Originality is the only currency now if you're shopping for anything worthwhile.'

1.2
final film

Deborah Harty & Phil Sawdon

UK / www.humhyphenhum.com

pivot

◎ featured on DVD / 2006 / 00:01:45

pivot documents an act of drawing; drawing that is dynamic, physical and progressive. The process is expressed as mechanical, repetitive and methodical. The tone is robotic but reflective, darkly poetic and thought consuming. It communicates at a multi-sensory level, is over-stimulating, invasive and repetitive. The sound is descriptive of the action of drawing but is unpleasant and confusing adding to the dark, crowding and chaotic feel of the film, which is reminiscent of a horror movie.

pivot is made to communicate the physicality of drawing while demanding discourse as it challenges notions of drawing as a media-specific activity. Deborah and Phil are not strangers to working on collaborative drawing projects and these manifest themselves through a variety of outputs, including animation. Here they provide an insight into how they collaborate.

Triptych 'W': Reflecting on Drawing, Practice as Knowledge Δ'/∞ Page 2

∞

'Δ

I think the fascination and the fear of the white page is the site in which one enacts differentiation as soon as a mark or sign is made. It changes the non-ness and establishes a place of action. As soon as that act occurs the paper becomes something.[1]

1

source material

...ersation', *The Stage of Drawing; Gesture and Act,* ...lishing and the Drawing Centre, New York 2003 –

↑

pivot is made in response to the Triptych drawing research project instigated by Loughborough University, Kingston University and Dublin Institute of Technology. Here, Deborah and Phil reflect on the questions posed through initial research around the theme using quotations, symbols and words to define 'drawing'.

→ ↗

The recycling of original footage creates additional layers of meaning. The compositions emerged and developed through a process of responsiveness and rigorous meaningful play.

How did you become interested in animation?
We don't consider ourselves as animators. This is not a positive statement of resistance simply that we hadn't really thought about it. Our interest in animation is as creative practitioners who encounter 'animation' through commercial and independent film, TV and festivals. We became interested through our visual education and curiosity.

How long have you been animators, directors or creators?
The word 'creator' best suits our collaborative position. In the spirit of what we think an animator is and that we agree we have produced an animation by this books terms, then Deborah for two years and Phil for four years. As individual visual artists/creators then suffice to say: 'for a long time'. As animator collaborators on various projects including pivot we have worked together for two years.

Who or what inspires or influences you?
Our collaborative influences and inspirations are repetitive processes of drawing, language, The League of Gentlemen TV series, David Shrigley, F.W. Murneau's Nosferatu, Tomato and The Radio Dept. Individually, our influences vary.

Describe your studio environment.
We would define our 'studio' as the place of production. There are three such literal places. One is an institutional type office in a 1960's two-storey office block. The 'office' has two computer workstations, and various other paraphernalia. Secondly, and in the same building, we also utilize another space that functions as a drawing research project space with blackout blinds and very little else. The third space is a virtual space of communication across and through the ether of the web. It is also worthwhile to identify a place or space for the production of thought and conceptualization within our collaboration, which we consider valid as an 'environment'. We are, through processes such as this exercise of questions, sharing; developing; communicating; and rehearsing on paper.

What is your own personal definition of animation?
We are not sure if we share a collaborative definition, however, during our collaborative editing/drawing process we will reach pauses. These pauses are for reflection, review, appraisal and comfort. Often in determining what will happen next or in reviewing what we have done we will discuss the process and progress using art and design words. We play with the meaning of some words, taking them back and forth between both day-to-day and art and design usage. This sometimes involves putting words into Internet searches and dictionaries and specialist glossaries to look at the etymology and contexts of usage.

So our definition of animation is as a noun that is liveliness in the way somebody speaks or behaves.

It is the production of films by photographing a sequence of slightly varying drawings or models so that they appear to move and change when the sequence is shown; and it is the act, process, or result of imparting life, interest, spirit, motion, or activity; and the quality or condition of being alive, active, spirited, or vigorous.

2
recycled material

← ↖
Stills from Deborah and Phil's experimental film hinged were morphed directly into pivot through a series of loops that were then re-looped.

To understand pivot, it is necessary to focus on the collaborative connection that exists between Deborah and Phil. While there is a literal connection in that Phil supervises Deborah as part of her post-graduate research study, the two flourish from each other's involvement in and around the creative pursuit of drawing. This takes place in various forms, including making, recording, editing, conversing and presenting at differing levels in a multitude of often unrelated sequences.

In order to develop a further collaborative response to be able to present themselves at the symposium in November 2006, Triptych: 'Δ': Reflecting on Drawing Practice as Knowledge, Deborah and Phil reviewed three films they had recently completed (1); hinged, Philosophers Request Tea While Drawing and Scratch.

They identified a common usage of certain raw material recorded during the process of making hinged, suggesting a mutual understanding of an aesthetic, which was then explored through an agreement to 'collage' shared elements and clips into another moving image drawing, pivot, using various readily available Mac software.

pivot was, in most part, a visualization or drawing of the process of bringing together ideas. No individual component or constituent part is intended as a representation of an idea, instead pivot is 'the idea' and the way in which these ideas manifest themselves make visible and audible film statements. The particular brief, to which the film responded, required a five-minute presentation that commented on the effect of participation in the project on individual's processes of drawing practice and to identify future interest in the project.

Part of Deborah and Phil's initial interpretation of 'Δ' was to identify themselves as participants in the collaboration as 'me,' 'you' and 'us.' This was to form the basis of their reflective statement and acknowledged both their status as individuals and their creative output as the collaborative us. This realization aided the transition between independent and collective thought processes and drawing practices, acknowledging the individual in the collaboration and made the emergence of a single 'voice' possible. pivot is a reflective response to this thought process and collaborative position.

The identification that footage, clips and other material that had been filmed by 'them' at the initial stages of the collaboration had been appropriated for solo projects by both me and you (2).

The films Philosopher's Request Tea Whilst Drawing and Scratch suggested various ways to comment on the effect of the collaboration on the individuals involved; it also provided the opportunity to infer a continued commitment to the project as the collective us. pivot, in response, was created through the appropriation of the two solo projects, Philosopher's Request Tea Whilst Drawing and Scratch.

↑
Part of the process of creation was developing a logical and coherent strategy as Deborah and Phil thought, talked and played.

removal of thought
– <o:p></o:p></
span></p>

<u>3</u>
markmaking

↖
Film stills from Scratch were imported to pivot to provide further layers of content, giving the film its crowding and chaotic feel.

Deborah and Phil view their collaboration as an opportunity to debate the meaning of process, as Phil describes, 'It is interesting to consider pre- and post-production as stages or phases, however, we are not sure if that is a process and or terminology that we recognize. We sit down and play. We play with images and words within a very notional initial structure or as in this instance, a task. We have yet, as a collaboration, to work to a script, however, that is an intention in the very near future. We will write the script, collaboratively, and then move to a moving image composition of text and image.'

In their making process, including the production of <u>pivot</u>, Deborah and Phil looked at stock, material and tools that they had at their disposal within individual time frames and then started to make or draw something, as Deborah states, 'Something here was taken as something and some thing; material can also be any of our other works including works that are moving image or images of drawings on paper, material that was text documents, samples of spoken word, captured and modified sounds and internet images.'

Phil elaborates upon the process, 'A mark, or our equivalent of a mark, was made on a screen, in this case through a clip or recorded sound and then we played and mark-made through trial and error around a developing shared aesthetic (3). As with any process of drawing there was a need to reflect and respond to the emerging work.

Therefore, the process involved erasure and redrawing, leaving a trace or residue of either sound or image of that removed. There were always points of radical change where, following either much discussion or a solitary comment, hours of work could be removed in a held breath, by a single click on the mouse. The composition emerged and developed through a process of responsiveness and rigorous meaningful play. When we collaborate, we sit together at a screen or screens literally sharing the physical tasks. The decision as to who does what is down to who takes up the mouse/keyboard and when they decide for whatever reasons to pass it to the other. Usually the decision to pass to the other is pragmatic. The work developed a logical and coherent strategy as we thought, talked and played.'

Deborah and Phil consider a process as their form of drawing, one of their agreed notions is that drawings are open and so any issue of the work being finished is decided by the availability of time and their continuing enthusiasm for the outcome:

'We know that we may well return to this work that has been published as pivot and continue to draw on and with it to produce another work. As we have stated earlier pivot is made up of material from other works that has then been further modified (4).'

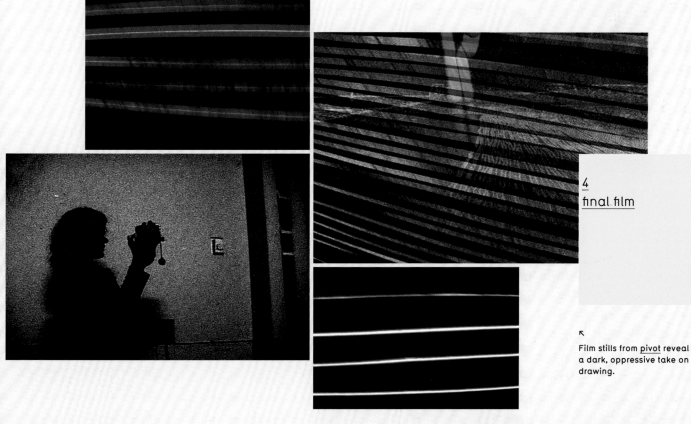

<u>4</u>
final film

↖
Film stills from <u>pivot</u> reveal a dark, oppressive take on drawing.

Phil Rice

USA / z-studios.com

Male Restroom Etiquette

2006 / 00:09:57

Enabling a 'macro effect in a micro world' is the benefit that Phil Rice sees in the harnessing and repatriation of the process of machinima. The ability to see the big picture in the realm of independent animation means that the creator must be able to wear a lot of hats and perform many of the production roles. As a director, the emphasis is not necessarily on the individual to be the best video editor, audio engineer, foley artist or actor, but to know enough about these areas to spot, attract and motivate the best talent. Machinima gives the opportunity to ask questions about that traditional model of practice.

Male Restroom Etiquette is a short 'mockumentary' film, much in the style of an old Public Service Announcement. The film is a satirical look at some aspects of male attitudes in the modern age, poking fun at habitual behaviours that are rooted in irrational phobias and paranoia. These were formed out of observations and comments made on the Everything2.com website back in 2000. The inclusion of the film in this book is timely, as it reminds creators that the Internet and resulting digital realms are not just for the discovery of information, but may also be harnessed for the contemplation, manipulation and distribution of material. By default, the thinking process from conception to consumption might be connected.

1
scriptwriting

↑
Celtx, a free screenwriting and pre-production utility, was used to transform the source material into a working screenplay, thus saving a great deal of time.

2
recording narration

↖ ↑
An experienced podcaster and performer in his own right, Phil did most of the voiceover work himself in his small home studio.

How did you become interested in animation?
A fan of animation in general since childhood, I first experimented with stop-motion animation as a teenager. When the ability to produce animated films at low cost by way of machinima came around, it attracted me because I lacked the resources and equipment to do traditional filmmaking; a computer-based filmmaking experience fit well with both my budget and my skill set.

How long have you been a director?
Apart from the youthful experimentation, I first became a director in October 1998, when I produced a cinematic version of a videogame tournament match. A month later, I produced my first proper film.

Who or what inspires or influences you?
My biggest film influences, in no particular order, are Alfred Hitchcock, David Fincher and music video director Mark Romanek. My biggest literary and philosophical influences are Ayn Rand, Friedrich Nietzsche and Chuck Palahniuk. I have numerous comedic influences, the biggest of which is certainly <u>Monty Python's Flying Circus</u>.

Describe your studio environment.
My studio is a small half-room in my house with odd-angled walls, with three computers specializing in various tasks, a MIDI keyboard, two guitars, a handful of microphones and lots of audio equipment.

What is your own personal definition of animation?
For me, animation is a method of rendering the slightly-more-than-real in a slightly-less-than-real manner. Animation is (or can be) radical independence, radical freedom as a director.

<u>Male Restroom Etiquette</u> began with Phil writing and relentlessly revising the screenplay. Since it was mostly narration, the regular rehearsal of the delivery of narration was important, to work out comic timing and to make sure the words could be spoken in a natural-sounding manner. <u>**The importance of this was reflected in the fact that nearly half of the film's production time was spent perfecting the screenplay (1).**</u>

Phil's first task was to bring the ideas from the collected stories into a visual medium. He found this richly rewarding, as many had very vivid visual suggestions built into them. Phil notes that, 'This film really felt like translation more than creation, as the visual ideas were in my head in concise detail. It was primarily a matter of getting the animated presentation to match the ideas I had in my head.'

For example, in the Ralph and Chuck sequence, there was no ambiguity in the ideas themselves as to what the action was supposed to be. As a director, it became Phil's job to decide what not to show to heighten the sense of cognition and understanding on screen. There was a deliberate and noticeable restraint regarding the level of detail in which some of the 'bathroom humour' elements were shown on screen, and in regards to the fight and resulting murder sequence. This ability to think beyond the literal interpretation was deliberate, as Phil was interested in preserving a sophisticated level of humour and, at least from a comedic standpoint, not insulting the viewer's intelligence.

To achieve this level of sophistication, Phil used the synergy or tension between visual and audio combinations to keep the viewer's imagination engaged, choosing a deliberately modest approach about some matters, and letting vehicles like the narration and the viewer's imagination fill in the gaps where a visual interpretation would have seemed obvious or crass. This made the film better both to create and to enjoy.

Apart from some help on one of the background voiceovers, <u>Male Restroom Etiquette</u> was an interesting illustration of the independence of animation, as Phil emphasizes when discussing his roles in creating the film: 'I was everything – writer, director, actor, sound engineer, composer and even promoter and distributor.'

↑ ↗
The workspace for sound and video editing is composed of a digital audio workstation and a sizeable collection of outboard gear.

Once the screenplay was completed, Phil began some test set designs, to get a feel for the space he would need and the colour schemes he wanted to use. One of the benefits of working entirely in a virtual set was that this experimentation could be undertaken without any budget fears. After completing some sample screen tests, Phil designed the characters and created a few tests with them as well, running them through the paces of some of the action they would be required to perform.

Around this time, he recorded a scratch performance of the entire narration, and would use that as a reference as he was working out the timing of certain scenes (2).

With the basic structure complete, the creation of the final set designs took place in earnest. Even though this process took a few weeks, it was made less difficult from all the initial tests Phil had already performed. In parallel he also completed the 2D animation segments, using a program called MOHO, a 2D keyframed animation software purchased specifically for use in the film. Two videogames generated much of the footage, namely The Sims 2 and SimCity 4 by EA Games. Phil used a freeware tool called WinMorph to create the face-morphing scene near the beginning of the film.

At this point, five months into production, the film stepped into high gear, as Phil recalls: 'I constructed a shot list, filmed multiple takes of each scene at each location, and assembled the footage into an organized naming system for easier reference when it came time to edit. I immediately moved on to the video-editing stage.

I used Sony Vegas for video editing (3), and Steinberg's Cubase SX3 for editing the audio and music.

Once I had a rough edit, I took that over into my audio software, recorded a final take of the narration, recorded all remaining audio, and then tuned up the video edit once more. The final touch was the music.

I'd been sketching ideas for the music for a few weeks, but ended up recording all of it in a few days (4), followed by the final audio mix. This flurry of activity took place in three weeks.'

At this point, Phil felt it necessary to take some time away from the film, and put it away out of sight. Returning refreshed after this break, he realized he needed to see the film from a fresh perspective. 'I decided to fine-tune the video and audio editing and mixes. I burned the audio mix onto a CD and took it to my car, to my home stereo, to my wife's half-broken boom box. I found this was the best way to ensure that your audio mix sounded good in places other than your studio.' A few more audio tweaks followed as a result of these tests, and then the final render of the film into various formats was released on the Internet.

Phil equates the extraordinary success of the film to releasing the film in a format that enabled a core of people to do the hard distribution work for him: 'I did almost no promotion on the film, just basic word of mouth. Someone on Digg.com posted it there; a few days later, YouTube featured it on their front page, and that accounts for the first two million views!'

The stellar success of Male Restroom Etiquette was fitting for Phil, as the film had absorbed a huge amount of time in an intensive six-month period, but also had an impact on his family life. He believes his family's help and support was pivotal to making, producing and distributing the film.

Phil is positive about his experiences of creating films in a machinima context: 'I will definitely continue to make films. There's not a great deal I would change about my process, if I were again working on an entirely self-produced work; I am very happy with how things went this time. I want to entertain, to provoke thought, but primarily, I make films that are the kind of things that I would enjoy watching. And, I suppose, when what I enjoy making is in alignment with what people enjoy watching, then I'm certainly glad for that. But in the same sense, there are benefits to being at odds with what the world wants to see because controversy sells.'

Male Restroom Etiquette is a film made for an audience by a creator who likes and values being an audience member. 'I hope most people laugh. I expect some to be offended, perhaps even angry. The film does toy with images that some would interpret to be sacrilegious, while others will miss the satire and think I'm promoting things like homophobia. And oddly, I find any of the above to be pleasing. A reaction, after all, is what I'm after, and I expect that people will react in some way, perhaps even discuss. That is all good, as far as I'm concerned.'

↓ → ↘

The final weeks of production
turned into a video editing
marathon, but the process was
helped by using Sony Vegas.

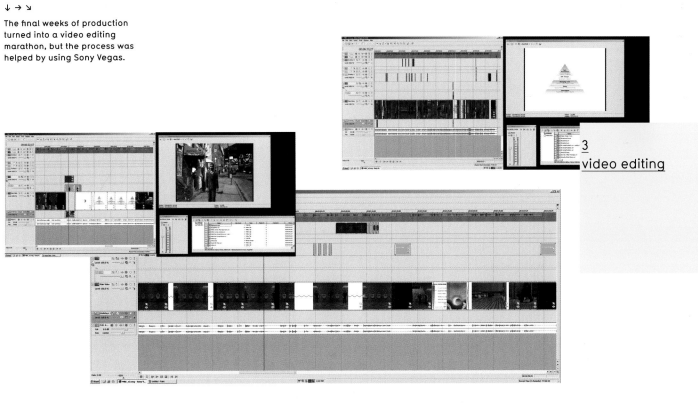

3
video editing

→

Phil Rice working on the
original musical score, which
was a combination of virtual
instruments and 'acidized'
rhythm loops.

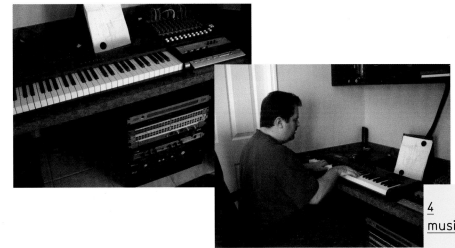

4
musical recording

→ ↗

Steinberg's Cubase SX3 was
used to create the high-
fidelity soundscape and
musical score for the film.

Paul Fletcher

Australia / digitalcompost.net

Dreamlake

⊙ featured on DVD / 2006 / 00:05:40

Made on an astonishingly small budget from the Melbourne Commonwealth Games Cultural Festival in 2006, Paul Fletcher's <u>Dreamlake</u> is an experimental, digitally animated film that attempts to work within a consistent pattern of discontinuity or dream-like logic. The film contains an abstraction of narrative and the foregrounding of an audio-visual and kinetic spectacle, and as such is reminiscent of a form found in classical ballet, modern action-adventure films and music video.

In <u>Dreamlake</u>, sounds sink slowly into the ground and thoughts float away as clouds, while dreams flow like water into a dreamlake, an emotional reservoir of dreams and memories. The film successfully attempts to create an 'e-scape', using electronic sound and video to create a surrealistic ballet of sound and images as a way of reflecting on the human-constructed lakes that feature heavily as meeting places in regional towns throughout Australia.

Paul's process is a constant cycle of brainstorming, experimentation, selection, reviewing, refinement and then beginning the brainstorming cycle over again, only reaching conclusion in a final editing stage that considers the overall pacing and energy together with the abstract musical structure. To truly see <u>Dreamlake</u> at its best, look out for its live performance in a city near you.

1
<u>source material</u>

How did you become interested in animation?

As a teenager, I began experimenting with music and visual art. I was absolutely fascinated reading and looking at the book Experimental Animation by Robert Russett and Cecile Starr. In fact, I still find this book inspiring to look at and think about although I don't currently have access to a copy of it. Ironically, only now am I getting to see some of the films via DVD and Internet sites. Inventors also inspire me, particularly the idea of inventing new objects and new ways to do things. I've always admired the inter-disciplinary skills and synthesis of historical figures such as Leonardo da Vinci, as much as 'backyard' inventors, where necessity, curiosity and ingenuity flourish.

How long have you been an animator and filmmaker?

I've been making short films using various animation and experimental techniques (Super 8, video, 16mm and digital technologies) for the last 25 years.

Who or what inspires or influences you?

Life. Other films and media, theoretical writing about film, scientific theories, crises, pressing issues and states of mind are absorbing too. I find friends and the general public, music and noise all inspirational. The occasional experimental/ innovative music video, advertisements and films that play with narrative and find new ways of telling stories or creating atmosphere and emotional affect also make me think. I admire the work of David Lynch, Ryoji Ikeda, Pierre Herbert, Oskar Fischinger and many others. My influences are pretty broad, encompassing advertisements containing ultra-condensed and disjunctive narratives and other artists working near where I live, such as the collectives Undue Noise and Punctum. In addition, the students I work with at various workshops from primary to University, particularly the Animation students at VCA School of Film and Television.

Describe your studio environment.

For the last five years, because of a four-hour return country train trip to my workplace every second day of the week, my studio has been my mobile laptop studio. I have produced much sound, music and digital animation on these journeys. Back at home, I have a small room inside my house as my office and studio, including two desks made out of various recycled doors and cupboards, walls lined with flimsy bookshelves piled high with books, DVDs and redundant formats such as zip disks, U-matic and VHS tapes, and an iMac, a G4 laptop, and a basic video and still camera. When making Dreamlake I had a pocket Vivitar 5.0Mb digital still camera, but since then I have bought a digital SLR. In the old farm barn, I have built a closed-in room that can be used for filming small sets and stop-motion.

What is your own personal definition of animation?

Inventing ways to express an idea or feeling, with visual movement, light and sound that can create an experience, provoke imagination, memories or thoughts. I would hope that this is something different or extraneous to communicating with written or spoken words or actions. My personal definition of animation is very broad and one that would like to embrace outcomes beyond traditional film and television screen formats including kinetic sculptures, wearable animation, interaction with performance and performers, gallery and public installations as well as reworking of traditional consumer objects.

↑
The exterior of Paul Fletcher's studio, formerly an old sheep-shearing shed.

↖ ← ↙ ↓ ↘
Paul filmed video footage on a JVC Mini DV camcorder and took still photos, From this material he selected images that he found typified the location.

Dreamlake came in response to the intention of Council Arts Officers administering the project to have artworks that responded to the historical and contemporary local environment. Paul's grant of AU$2000 covered some basic costs and provided for the purchase of additional lights and a FireWire hard drive to complement his existing equipment. Most of his time and the use of Graham Matthews' sculpture were 'in-kind' contributions to the budget.

Paul chose a local lake at Bendigo as a focus to build the film around; 'Dreamlake was a natural and convenient extension of my then preoccupations.

In an earlier film, Lake Qualm (2005), I had already worked with lakes as subjects for exploring tensions between calmness and a brooding unease, through a reservoir of memories containing many emotions, situations and events. In an earlier gallery installation, Time Decomposing and its associated film, 10,000days, I had also worked with the idea of a dream-like collage of past and present histories of a particular location. I was also fascinated in trying to simulate unusual states or confusions of perception, and found I could relate this interest by attempting to create the atmosphere of traces of people and times past and present, influenced by all the talk and theories about memory and time, including such concepts as there being eleven dimensions instead of the three we know well.'

Paul filmed video footage on a JVC Mini DV camcorder and took still photos (1). He selected from this material images that he found typified the location, from the mundane to the more interesting images. He chose ones that had some sort of evocative potential or that fitted with objects and images he was already working with. He ran this process in parallel to looking at historical images captured by Eadie Erskine, through glass slide photos taken of the same township in the 1940s.

In preparation for creating Dreamlake, Paul studied two film productions of Swan Lake, which his film makes reference to. He explains, 'The aspect which most struck me about watching these films was how they both created a symbolic and abstracted telling of the same story in very different ways and that they both seemed to rely on an assumed prior knowledge of the basic story. It seemed to me that their main interest was in a kinetic, visual and emotive spectacle, using both effect and affect. I hoped to rely on previous experience and knowledge possessed by my audience in terms of associations and allusions, like the fairytale icons, pumpkins, castles and dream-like landscapes and strange juxtapositions, all hopefully provoking imaginative if not emotive or reflective responses rather than just distanced irony and cool cynicism.'

No storyboards were ever created for the film. Instead Paul relied on drawings and a few lists of ideas and scenes that were updated regularly, through an idiosyncratic and organic process of trial and error (2).

With only six months to complete the whole project, this improvisational approach to production was both an aesthetic and a practical choice for Paul. The editing stage in the process became a writing process, resulting in 30 minutes of possible footage for Dreamlake by the end of the free-form, short but intense production period of just eight weeks.

The process of narrative was matched by the selection of suggestive imagery, as Paul notes: 'I pretty much was always looking and listening for

←↖
Paul layered current and
historical images in an
attempt to create a kinetic,
visual and emotive spectacle,
using both effect and affect.

2
layering imagery

←↖↑
The images are superimposed
together using the multi-
media programs Corel Poser
and Voyager, to create
layers of meaning, often from
surprising and unexpected
resources.

165 / Paul Fletcher

any ideas, objects, images or sounds that I might use, like an audio-visual hunting and gathering.

For instance, in following an interest in combining past and present, digital, virtual, analogue and known natural worlds, I noticed my collection of various pumpkins grown the year before, now in various dried-out and decaying stages, as well as a cupboard full of sprouting and shrunken potatoes.

These became two major elements incorporated as either characters or props, leading to the potato character in a potato boat and to the idea of the white horses pulling the pumpkin coach across various landscapes, created using Corel Poser. The virtual landscapes were created using the program Voyager.'

Paul describes the editing process as being central to his ideas about the role of narrative; 'My idea of "dream logic" manifested itself in this film in the form of many short scenes that somehow blend into each other.

For instance, by one object or layer remaining while the rest of the image changes, a phenomenon I remember from my own dreams, of being in one place then all of a sudden being in a quite different location and situation. The flying moth formations at the start of the film appear over the lake, and continue their patterned flying as the scene behind them changes from a theatre stage to a large landscape with white horses pulling a pumpkin coach. This strange pattern of flying moths was created by first animating a human figure in Maxon Cinema 4D, with re-coloured scans of real moth wings attached, then exporting this cycle as a QuickTime movie into the program Artmatic to create an iterative, almost fractal repetition of the image. Other images were created in Photoshop.

with After Effects and Final Cut Pro used for compositing and editing respectively.'

Graham Matthews' sculpture assemblages (3) were essential to inspiring and contributing to many of the collaged worlds and scenes in Dreamlake.

The collaboration inspired Paul to work more with actual collage/assemblage miniature sets and props. The combination of tight deadline, peer pressure and public exhibition of the Cultural Festival for which the film and performance version of the film were made, gave him the motivation he needed to complete the project.

Paul enjoyed the challenge of creating a live performance version of Dreamlake that utilized live sequencing, compositing and effects of the sounds and images in concert with live music performance (4).

'The musicians I worked with live tended to respond as much to the sound and music fragments associated with the footage as to its visuals. In the live performance version, with the vacuum cleaner audio-visual instrument/MIDI interface and live musicians, the film lasted for 20 minutes and probably only used an absolute maximum of 15 minutes of discrete footage, employing many loops with improvised sequencing and layering in various combinations. The performances informed my final edit of the film version with some arrangements I had not previously thought of.'

← ↖
A collection of dried pumpkins and other organic foodstuffs that Paul had collected were transformed into characters and objects to be manipulated using Photoshop.

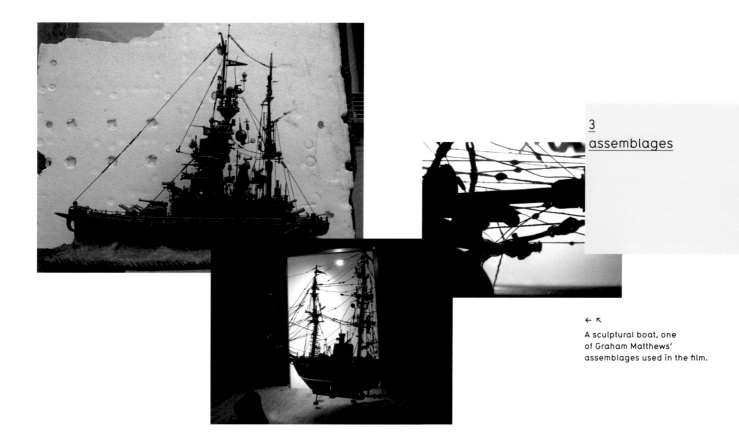

← ↖

A sculptural boat, one
of Graham Matthews'
assemblages used in the film.

← ↖

A modified vacuum
cleaner was used as a live
performance audio-visual
instrument. Various controls
using MIDI technology and
Max/MSP/Jitter software
were controlled by TV
antennae that had crude
touch-sensitive-triggering
technology. This produced
random MIDI piano phrases
when touched by performers'
hands. A long lever on the
other end of the vacuum used
pitch-bend MIDI information
to fade images up and down,
control blur effects and so on.

169 / Paul Fletcher

Semiconductor

UK / semiconductorfilms.com

Magnetic Movie

◉ featured on DVD / 2007 / 00:04:47

The secret lives of invisible magnetic fields are revealed as chaotic ever-changing geometries by artists Ruth Jarman and Joe Gerhardt, better known as Semiconductor. All of the action in Magnetic Movie takes place around NASA's Space Sciences Laboratories at the University of California, Berkeley, to recordings of space scientists describing their discoveries. Actual VLF audio recordings control the evolution of the fields as they delve into our inaudible surroundings, revealing recurrent 'whistlers' produced by fleeting electrons. Are we observing a series of scientific experiments, the universe in flux, or a documentary of a fictional world?

Magnetic Movie is an Animate Projects commission for Channel 4 in association with Arts Council England. It is a project created from highly scientific information filtered through everyday logistics to arrive at a shared and multi-faceted language. Throughout the interviews, the scientists used metaphors in order to find a common language whereby Ruth and Joe could comprehend the complex science they were describing; they learnt of hairy balls on the sun and dancing dots. When there were no likenesses, the scientists would describe abstract form and motion. Being confronted with the unseeable and the unknown challenged the artists' capacities to make sense of such an experience. Through their desire to find meaning they began to devise their own imaginary interpretations of what was expressed to try to find a way to comprehend and picture this world that exists beyond our sensory perceptions.

↑
The Samuel Silver Space Sciences Laboratory at the University of California in Berkeley, USA.

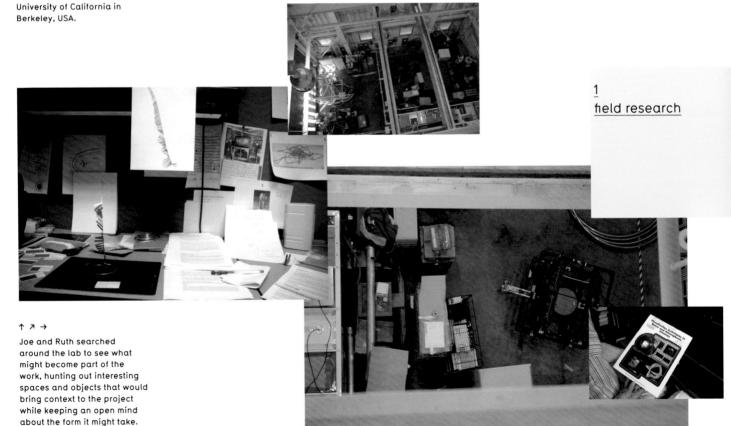

1
field research

↑ ↗ →
Joe and Ruth searched around the lab to see what might become part of the work, hunting out interesting spaces and objects that would bring context to the project while keeping an open mind about the form it might take.

How did you become interested in animation?

Animation became part of our making process quite naturally. As far as we were concerned, we were making artworks that explored specific themes and it wasn't important to define them by technique. Animation was a useful tool for the way we wanted to explore man's relationship to and experience of the natural environment, allowing us to manipulate and control time beyond human experience and scales larger and smaller than us. We use time-lapse as a way to experience thousands of years and the infinite 3D world the computer offers to experience and control vast and minute scales.

The computer of course plays a big part in this. Although we had been exploring more analogue process of moving image before we started working digitally – manipulating old slide projectors, monitors and projection equipment to explore new ways to present old technologies – the new challenges that the first generation of domestic computer software posed were too intriguing to pass by. The computer was offering us a new tool to play with. It came with all the potential a new material has brought to artists throughout history, and we set about bringing our demands to it.

There wasn't the proliferation of animation and moving-image work as there is now, so the dissemination platforms didn't create a context in the same way as they currently do. This really forced us to find our own audiences and define how we wanted the work to be seen by organizing our own events, releasing our work online and similarly releasing the first independent DVD compilation of our works. As our work has always spanned across genres and specifically into the art gallery world, this step was quite frowned upon at the time. Making available your artworks so readily to buy at an affordable price was deemed contrary to what the art world was about, but we were more interested in a dialogue with the audience and seeing where we could take what we were doing.

How long have you been animators, directors, producers or creators?

We have been working together as Semiconductor since 1997. Prior to this we were working individually on large-scale installations that incorporated construction, objects, moving image and sound. Our first projects as Semiconductor were creating sound works. Some of these were released on vinyl with labels such as Hot Air. We also performed soundtracks to films. Our first film work was Retropolis (1998), using computerized stop-frame capturing techniques of a real-world model that we then edited and processed in the computer. Because of the reliance on sound and the anti-narrative structure, we called these works Sound Films as a way to distinguish them from more traditional methods of filmmaking, thereby defining our own language and our intent. There was nothing immediate going on that we could relate to; we connected more with visual artists abroad who were experimenting with moving image utilizing the material of the computer, who we met

through screening and exhibition opportunities. It was three years and many works later that we asked ourselves if this was what we did now, made moving-image works, and also realized what we made could be called animation.

Who or what inspires or influences you?

We are directly inspired by experiences of natural and man-made landscapes and how as humans we interpret this. We have many influences from writers, scientists, filmmakers, artists, architects and musicians, most of whom lie on the more experimental edge of their field and who push the possibilities of the world around us.

Describe your studio environment.

For us a studio is somewhere you can retreat to, to focus your mind, and provides good stimulation for ideas and production. For the past few years our studio has been in a constant state of transformation. Multiple residencies have seen us sited in widely varying locations, which have all directly fed into the work and are often site-specific. During these opportunities the ideas are born and developed on location and it is these places that have become our studio.

Our first foray into residencies and one of our city projects was at Couvent Des Recollets in Paris. We were there for three months and the city became our studio. We were quite literally exploring and documenting on a daily basis using the architecture and planning as the material for a city-wide artwork that became our film The Sound of Microclimates. Other city-specific projects have included Venice for the Biennale and Prague for the Contemporary Art festival.

During a fellowship in Berwick-upon-Tweed, on the English/Scottish border, our studio became the Northumberland landscape, which exhibits a diverse geological history; evidence of glaciers, land formation and geological structures strewn across the landscape. We spent six months marching up hills, through bogs and scouring the beaches to document them. These became the basis for All the Time in the World, a surround-sound moving-image installation. Using seismic data acquired from the British Geological Survey in Edinburgh, we visually reanimated the landscape. We devised a process of attaching the sound to the image that sculpted it to suggest the motion that had gone into shaping the land, as if we were watching hundreds of thousands of years condensed into the length of a few minutes.

Our most recent fellowship and the one that formed the inspiration for Magnetic Movie was being placed in a NASA Space Sciences Laboratory at the University of California in Berkeley, USA. We were in the lab for five months virtually every day; interviewing scientists, exploring the many laboratories, following the various missions, witnessing the construction of satellites, attending presentations and generally absorbing information by being a fly on the wall and becoming detectives. We had a space in the lab to which we would

return with our findings; interviews, diagrams, visualizations and discoveries. It was here that we developed and discussed our ideas, which so far have turned up three moving-image works: Brilliant Noise, Do You Think Science and Magnetic Movie. Future space science-inspired projects see us taking the moving image away from the screen and placing it in an installation context.

What is your own personal definition of animation?
Animation is a tool that enables us to step outside of everyday human experiences of time and space and represent these; we can traverse the constraints of time by experiencing the evolution of a geological transformation, for example, or step into a world so small, on a nano scale, that it is unperceivable to us with our senses alone. As a tool it gives us infinite possibilities to explore the world that goes unseen and unheard due to our limited perceptive abilities.

↓ ↘
Throughout the interviews, the scientists Janet Luhmann, David Brain, Bill Abbett and Stephen Mende would use metaphors in order to find a common language so that Ruth and Joe could comprehend the complex science they were describing.

In 2005, Ruth and Joe were awarded an Arts Council international fellowship at NASA's Space Sciences Laboratory. Spending five months there, in the lab every day, the pair roamed corridors to see what was happening, pestered scientists to tell them about their science or attended presentations and meetings to try to get a hold on the science explored there (1).

Ruth explains: 'We arrived fairly naive about the particular fields studied, but hoped we could use this to our advantage, starting with a blank canvas. It was an experiment on ourselves in many ways and felt quite risky. We were familiar with these feelings of arriving in a new place through previous residency experiences, but we couldn't anticipate quite what it would be like in a NASA Space Sciences Lab.

We arrived with no preconceived ideas about the artworks we might make. Rather we hoped to be guided by the things we would come across and absorb.

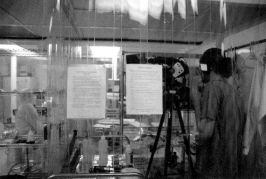

 ↗
Drawings were made back in the studio from location shots that would later help plan the CGI components of the film.

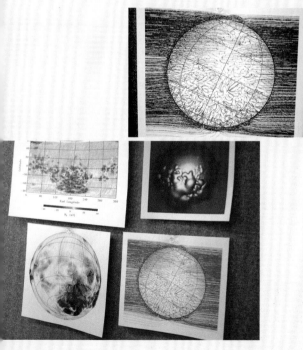

↑
Ruth and Joe explored the visual techniques the NASA scientists used to reveal their discoveries, including actual data from satellites and computer-generated visualizations of their results.

Of course we have particular interests but we had no idea if these were relevant to the situation or would come out in the work. Through a process of investigation we started to follow varying lines of discovery, being quite freeform about it.'

The pair interviewed space physicists and explored the visual techniques they use to reveal their discoveries (2), including actual data from satellites and, using computers, made accurate visualizations of their results, rendering the invisible visible.

The physicists use specific methods to represent various measurements, which they have the shared knowledge to interpret, but which appear to be abstract visual depictions and concepts to the layman. Ruth and Joe felt they could visually interpret this situation: 'We thought it would be interesting to introduce these objects back into the lab, bringing them down to a human scale so we could experience them on our own terms. We were interested in making what we refer to as a fictional documentary; a first-person journey where the audience can catch a glimpse of a hidden physical world within our everyday life.'

During the fellowship, Ruth and Joe developed the idea for Magnetic Movie with a rough idea of the form the film would take. They realized it was a long-term project that would need some funding. They applied to the Animate Projects scheme, only to be told that the funding body needed to see the work in much more detail with visualizations of what the work would look like. Ruth explains, 'This normally becomes part of an elaborate process in making our work, where we experiment with where to take the visual aspect of the work. Here it had to be done first, so the structure we normally take was already being thrown on its head. We received the funding eight months after returning from the laboratory and were given a longer deadline than we were used to – a year – which meant we would be able to step back from the work and keep re-evaluating it.'

In late 2006, Ruth and Joe returned to the laboratory for two weeks. They had been in contact with the scientists to check they would be about, planned questions to ask, and prepared themselves technically, updating their equipment to make sure they would get high-quality recordings of the scientists and the best visual documentation of the laboratory possible. They decided to work from photographs as they had done in a previous work, as this allowed better quality than digital video and offered more flexibility during production and editing. They also liked the idea of a photograph being a still moment in time that they could reanimate with time itself.

'During these two weeks we had to be on our toes, searching around the lab to see what might become part of the work, hunting out interesting spaces and objects that would bring context to the work while always trying to keep an open

mind about the form it might take' explains Joe. 'We knew we had one shot to gather everything we needed to make the work. We had to trust our instincts and keep evaluating what we needed more of or any creative eventualities that may come out of constructing the work in one way or another. We felt nervous about travelling with all our documentation on us, and the advantage of working digitally allowed us to make the decision to leave doubles with friends, just in case.'

Returning home, the pair worked on the dialogue, familiarizing themselves with the scientists' interviews and starting to plot out possible structures. The first one was too linear and was becoming too much of a narrative. They sought a different viewpoint and started to work in scenes where each scientist would be linked to a particular event and location. This offered the viewer possibilities rather than trying to dictate meaning. Editing the dialogue became an intensely rigorous process over two solid weeks, pulling out intriguing descriptions and editing out some of the scientists interviewed completely, ensuring the dialogue created form and rhythm.

The editing process then moved to link the dialogue visually. 'Bringing the images to the dialogue was a really fun process. We had pulled together our best images, which formed their own groups, as locations. We started to unite them with parts of the dialogue, imagining the forms that would appear within them. We went through the whole sequence doing this, continually shuffling about until it started to come to life and seemed to create meaning in itself. The choice to use photographs was really useful at this stage, as we could easily adapt the length or composition of a shot to suit its neighbour or the overall piece' Ruth explains. The opportunity to use Stephen P. McGreevy's natural VLF radio recordings, which he had been compiling for many years, mainly from his home in Nevada, proved an unmissable prospect.

Part of the commissioning process included several editorial meetings that gave deadlines for completing various stages of the work. Here the pair presented and talked about the work in progress. This was very useful and helped to confirm the direction in which the work should go, including the pace and complexity of the scientists' dialogue. Joe says, 'We spent more time here developing the techniques we would use to create the CGI and the way we would go about implementing it. We tried out a couple of shots and we soon realized with the introduction of the CGI into the scenes we had over-planned the number of shots that were necessary. There needed to be much more time in each shot to take in what you were seeing, so we stripped out a lot of shots.'

The pair worked scene by scene, developing the choreography of the animation and deciding on other techniques that would be used to bring the scenes to life, including the use of the VLF recordings to animate the fields, the camera motion they would introduce to suggest the human present watching, the objects' shadows and various other visual illusory methods. They implemented the animation over a seven-month period, constantly standing back to see how it was working and going back and tweaking various aspects.

The CGI was all based on actual scientists' visualizations of magnetic fields. Many of these are formed of manifestations of millions of lines of varying geometries that define the presence of magnetic fields and sometimes multicoloured lines that bring additional meaning such as open or closed field lines. The scientists can animate the fields over time with a sequence of images to show how they change shape through external influences.

Ruth and Joe took the basic form and motion of these visualizations to create their own elaborations of this visual language. Each scene introduced a different visualization technique suitable to the forms the scientists were describing (3).

For example, as one of the scientists, Janet Luhmann, describes the fields as a 'hairy ball', Ruth and Joe attempted to manifest this visually, placing it within the laboratory itself rather than on the sun from where it was born. This placed the field within a human scale, emphasizing the 'hairy ball' as a fantastical object in such a man-made environment, something that was unfamiliar to us yet supposedly existed, so begging the question, 'Is this what it would look like if we could see it?'

The pair wanted to use the camera motion to suggest someone witnessing these events occurring, using a very shaky hand-held camera so that the film appeared less of a science documentary but more akin to someone coming across these happenings by accident.

<u>Magnetic Movie</u> took two years to complete, and it has already caused a stir at festival screenings. Ruth and Joe are constantly looking for ways to approach subject matter with a dynamism and enthusiasm, often as they rely on human interaction to act as a catalyst for their work: 'All our films are very different technically. We challenge ourselves in a new way each time we make a moving-image work, and two works are never the same. <u>Magnetic Movie</u> has a new approach of using dialogue; our works are normally sound-led and we quite surprised ourselves by introducing the possibility of working with recordings of the scientists.'

3
final film

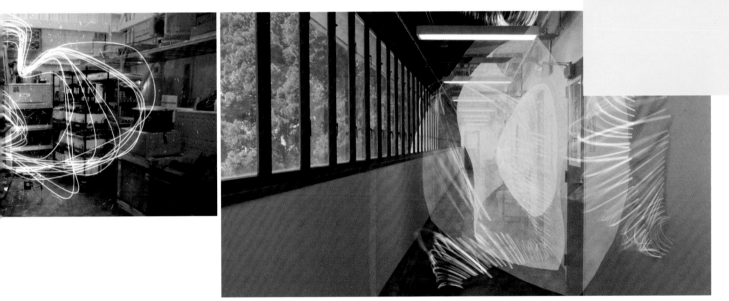

Awards & Festivals

Further Reading

Inspiration

Web Links

Index

Acknowledgements

Awards & Festivals

Cel & Drawn

Run Wrake
Tiger Award for Short Film, Rotterdam International Film Festival, Netherlands, 2006

Nomination, Best Animated Short, BAFTA (British Academy of Film and Television Arts) Awards, UK, 2006

Best Short Film and Best Film at the Cutting Edge, British Animation Awards, UK, 2006

Onda Curtas Award for Short Film, Lisbon Independent Film Festival, Portugal, 2006

Special Mention, Cartoons on the Bay, Italy, 2006

Jury Distinction, Annecy International Film Festival, France, 2006

Special Merit, Cracow Film Festival, Poland, 2006

Best Animation, Vila do Conde Film Festival, Portugal, 2006

Best Animation, Soho Shorts Festival, UK, 2006

McLaren Award for Animation, Edinburgh Film Festival, UK, 2006

Best Animation, Palm Springs Short Film Festival, USA, 2006

Special Jury Prize, Hiroshima International Animation Festival, Japan, 2006

Grand Prix, Imago Film Festival, Portugal, 2006

Grand Prix, Holland Animation Festival, Netherlands, 2006

Golden Dove, International Leipzig Festival for Documentary and Animated Film, Germany, 2006

Audience Award Best Animation, San Francisco Independent Film Festival, USA, 2007

Yoram Gross Award for Best Animation, Flickerfest, Australia, 2007

Best Film 5-10 minutes, Krok International Animation Festival, Russia, 2007

Best Short Film, St. Louis International Film Festival, USA, 2007

The Blackheart Gang
Special Distinction Award, Annecy International Film Festival, France, 2007

Best Independent Film Award, Bradford Animation Festival, UK, 2007

Canal+ Award, Clermont Ferrand Short Film Festival, France, 2007

Excellence Award, Exposé 3, Australia, 2005

Master Award, Exposé 4, Australia, 2006

Artistic Perfection Prize, International Festival Of Animation, Saint Petersburg, Russia, 2007

Grand Prix Of The Festival ('Golden Peg Bar'), Animanima, Serbia, 2007

Best Video Creation, Curtocircuito International Short Film Festival, Spain, 2007

Third Prize, Backup Festival 2007, Germany

Best Animation, Internacional De Cortometrajes 'La Boca Del Lobo', Spain, 2007

Best Film, Mnet Edit, Johannesburg, South Africa, 2007

Best Short Film, South African Film And Television Awards, 2007

Koji Yamamura
Official Invitation, Tokyo International Film Festival, Japan, 2007

Budapest Animation Festival, Hungary, 2007

Analogue and International Animation Festival – Animateka, Slovenia, 2007

Michael Dudok de Wit
Annecy Festival International du Film d'Animation, France, 2006

Seoul International Cartoon and Animation Festival, Korea, 2006

Huesca International Film Festival, Spain, 2006

Zagreb World Festival of Animated Films, Croatia, 2006

Anima Mundi, Brazil, 2006

Message to Man Festival, Russia, 2006

Best of the World Program, Hiroshima International Animation Film Festival, Japan, 2006

20th Odense Film Festival, Denmark, 2006

Busan International Kids Film Festival, Korea, 2006

Netherlands Film Festival, Netherlands, 2006

London International Animation Festival, UK, 2006

Holland Animation Festival, Netherlands, 2006

Bradford Animation Festival, UK, 2006

International Leipzig Festival for Documentary and Animated Film, Germany, 2006

Cinanima, Portugal, 2006

Cinemagic, Ireland, 2006

Brest Short Film Festival, France, 2006

I Castelli Animati, Italy, 2006

Mischa Kamp
Cinekidfestival, Netherlands, 2006

Animacor, Spain, 2006

Cinanima, Portugal, 2006

NYC Shorts, USA, 2006

Bradford Animation Festival, UK, 2006

IDFA Kids & Docs, Netherlands, 2006

Oneworld, Czech Republic, 2007

Sprockets International Film Festival for Children, Canada, 2007

Viewfinders International Film Festival, Canada, 2007

Academia Film Olomouc, Czech Republic, 2007

Indie Lisboa, Lisbon Independent IFF, Portugal, 2007

Platform Animation Festival, USA, 2007

Best TV series, Trebon International Festival of Animated Films, Czech Republic, 2007

Special Jury Prize, Seoul International Cartoon and Animation Festival, Korea, 2007

Best Educational, Scientific or Industrial Film, Annecy International Film Festival, France, 2007

Julian Grey
Ottawa International Animation Festival, Canada, 2007

Platform Animation Festival, USA, 2007

Gold, Advertising & Design Club of Canada, 2006

Gold Pencil, The One Show, USA, 2006

Silver, Art Directors Club, USA, 2006

Finalist – Television/Cinema, London International Awards, UK, 2006

Silver – Animation, ANDY Awards, USA, 2006

Merit – Consumer TV, ANDY Awards, USA, 2006

Finalist, Zebra International Poetry Film Festival, Germany, 2006

interfilm Berlin – 22nd International Short Film Festival Interfilm, Germany, 2006

Lumen Eclipse Showcase, USA, 2006

Anima Mundi, Brazil, 2006

onedotzero Digital Creativity Festival 10, UK, 2006

Stash, Canada, 2006

Sadho Poetry Film Festival, India, 2007

San Francisco International Film Festival, USA, 2007

Computer Generated

Motomichi Nakamura
Resfest 10, 2006

onedotzero Digital Creativity Festival 10, UK, 2006

Best Music Video, Platform Animation Festival, USA, 2007

Edinburgh Film Festival, UK, 2006

2nd Pictoplasma Animation Festival – Characters in Motion, Germany, 2007

53rd International Short Film Festival, Germany, 2007

Uchiyama and Kuroda Prize, Adobe Motion Awards, Japan, 2006

Paul Bush
Best Experiment in Film, Balkanima, Serbia, 2006

Jury Special Distinction, Animated Film Festival of Wissemburg, France, 2005

Best Animation, L'Alternativa, Spain 2005

2nd Prize, Media Forum, Moscow International Film Festival, Russia 2005

Frank Flöthmann
1st Pictoplasma Conference on Contemporary Character Design and Art (solo exhibition), Germany, 2004

2nd Pictoplasma Conference on Contemporary Character Design and Art (solo exhibition), Germany, 2006

1st runner-up in the comics category, The Greatest Story Never Told IV, Platform Animation Festival, USA, 2007

Jerôme Dernoncourt, Corentin Laplatte and Samuel Deroubaix
Imagina 2006 , Monaco

Shanghai TV Festival, China, 2006

Clermont Ferrand Short Film Festival, France, 2006

Resfest Italy, 2006

27ème Festival du Film Court de Villeurbanne, France, 2006

ReAnimacja Animation Festival, Poland, 2007

ANIMA Brussels, Belgium, 2007

Virtuality 2006, Italy

Brief Encounters, International Short Film Festival, UK, 2006

Miami, Romance in a Can, USA, 2007

Platform Animation Festival, USA, 2007

Nemo Festival, France, 2007

Melbourne Animation Festival, Australia, 2007

London International Animation Festival, UK, 2007

Brisbane International Animation Festival, Australia, 2007

Australian International Animation Festival, Australia, 2007

Jordan Short Film Festival, 2007

European Film Festival, France, 2007

36th Wellington Film Festival, New Zealand, 2007

KAFF 2007, Hungary

Anima Mundi, Italy, 2007

Bimini International Animated Film Festival, Georgia, 2008

Emirates Film Competition, 2008

Lycette Brothers
<u>Birdcage</u>
Spring-Loaded Festival, Australia, 2005

Platform Animation Festival, USA, 2007

Festival Pocket Films, France, 2007

<u>dConstruct</u>
D>Art.06, Locative/Mobile, Australia, 2006

Festival Pocket Films, France, 2007

<u>I Ride Over Alphabet Town</u>
Digital Projections, Resfest, Australia, 2004

Graphite 2005, New Zealand

Bimini International Animated Film Festival, Latvia, 2006

<u>Cinebugs</u>
DOTMOV Festival, Japan, 2004

Digital Projections, Resfest, Australia, 2005

Applied Animation, Holland Animation Festival, Netherlands, 2006

Chel White
Best Music Video, South by Southwest Film Festival, USA, 2007

Future Shorts Festivals (worldwide), 2006

interfilm Berlin – 22nd International Short Film Festival Interfilm, Germany, 2006

Resfest 10, 2006

Grant Orchard
onedotzero Digital Creativity Festival, UK, 2007

Annecy International Film Festival, France, 2007

Platform Animation Festival, USA, 2007

Award For The Best Achievement, Animated Music Videos and Commercials, Animanima, Serbia, 2007

London Short Film Festival, UK, 2007

Max Hattler
Runner-up, Best Animation, One-Minute Wonders, UK, 2006

Visionaria International Video Festival, Italy, 2006

BYDESIGN, Northwest Film Forum, Seattle, USA, 2006

Aurora: Norwich International Animation Festival, UK, 2006

International Leipzig Festival for Documentary and Animated Film, Germany, 2007

Tindirindis International Animation Film Festival, Lithuania, 2007

Flensburger Kurzfilmtage, Germany, 2007

One Minute Film and Video Festival, Switzerland, 2007

Theodore Ushev
Jury's Special Prize (Best Animation Film) – Prize City of Espinho, CINANIMA, Portugal, 2006

Best First Professional Film, Krok International Animation Festival, Russia, 2006

Best Non-Narrative Film, I Castelli Animati, Italy, 2006

Award for Best Abstract Film, London International Animation Festival, UK, 2006

Platform Animation Festival, USA, 2007

Special Mention, Animated Film Festival of Wissemburg, France, 2007

Jonathan Hodgson
London Film Festival, UK, 2006

Nominee, British Animation Awards, UK, 2006

Stuttgart International TrickFilm Festival, Germany, 2007

London International Animation Festival, UK, 2008

Mediawave, Hungary, 2007

Britspotting – British Independent Film Festival, Germany, 2007

UK Film Centre, Cannes International Film Festival, France, 2007

Prize, Anima Mundi, Brazil, 2007

interfilm Berlin – 23rd International Short Film Festival Interfilm, Germany, 2007

Cinanima, Portugal, 2007

Swerve Festival, USA, 2007

International Leipzig Festival for Documentary and Animated Film, Germany, 2007

Ottawa International Animation Festival, Canada, 2007

Future Shorts at Favela Chic, UK, 2007

Cinematheque Quebecoise, Canada, 2007

27th Uppsala International Short Film Festival, Sweden, 2008

Rotterdam International Film Festival, Netherlands, 2008

Animac, Spain, 2008

Clermont Ferrand Short Film Festival, France, 2009

Stop Motion & 3D CGI

Smith & Foulkes
Silver Prize, Epica, France, 2006

Special Jury Creative Prize, Meribel Ad Festival: Film Cristal, France, 2006

2 in-book entries, D&AD, UK, 2006

Silver Prize, BTAA (British Television Advertising Awards), UK, 2007

Gold Pencil, The One Show, USA, 2007

Gold Prize, Cannes Lions, UK, 2007

Silver Prize, London Midsummer Awards, UK, 2007

Bradford Animation Fetival, UK, 2007

Joint winner, Computer animation, BTAA (British Television Advertising Awards) Craft Awards, UK, 2007

3 Gold Prizes, 1 Silver Prize, The Kinsale Shark Advertising Awards, Ireland, 2007

Marc Craste
Platform Animation Festival, USA, 2007

Gold Prize, Best Animation (Commercials), London Midsummer Awards, UK, 2007

Bradford Animation Festival, 2007

Best Computer Animation, BTAA (British Television Advertising Awards), UK, 2007

The Kinsale Shark Advertising Awards, Ireland, 2007

Best Commercial, ANIMA Brussels, 2008

Robert Seidel
Honorary Award, KunstFilmBiennale, Cologne, Germany, 2007

Special Selection, Shift, DOTMOV Festival, Sapporo, Japan, 2004

Cartoombria, Italy, 2005

Honorary Mention, Animex, UK, 2005

Audience Award, ZEMOS98_7, Spain, 2005

Honorary Mention, BL!NDSPOT, Germany, 2006

1st Place, Education/Animation/Art, Animago @ fmx, Stuttgart, Germany, 2005

Audience's Choice, Best Film, fluxus, Brazil, 2005

Honorary Award, Sopot Film Festival, Poland, 2005

3rd Place Independent Non-Narrative, KAFI Kalamazoo Animation Festival International, USA, 2005

1st Place, Experimental/Abstract Work, Ottawa International Animation Festival, Canada, 2005

Special Mention, 9th Ismailia International Festival for Documentary & Short Films, Ismailia, Egypt, 2005

1st Place, Experimental Film, Lausanne Underground Film & Music Festival, Switzerland, 2005

Leo – Prize for best combination of film music/visuals, Filmfest Braunschweig, Germany

Runner-up, Creative Futures Award, Creative Review, UK, 2005

Suzie Templeton
Nomination, BAFTA (British Academy of Film and Television Arts) Awards, UK, 2007

Nomination, Royal Television Society Programme Awards, UK, 2007

Pulcinella Award, Best European Programme, Cartoons on the Bay, Italy, 2007

Nomination, Cartoon D'Or, 2007

Golden Rose, Best Performing Arts, Rose D'Or, Switzerland, 2007

Annecy Cristal, Annecy International Animation Festival, France, 2007

Audience Award, Annecy International Animation Festival, France, 2007

Special Prize, Krok International Animated Film Festival, Russia, 2007

Oscar, Best Animated Short Film, 80th Academy Awards, USA, 2008

Guilherme Marcondes

onedotzero Digital Creativity Festival 10, UK, 2006

Ottawa International Animation Festival, Canada, 2006

San Francisco International Film Festival, USA, 2006

Brooklyn International Film Festival, USA, 2006

Honorary Mention, Labo Competition (Official Jury); Best Film at Labo Competition (Press Jury), 29th Clermont Ferrand Short Film Festival, France, 2007

Best Animation, 37th Tampere International Short Film Festival, Finland, 2007

Best Film (Special Award by the festival direction); 2nd Place in Brazilian Short Films Award (audience choice in São Paulo), Anima Mundi, Brazil, 2007

Best Short Film, ANIMA Brussels, Belgium, 2007

Chris Frayne Award for Best Animated Film; Daily Audience Award, Ann Arbor Film Festival, USA, 2007

Best Animation (decided by audience online vote); Best Brazilian Animation (decided by jury); Onda Curtas Internacional Awards, Rio de Janeiro International Short Film Festival, Brazil, 2006

One of the 10 Best Brazilian Short Films (voted by audience); Special Mention by ABD (Brazilian Short-filmmakers Association), 17th São Paulo Short Film Festival, Brazil, 2007

2nd Prize, Animated Short Film (Adult Jury), 24th Chicago International

Children's Film Festival, USA, 2007

Best Animated Short Film, Leeds International Film Festival, UK, 2007

Resfest 10, 2006 (World Tour: Chicago, New York, Paris, Tokyo, São Paulo)

2nd Pictoplasma Animation Festival – Characters in Motion, Germany, 2007

Danish Animation Award for Best Animation in Competition, 22nd Odense Film Festival, Denmark, 2008

Clyde Henry Productions

Best Animated Film, Worldwide Short Film Festival, Toronto, 2007

Canal + Award, Cannes International Film Festival, France, 2007

Petit Rail d'Or, Cannes International Film Festival, France, 2007

Unorthodox

Phil Rice

Best Writing, Machinima Film Festival, USA, 2006

Nomination, Best Independent Film, Machinima Film Festival, USA, 2006

'Best of the Web', Animation World Network, USA, 2007

Second Prize, DivX Film Festival, USA, 2007

Best of Genre (Comedy), DivX Film Festival, USA, 2007

Official Selection, Platform Animation Festival, USA, 2007

Official Selection, Bitfilm Festival, Germany, 2007

Official Selection, Machinima Category, DragonCon Film Festival, USA, 2008

Paul Fletcher

Microcinema's Mind Over Matter, USA, 2007

Independent Exposure Animation, USA, 2007

Award for Best Film Under 10 Minutes, Theatre Royal Digital Chaos Film Festival, Castlemaine, Australia, 2007

Semiconductor

Best Experimental Film Award, Tirana International Film Festival, Albania, 2007

Rotterdam International Film Festival, Netherlands, 2007

Transmediale, Berlin, Germany, 2007

San Francisco International Film Festival, USA, 2007

Aurora: Norwich International Animation Festival, UK, 2007

London Short Film Festival, UK, 2007

Encounters Short Film Festival, UK, 2007

Brilliant Noise touring exhibition: Arnolfini/ Watershed, Bristol; Fabrica, Brighton; BA Festival of Science, Sightsonic Festival, York, UK, 2007

Amsterdam Film Experience, Netherlands, 2007

Playground Festival, Tilburg, Netherlands, 2007

Further Reading

Barrier, M. Hollowood Cartoons: American Animation in the Golden Age. New York & Oxford: Oxford University Press, 1999.

Beck, J. Animation Art. London: Flame Tree Publishing Co, 2004.

Beckerman, H. Animation; The Whole Story. New York: Allworth Press, 2004.

Bell, E. et al (eds). From Mouse to Mermaid: The Politics of Film, Gender and Culture. Bloomington & Indianapolis: Indiana University Press, 1995.

Birn, J. Digital Lighting and Rendering. Berkley: New Riders Press, 2000.

Blair, P. Cartoon Animation. Laguna Hills: Walter Foster Publishing, 1995.

Brierton, T. Stop-Motion Armature Machining. Jefferson, NC: McFarland & Co., 2002.

Brierton, T. Stop-Motion Puppet Sculpting. Jefferson, NC: McFarland & Co., 2004.

Brierton, T. Stop-Motion Filming and Performance. Jefferson, NC: McFarland & Co., 2006.

Brophy, P. (ed). Kaboom!: Explosive Animation from Japan and America. Sydney: Museum of Contemporary Art, 1994.

Bruce Holman, L. Puppet Animation in the Cinema: History and Technique. South Brunswick: A.S. Barnes, 1975.

Bryman, A. Disney and His Worlds. London & New York: Routledge, 1995.

Byrne, E. & McQuillan, M. Deconstructing Disney. London & Sterling: Pluto Press, 1999.

Cabarga, l. The Fleischer Story. New York: Da Capo, 1988.

Canemaker, J. (ed), Storytelling in Animation. Los Angeles: AFI, 1988.

Cholodenko, A. (ed). The Illusion of Life. Sydney: Power/AFC, 1991.

Cohen, K. Forbidden Animation. Jefferson, NC & London: Mc Farland & Co, 1997.

Cook, B. & Thomas, G. (eds). The Animate! Book Rethinking Animation. London: LUX, 2006.

Corsaro, S & Parrott, C. J. Hollywood 2D Digital Animation. New York: Thompson Delmar Learning, 2004.

Cotte, O. Secrets of Oscar-winning Animation. London & New York: Focal Press, 2007.

Culhane, S., Animation: From Script to Screen. London: Columbus Books, 1998.

Currell, D. Puppets and Puppet Theatre. Marlborough: The Crowood Press, 1999.

Demers, O. Digital Texturing and Painting. New Riders Press: Berkeley, 2001.

Drate, S. & Salavetz, J. Pure Animation – Steps to Creation with 57 Cutting-Edge Animators. London & New York: Merrell, 2007.

Edera, B., Full Length Animated Feature Films. London & New York: Focal Press, 1977.

Faber, L. & Walters, H. Animation Unlimited; Innovative Short Films Since 1940. London: Laurence King Publishing, 2004.

Finch, C. The Art of Walt Disney: From Mickey Mouse to Magic Kingdoms. New York: Portland House, 1988.

Frierson, M. Clay Animation: American Highlights 1908–Present. New York: Twayne, 1993.

Furniss, M. Art in Motion: Animation Aesthetics. London & Montrouge: John Libbey, 1996.

Gardner, G. Computer Graphics and Animation: History, Careers, Expert Advice. Washington D.C.: Garth Gardner Co., 2002.

Gehman, C. & Reinke, S. (eds). The Sharpest Point: Animation at the End of Cinema. Toronto: YYZ Books, 2006.

Grant, J. Masters of Animation. London: Batsford, 2001.

Halas, J. Masters of Animation. London: BBC Books, 1987.

Harnes P. (ed). Dark Alchemy: The Films of Jan Svankmajer. Trowbridge: Flicks Books, 1995.

Hart, C. How to Draw Animation. New York: Watson-Guptill Publications, 1997.

Hoffer,T. Animation: A Reference Guide. Westport, Conn.: Greenwood, 1981.

Hooks, E. Acting for Animators. Portsmouth, NH: Heinemann, 2000.

Horton, A. Laughing Out Loud: Writing the Comedy Centred Screenplay. Los Angeles: University of California Press, 1998.

Johnson, O & Thomas, F. The Illusion of Life. New York: Abbeville Press, 1981.

Kanfer, S. Serious Business: The Art and Commerce of Animation in America from Betty Boop to Toy Story. New York: Scribner, 1997.

Kerlow, I.V. The Art of 3D: Computer Animation and Effects. New York: John Wiley & Sons, 2003.

Kuperberg, M. Guide to Computer Animation. Boston & Oxford: Focal Press, 2001.

Laybourne, K. The Animation Book. Three Rivers, MI: Three Rivers Press, 1998.

Lent, J. (ed). Animation in Asia and the Pacific. London & Paris: John Libbey, 2001.

Leslie, E. Hollywood Flatlands: Animation, Critical Theory and the Avant Garde. London & New York: Verso, 2002.

Levi, A. Samurai from Outer Space: Understanding Japanese Animation. Chicago & La Salle: Open Court/ Carus, 1996.

Leyda, J. (ed). Eisenstein on Disney. London: Methuen, 1988.

Lord, P. & Sibley, B. Cracking Animation: The Aardman Book of 3D Animation. London: Thames & Hudson, 1999.

McKee, R. Story: Substance, Structure, Style and the Principles of Screenwriting. London: Methuen, 1999.

Missal, S. Exploring Drawing for Animation. New York: Thomson Delmar Learning, 2004.

Napier, S. Anime: From Akira to Princess Mononoke. New York: Palgrave, 2001.

Neuwirth, A. Makin' Toons: Inside the Most Popular Animated TV Shows & Movies. New York: Allworth Press, 2003.

Patmore, C. The Complete Animation Course. London: Thames & Hudson, 2003.

Pilling, J. (ed). That's Not All Folks: A Primer in Cartoonal Knowledge. London: BFI, 1984.

Pilling, J. (ed). Women and Animation: A Compendium. London: BFI, 1992.

Pilling, J. (ed). A Reader In Animation Studies. London & Paris: John Libbey, 1997.

Pilling, J. 2D and Beyond. Hove & Crans Pes-Celigny: RotoVision, 2001.

Pointon, M. (ed). Cartoon: Caricature: Animation, special issue of Art History, vol 18, no. 1, March 1995.

Priebe, K. The Art of Stop-Motion Animation. Clifton Park, NY: Delmar, 2006.

Purves, B. Stop Motion: Passion, Process and Performance. St. Louis & Oxford: Focal Press, 2007.

Rattner, P. 3D Human Modelling and Animation. New York: John Wiley & Sons, 2003.

Roberts, S. Character Animation in 3D. Boston & Oxford: Focal Press, 2004.

Russett, R. & Starr, C. Experimental Animation: Origins of a New Art. New York: Da Capo, 1988.

Sandler, K. (ed). Reading the Rabbit: Explorations in Warner Bros. Animation. New Brunswick: Rutgers University Press, 1998.

Scott, J. How to Write for Animation. Woodstock & New York: Overlook Press, 2003.

Segar, L. Creating Unforgettable Characters. New York: Henry Holt & Co, 1990.

Shaw, S. Stop Motion: Crafts for Model Animation. Boston & Oxford: Focal Press, 2003.

Simon, M. Storyboards. Boston & Oxford: Focal Press, 2000.

Simon, M. Producing Independent 2D Character Animation. Boston & Oxford: Focal Press, 2003.

Smoodin, E. Animating Culture: Hollywood Cartoons from the Sound Era. Oxford: Roundhouse Publishing, 1993.

Stabile, C. & Harrison, M. (eds). Prime Time Animation, London & New York: Routledge, 2003.

Subotnick, S. Animation in the Home Digital Studio. Boston & Oxford: Focal Press, 2003.

Taylor, R. The Encyclopaedia of Animation Techniques. Boston & Oxford: Focal Press, 1996.

Tumminello, W. Exploring Storyboarding. Boston & Oxford: Focal Press, 2003.

Wasko, J. Understanding Disney. Cambridge & Malden: Polity Press, 2001.

Webster, C. Animation: The Mechanics of Motion. Boston & Oxford: Focal Press, 2004.

Wells, P. Around the World in Animation. London: BFI/MOMI Education, 1996.

Wells, P. (ed). Art and Animation. London: Academy Group/John Wiley, 1997.

Wells, P. Understanding Animation. London & New York: Routledge, 1998.

Wells, P. Animation: Genre and Authorship. London: Wallflower Press, 2002.

Wells, P. Animation and America. Edinburgh: University Press, 2002.

Whitaker, H. & Halas, J. Timing for Animation. Boston & Oxford: Focal Press, 2002.

White, T. The Animator's Workbook. New York: Watson-Guptill Publications, 1999.

Wiedemann, J. (ed). Animation Now!. London & Los Angeles: Taschen, 2005.

Williams, R. The Animator's Survival Kit. Faber & Faber: London & Boston, 2001.

Winder, C. & Dowlatabadi, Z. Producing Animation. Boston & Oxford: Focal Press, 2001.

Withrow, S. Toon Art. Lewes: Ilex, 2003.

Inspiration

Want to see more?
You might want to explore some
of these festivals and events
for more pioneering animation.
Perhaps, even better, you might
want to enter your film into some
of these – that is how many of
these animators in this book were
originally discovered.

Anima
Cordoba, Argentina

Anima Mundi
São Paolo and Rio de Janeiro, Brazil

Animac
Lleida, Spain

Animated Encounters Festival
Bristol, UK

Animerte Dager
Fredrikstad, Norway

Animex
University of Teeside, UK

Annecy: Centre International
du Cinema d'Animation
Annecy, France

Aurora
Norwich, UK

Australian International
Animation Festival
Wagga Wagga, Australia

Bradford Animation Festival
Bradford, UK

Brisbane International
Animation Festival
Brisbane, Australia

Cartoons on the Bay: International
Festival of TV Animation
Amalfi, Italy

Cineme International
Animation Festival
Chicago, USA

Clermont Ferrand Short Film Festival
Clermont Ferrand, France

Fantoche International
Animation Festival
Baden, Switzerland

Hiroshima International
Animation Festival
Hiroshima, Japan

Holland Animation Festival
Utrecht, Holland

Incunabula
Cesena, Italy

London International
Animation Festival
London, UK

Melbourne International
Animation Festival
Melbourne, Australia

New York Animation Festival
New York, USA

Ottawa International
Animation Festival
Ottawa, Canada

Platform Animation Festival
Portland, Oregon, USA

San Francisco International
Film Festival
San Francisco, USA

Taiwan International
Animation Festival
Taipei, Taiwan

Zagreb World Festival of
Animated Films
Zagreb, Croatia

Web Links

If you can't get to festivals, let the work come to you. Below is a selection of sites that might inform and question your approach to animation. Click and absorb.

A-HAA!
www.animationarchive.org/

Animate!
www.animateonline.org/

AniPages
www.pelleas.net/aniTOP/

Ars Electronica
www.aec.at/en/index.asp

As Far As The Eye Can See
asfarastheeyecansee.blogspot.com/

ASIFA
asifa.net/

AWN
www.awn.com/

BBC Animation
www.bbc.co.uk/dna/filmnetwork/
animation

Cartoon Brew
www.cartoonbrew.com/

Center for Visual Music
www.centerforvisualmusic.org/
index.html

Cold Hard Flash
coldhardflash.com/

Data is Nature
www.dataisnature.com/

Directors Notes
www.directorsnotes.com/

Drawn!
drawn.ca/

Experimenta
www.experimenta.org/

Feed
feed.stashmedia.tv/

Fous D'Anim
www.fousdanim.org/

FPSmagazine
www.fpsmagazine.com/blog/index.php

hydrocephalicbunny
hydrocephalicbunny.blogspot.com/

Information Aesthetics
infosthetics.com/

Iota Center
www.iotacenter.org/

I.S.E.A.
www.isea-web.org/eng/index.html

Le Wub
http://www.lewub.com/

Mesh
www.channel4.com/culture/
microsites/M/mesh/

Motionographer
motionographer.com/

Neural
www.neural.it/

Neurastenia
www.neurastenia.blogger.com.br/

NFB
www.nfb.ca/splash/splash.php

No Fat Clips!
dekku.blogspot.com

S.A.T.
www.sat.qc.ca/

Society for Animation Studies
gertie.animationstudies.org/

StopMotion Animation
www.stopmotionanimation.com/

The Animation Podcast
animationpodcast.com/

YearZeroOne
www.year01.com/

Index

Page numbers in **bold**
refer to illustrations

Acknowledgements

I would like to thank everyone who made this book possible:

In particular, I'd like to thank Helen Evans and Donald Dinwiddie at Laurence King for commissioning and editing a book of this nature with much patience and good humour and to Philip O'Dwyer for designing in exactly the way that I had imagined. I am also grateful for the help and support of Tim Grabham of cinema iloobia for authoring the DVD accompanying this book.

I'd also like to thank the Animation Academy at Loughborough University, a research cluster consisting of a number of inspiring minds, especially Professor Paul Wells, for his much-appreciated and vastly superior knowledge, help and support and Andrew Chong for his encyclopaedic technical wisdom, plus my colleagues Alastair Adams, Julia Bracegirdle, Stephen Waterhouse and Andrew Davies and all of the illustration, animation and graphic design students for their continued patience and support.

My special thanks go to Jemma Robinson for doing such a fantastic job in teasing the most stunning images out of the contributors, and in the most polite and charming way – this book could not have existed without you.

I'd also like to express my profound thanks to all of the talented animators, directors, artists, designers, editors, production teams and festival organisers for generously allowing me to use such a myriad of information and images and for being so tolerant of my hounding. They are:

Annecy International Animation Festival [France] / Cindy Bazaugour / CITIA / CICA / Roy Disney | Ottawa International Animation Festival [Canada] / Jennifer Noseworthy / Jim Blashfield / Gary Baseman / Petr Maur / Andre Coutu / Tyler Platt / Scott Switzer / Andreas Hykade / Oscar Grillo | Platform Animation Festival [USA] | The Blackheart Gang / Jannes Hendrikz / Ree Treweek / Markus Smit / Justin Baker / Blackginger Special Effects [Cape Town] | Paul Bush / Marie-Christine Kamke / Natur-Museum Luzern / Andy Cowton | Claude Chabot / Stéphane Scott / Dominique Dalmasso / Xavier Langlet / Studio Archipel [France] | ClydeHenry Productions (Chris Lavis / Maciek Szczerbowski) / David Bryant / Jean-Frédéric Messier / Lea Carlson / Laurie Maher / Jason Walker / National Film Board of Canada | Marc Craste / Pam Dennis / Andy Staveley / Nikki Kefford-White and everyone at StudioAKA / Lloyds Bank plc | Michael Dudok de Wit / Willem Thijssen / Marc Schopman / Nic Gill / Maya Dudok de Wit | Paul Fletcher / Graham Matthews | Frank Flöthmann / Ommo Wille / Axel Meintker | Julian Grey / Kathryn Rawson and all the team at Headgear Animation [Toronto] / Jonathan Fusco, J WalterThompson [New York] / Billy Collins | Johnny Hardstaff / Ridley Scott Associates / Rebecca Grey Advertising [London] / Toshiba | Deborah Harty and Phil Sawdon / | Max Hattler / Pablo Gav | Jonathan Hodgson / HodgsonFilms | Mischa Kamp / Yaniv Wolf / Submarine [Netherlands] | Samuel Deroubaix / Corentin Laplatte / Jerôme Dernoncourt | John and Mark Lycette / Aaron McLoughlin / Markus Kellow | Guilherme Marcondes / Andrezza Valentin / Cia Stromboli / Trattoria / Cassiano / João / Fábio / Samuel Casal / Birdo Studio / Paulo Beto / Zeroum | Motomichi Nakamura / The Knife / Rabid Records | Grant Orchard / Pam Dennis / Sue Goffe / Phil Warner / Nic Gill / Sander Jones / Gideon Regal / Ren Pesci / QOOB [Italy] | Phil Rice | Romain Segaud / Michael Adamo / Katie Mackin and everyone at Passion Pictures [London] / Alex Hillkurtz / Mary Andrews / The Guardian Picture Library | Robert Seidel / Heiko Tippelt / Philipp Hirsch / Universal Everything / José González / Sleek Magazine [Berlin]| Semiconductor / Ruth Jarman / Joe Gerhardt / NASA Space Sciences laboratories at University of California, Berkeley / Janet Luhmann / Bill Ablett / David Brain / Stephen Mende | Alan Smith and Adam Foulkes / Julia Parfitt and everyone at Nexus Productions [London] / Weiden+Kennedy [London] / Johnny Trunk | Suzie Templeton / Elva Tarpey / Hugh Welchman and everyone at Breakthru Films [London] / Mark Stephenson / Martin Clapp / Ewa Maliszewska / Se-ma-for [Poland] / Jane Morton / Marek Skrobecki / Hugh Gordon / Tony Fish | Theodore Ushev / Marc Bertrand / National Film Board [Canada] | Chel White / Bent Image Lab [Portland, Oregon] / Thom Yorke / Radiohead / Dilly Gent / XL Recordings / David Russo / Mark Eifert | Run Wrake / Gareth Evans / Gary Thomas and everyone at Animate Projects / Howie B / Craig Richards | Koji Yamamura / Hitomi Shimizu / Shochiku Co. Ltd. / Kiri Yamamura and anyone else who I have forgotten to mention.

And finally to Felicity, Thomas and the growing bump – this is for you all.

This book is dedicated
to the life and memory
of Lucy Anne Parker,
a little animation fan.
28th January, 2006
– 3rd March, 2008